Carvalho

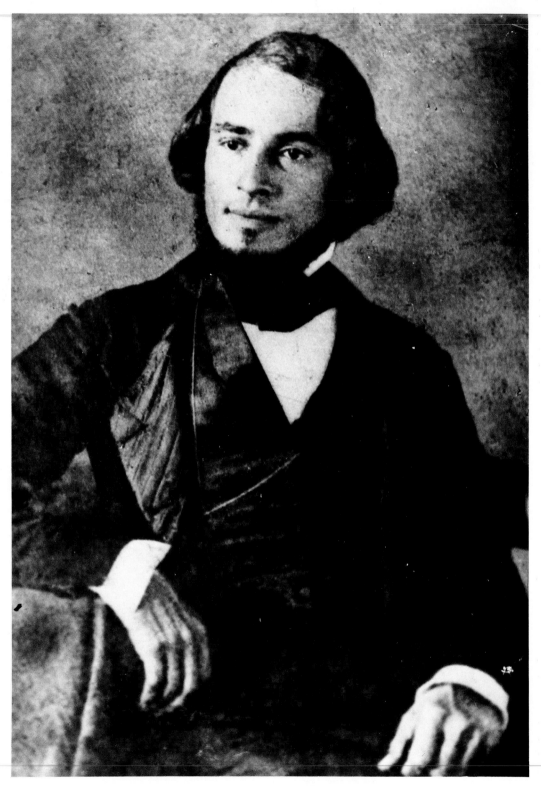

Self Portrait, c. 1848. Daguerreotype. Library of Congress.

Carvalho,

ARTIST – PHOTOGRAPHER – ADVENTURER – PATRIOT

Portrait of a Forgotten American

by Joan Sturhahn

Introduction By
Donald M. Early

RPC RICHWOOD PUBLISHING CO.
MERRICK, NEW YORK

Library of Congress Cataloging in Publication Data
Sturhahn, Joan, 1930-

Carvalho, artist-photographer-adventurer-patriot:
portrait of a forgotten American.

Bibliography: p.
Carvalho, Solomon Nunes, 1815-1897. I. Title.
TR140.C29S88 770'.92'4 [B] 75-22386
ISBN 0-915172-01-1

Dedicated to

PROF. THOMAS CORRELL
DR. CHARLTON TEBEAU
DR. BERTRAM W. KORN
MRS. MILDRED MERRICK AND DR. ANA ROSA NUNEZ
DR. CLARENCE STUCKWISCH AND STAFF
PROF. ROBERT WILLSON
PROF. DONALD M. EARLY
MR. IRA KAPLAN
AND TO SOLOMON NUNES CARVALHO HIMSELF,
WITH LOVE AND APPRECIATION

Contents

page

List of Illustrations ix
Introduction by Donald M. Early xi
Preface xv
Prologue xix

Chapter
I Charleston 1
II Travels at an Early Age 20
III Establishment in Philadelphia and Baltimore 36
IV The 1850's 45
V New York 1852-1853 64
VI John Charles Fremont and the Fifth Expedition 70
VII Utah Territory 99
VIII The Grand Canyon and other scenes 114
IX Fremont for President 124
X Baltimore 139
XI The 1860's 150
XII Failing Eyesight 168
XIII Later Years 183
Conclusion 192

Addendum 197
Appendix A—Inventory of existing works 201
Appendix B—Works known to be done, whereabouts unknown 206
Notes 209
Bibliography 217
Acknowledgments 223

List of Illustrations

Color Plates *Page*

Miriam Woolf Hirsch facing p. 34
Self Portrait facing p. 35
Brigham Young facing p. 98
Warka, Indian Chief facing p. 99
Rio Grande River facing p. 146
Sarah Solis Carvalho facing p. 147
Annie Abrams facing p. 162
Abraham Lincoln facing p. 163

* * * *

Self Portrait Frontispiece
Interior, Beth Elohim Synagogue 15
Exterior, Beth Elohim Synagogue 16
Dr. David Camden DeLeon 19
Silhouette 22
Johovath Isaacs 25
Unknown Young Man 26
Moses Finzi Lobo 28
Self Portrait 29
Child with Rabbits 31
Child with Rabbits, on paper money 33
John M. Hirsch 35
Unknown Young Man 35
Charity Hays 38
Jacob da Fonseca DiSilva Solis 38
Rabbi Isaac Leeser 47
The Lovers 51
Moses Before the Amalekites 56
Little Miss Carvalho 58
Fruit Still Life 59
Buffalos Escaping Prairie Fire 82
James Hamilton, *Buffalos Escaping Prairie Fire* 83
Indian Village 86
Cheyenne Princess 87
Huerfano Butte 90
Sketch of a Dead Child 108
Western Landscape 118
Entrance to Cochotope Pass 119
Landscape 122
Title page from Fremont *Memoirs* 131
John Charles Fremont, engraving 132
John Charles Fremont 135
George Murray Gill 140
Paul Charles Morphy 143
Program 144
David Nunes Carvalho 151
Judah Touro 154
Jacob Solis Carvalho 156
Aaron Lopez Gomez 157
Isaac Seixas Mendes Nathan 158
Solomon Da Silva Solis 160
Miriam Nunes Carvalho Osorio 160
David Hays Solis 160
Myer David Cohen 161
Mrs. Myer David Cohen 161
Two Fishermen at the Edge of a Stream 167
Portrait of Florencio Serrano and family 170
Sarah Solis Carvalho 173
Solomon Nunes Carvalho and son David 174
Ablum of Martinique—Birthplace of Empress Josephine 177
Album of Martinique—Dry Dock 178
Album of Martinique—Travellers Palm 179
Solomon Nunes Carvalho and Unknown Friend 184
Solomon as an old man 190
David Nunes Carvalho 198
Hudson River Scene 199

ix

INTRODUCTION

There is a point of view from which one is tempted to regard a nation's art traditions as largely the creation of its art historians. And nowhere is this temptation greater than when one views the history of American art. For it was the historians who first established that there *was* an American art, worthy of Europe's attention, with native currents that would one day enrich the cultural mainstream. And it was they—the historians—who rescued an imposing array of American genius from neglect and made it possible for us to see them (and ourselves) clearly for the first time. One thinks of such figures as Edward Hicks, the Quaker who preached the peaceable kingdom on Sundays and painted it repeatedly on canvas throughout his lifetime; of painter George Catlin who was fired with the mission to record "the red majesty" of the Western tribes before it was too late, and whose Gallery of Indian Portraits is now a cherished national treasure; of Ralph Albert Blakelock who painted in poverty and despair, went mad, and at the age of 70 regained sanity long enough to learn that his canvases were selling for $20,000 each.

One recalls, too, the work of Albert Pinkham Ryder, the childlike, half-mad perfectionist who while living in wretched squalor created the greatest lyrical paintings in American art. One remem-

bers Mathew Brady, the daguerreotypist, whose superb and indefatiguable artistry in recording the American Civil War in photographs was virtually forgotten until scholars exhumed his plates from the dust of a government archives attic.

And now, in hope of adding another name to that bright company, Joan Sturhahn has undertaken the task of rescuing and reappraising, in the light of American tradition, the work of the painter Solomon Nunes Carvalho. Obviously the task has not been easy. Over the years, owing to a number of circumstances, Carvalho's paintings have become widely scattered and have had to be traced through private ownership; some, of course, have been lost. Most tragic of all was the loss through fire of the priceless collection of daguerreotypes which Carvalho made as official photographer ("daguerian" was the term then used) on Col. John Charles Fremont's Fifth Expedition West. The best of Carvalho's work, however, remains, including some newly discovered paintings of unusual interest, and these provide the basis for an impressive accounting of Carvalho's accomplishments.

Joan Sturhahn's study of Solomon Nunes Carvalho reveals a man of many talents: painter, photographer, scientist, explorer, historian, cultural activist, and inventor. Historians in particular welcome Carvalho among their company because, in view of the loss of the daguerreotype plates, Carvalho's lively and detailed literary account of the Fremont Expedition *(Incidents of Travel and Adventure in the Far West)* remains the only record in any form that we possess of that well-nigh disastrous undertaking. Fortunately, much that Carvalho recorded in photographs, often standing waist-deep in snow on mountaintops to get the precise view he felt was needed for the Expedition's reports, was also described vividly in his words. His devotion to accuracy makes these impressions doubly valuable. One reads with amusement how Carvalho measured the size of the dried buffalo chips they used for fuel, noting that the largest found was two feet in diameter. He ends by telling how the starving party finally stumbled into a Mormon settlement where they fell to the ground, weeping from exhaustion and relief.

History and art both take note of the fact that Carvalho was probably the first American painter whose work appeared on United

States banknotes. An early painting of Carvalho's—and not a very good one—called "Child with Rabbits" was the subject honored in this case. For fifteen years or more it embellished bills of $1 and $10 denominations and was, in consequence, the best known painting in America. Later, "Rabbits" appeared on Canadian and Argentine banknotes.

A notable work of Carvalho's is a Lincoln portrait, painted in 1865, that now hangs in the Rose Art Museum of Brandeis University. It is an allegorical work, unlike any other Lincoln portrait we possess from that time, and its iconographical elements are of extraordinary interest. One wonders why it is not more widely known and reproduced. Perhaps this is one of those errors that Joan Sturhahn's book will correct.

It has been stated that during the 19th century virtually every American male fancied himself an inventor and had at least one patented device to his credit that would accelerate Progress and perhaps make his fortune. Lincoln, for example, held patent on a method of raising flatboats over dams and other navigational barriers. Carvalho, too, was typical of his time. In his later years he invented and promoted "An Entirely New Steam Super-Heating System by Hot Water Circulation Under Pressure." This system was offered

> "To Engineers, Piano Manufacturers, Cabinet Makers, Sugar Refiners, Bread and Cracker Bakers, Chemists, Hotel Keepers, Woolen and Cotton Mills, Dyers, Brewers, Oil Refiners, Soap Boilers, Desiccating Vegetables and Milk, and all other Industrial and Manufacturing Pursuits . . .

Whether the system was ever adopted by industry is not known, but that it had obvious merit is attested by its having been awarded the Medal of Excellence by the American Institute of New York.

The portrait of Solomon Nunes Carvalho that Joan Sturhahn has drawn for us in this work is that of a many-talented, vivid, engaging personality who clearly has not deserved the neglect that he has had to endure. One feels that now this situation will be

changed . . . that every lover of American art who reads her book will never again envision the constellation of 19th century American artists without Solomon Nunes Carvalho occupying his rightful place among them.

<div align="right">

Prof. Donald M. Early
Miami-Dade Community College
June, 1975

</div>

PREFACE

Of the myriad of books published since mid-nineteenth century on the subjects of American photography and painting, many mention the name of Solomon Nunes Carvalho. Most give only a brief account of his work as artist and daguerreotypist on Colonel John Charles Fremont's expedition to the West in 1854-56, for his name is eclipsed by those of Mathew Brady, Jeremiah Burney, Marcus Root and others.

Until the publication of Dr. Bertram Korn's monograph in 1954, there had been little critical writing about Carvalho or his works. Appearing in that volume, for the first time, were extensive illustrations of his paintings, and discussions of the artist's religious and political activities.

Since beginning a search in 1969, the author of this work has discovered and identified a new body of Carvalho paintings and photographs along with a number of written sources which greatly expand our resources for a study of this versatile man's accomplishments and activities. It is the purpose of this book to present this material and relate it to the events and mood of the era, and to further assess the artist's place in nineteenth century art.

To accomplish this, the author has chosen to treat Carvalho's

life and works in a chronological order, thus placing him and all of his known works in historic perspective. Charleston, South Carolina, Carvalho's birthplace, was a city of great culture early in American history. A discussion of the artistic climate of Charleston reveals the effect of its cultural heritage on Carvalho and his Charleston contemporaries.

Fortunately for the art historian, Carvalho was a Sephardic Jew, that is, a Jew of Spanish and Portuguese blood. In Judaism, the Family is a treasured concept and its artists and their works are accorded reverence and respect. Records are kept and miniatures and portraits are displayed and dusted. Solomon Carvalho's father, David, had been one of the early crusaders for reform movements within Judaism. Solomon, too, involved himself with matters of religion; although his ideas were not quite as liberal as his father's had been, he made his own contribution to his faith by helping pioneer Jewish communities to organize for mutual assistance and strength, a contribution called the Hebrew Benevolent Society. Since Carvalho traveled extensively, this contribution was indeed widespread. In addition, he recorded on canvas likenesses of many prominent members of the Sephardic Jewish society.

In terms of art history, Solomon Carvalho's daguerreotypes of the western United States were among the earliest known, and his photographs and narrative account of Martinique are valuable to Caribbean historians.

As a portrait painter, Carvalho was well acquainted with such important people as John Fremont, Abraham Lincoln, Brigham Young, Dr. David Camden DeLeon, Warka, the Utah Indian Chief, and others, painting their portraits both from life and from photographs, adding to our library of art history. It is interesting to see the difference in a painting by Carvalho from an actual sitting, and a painting from a photograph. Most of Carvalho's portraits have the intimacy and pervading light true of a painting done at an actual sitting. In photography, studio lighting was strong with high contrasts of light and dark. When Carvalho painted a portrait from a photograph, he carried over these strong contrasts. Psychological implications are absent due to the remoteness of the subject. His portraits, in general, follow the Stuart tradition, seeking to capture in his

likenesses the one expression that contains all others, emphasizing pose against plain ground, with prominence given to the eyes and the nose.

Although Carvalho was a contemporary of artists of the Hudson River School, he seems not to have come into his own in landscape painting until his transcendental experiences during his trip west with the Fremont expedition—feelings that he expresses both in written word and in paint. At the point where he begins painting landscape, it seems obvious that he had studied the works of Doughty, Morse, Kensett, Cole and Durand. Of these, his greatest affinity seems to lie with the works of Kensett: a pervading silver light lives within the landscapes of both artists. His paintings of the western peaks may have inspired other artists to go West, as he preceded the Rocky Mountain "School" by some five years. The shimmering light of his painting, "The Rio Grande River," in the Kahn Collection of the Oakland Museum, speaks of the quietude of nature and virtue become One, and shares no resemblance to the harsh, huge canvases of Bierstadt, who came after him.

Carvalho's prominence in art is in the areas of portraiture, landscape painting and photography. One may add to that, writing, scientific inquiry and inventing—a man true to the ideal of the nineteenth century. Since beginning my search in 1969, new and important sources have been uncovered which shed new light on Carvalho's art. They range from discoveries of Carvalho's art on paper money, arcane magazine and newspaper articles, unpublished letters and family documents, privately printed and uncirculated materials, autobiographies from Carvalho's time and place, to inscriptions on tombstones in an ancient Sephardic cemetery in Barbados. The additional works found expand and enhance our knowledge of Carvalho's artistic achievements. In his last works, we see a definite movement toward what we now call Impressionism—a new plateau for Carvalho, and the point at which his painting career abruptly ends because cataracts on his eyes, though removed, left him with impaired vision.

PROLOGUE

Dear S____:

The duties of camp life are becoming more onerous as the weather gets colder. It is expected that each man in camp will bring in a certain quantity of firewood! My turn came today, and I am afraid I shall make a poor hand, in using the axe; first, I have not the physical strength, and secondly, I do not know how. I managed by hunting through the woods to find several decayed limbs, which I brought in on my shoulder. I made three trips, and I have at all events supplied the camp with kindling wood for the night. I certainly, being a 'Republican,' do not expect to warm myself at the expense of another; therefore, arduous as it is, I must, to carry out the principle of equality, do as the rest do, although it is not a very congenial occupation.

Solomon Nunes Carvalho reveals some things about himself in this letter to his wife, written late in 1853: he is camping in cold weather, has never chopped firewood, is a "Republican," is willing to try to perform the same tasks as his fellows, and has a wry sense of humor.

Besides being a writter of letters, an author of an historical account of an expedition to the West and a husband, what else was Solomon Nunes Carvalho?

Prologue

We know that he was daguerreotypist and artist on John Charles Fremont's fifth expedition—the historians tell us so. Solomon, himself, tells us so.

There are many blank spaces in Carvalho's personal history, something he shares with his contemporaries, David Gilmour Blythe and James Hamilton.

The task of the biographer is like that of the detective who must build his total picture from a series of clues. In Carvalho's case, there are many such clues, but no single effort has been made to follow all of them down to the tiniest pinpoint, to put all of them together in a single effort, in order to fill those blank spaces in his life.

Usually, one begins at the beginning, the date of birth. In this case it is necessary to review the cultural milieu of Charleston, South Carolina, the city of Solomon's birth, in order to set the scene for his entrance into the nineteenth century.

CHAPTER I

CHARLESTON

Charleston, gracious lady, center of trade and culture. In spring the sun warms and camellias blossom; dark blue waters spill down her side. But in winter, damp chill sent some early settlers into consumptive spasms and quick graves, while in summer the planters fled malarial indigo and rice marshes for more hospitable climates.

To her many moods, the verandahed homes and moss drenched oaks, settlers were drawn from England, France, Portugal, Spain, the Caribbean and from the colonial cities of Philadelphia and New York. For a time, the cosmopolitan population was largely one of prosperous planters and merchants, and her port was the busiest on the entire eastern seaboard.

> . . . the city was the shipping and storage center of European merchandise for the West Indies and of coffee and West Indian sugar for Europe.[1]

This prosperity lasted for some fifteen years after the French Revolution, but after 1820 trade began to fall to New York, New Orleans and Mobile.

The charm of Charleston was influenced by two factors: one, a man; the second, climate.

Gabriel Manigault was a designer with consummate taste and skill. In his architectural designs, he synthesized classical elements

1

with influences from New England and France. His style was so
popular that it took an architect of Robert Mills' stature to introduce
Greek Revival architecture into the landscape of the town, and even
then it affected only a few buildings. Manigault's influence persisted
until the 1840's, when the Greek Revival style became common.

Manigault's personal, refined design, had to accommodate
Mother Nature's spells of extreme heat and dampness. In order to
live with these extremes, the planners developed a house and orien-
tation to weather which had a unique effect. Who can forget the
storied, galleried houses of Charleston, their piazzas and walled
gardens, the breezes across a verandah, the ornamented pillars, the
harmony and variety, the charm.

With growing affluence and a continental heritage came the
need for educational institutions, theater and the arts. As early as
1783, Charleston had a theater. In 1792, an upheaval at St.
Domingo brought numbers of French refugees to join the already es-
tablished Huguenot settlement.

> Being kindly received and welcomed by the Charleston
> people, they were afforded opportunities of earning livelihoods.
> They brought an atmosphere of gaiety and gallic vivacity to the
> life of the city, soon to be reflected in the diversions and
> amusements of the place. Music and dancing were made acces-
> sible, through the knowledge and teaching of the newcomers.[2]

Painting was a Charleston activity early in the 1700's. The first
known painters were Henrietta Johnston, who did pastel portraits;
the Swiss academician, Jeremiah Theus; and Alexander Gordon.

The College of Charleston was established, and in 1791 held an
exhibition of paintings, the establishment and exhibition probably
resulting from the following article of 1784 in the *South Carolina
Gazette and General Advertiser*:

> While our thoughts are employed to cultivate
> amusement—in Musical and Dancing Assemblies, in Smoking
> Clubs, Ugly Clubs and Rabbitt Societies, do let some attention
> be engaged to form an establishment for THE ARTS.
> . . . But as it is evident our care and substance ARE daily em-
> ployed to raise the trifling superstructures of dissipation, it
> would be more to our honor as a people that BOTH should be

directed to those Arts which will afford entertainment, recreation, liberality of sentiment, and a refinement of knowledge. . . . The state has already provided funds for a Seminary, or College, and I am informed many valuable bequests, unappropriated, have been made for the same purpose—A SMALL SUM ONLY WILL BE NECESSARY TO FOSTER INGENIOUS ARTISTS.[3]

There was a long history of those "ingenious artists" in the annals of Charleston. Henry Benbridge, formerly of Philadelphia, studied in Italy with Mengs and Battoni, and went on to London where he painted portraits with apparent success. Returning to Philadelphia in the fall of 1770, he married Letitia Sage, a painter of miniatures, and in 1773 the couple settled in Charleston according to the following extract of a letter:

I saw Mr. Bembridge [*sic*] who is settled very advantageously there, and prosecutes his profession with reputation and success.[4]

Two sons of South Carolina whose works were esteemed were Washington Allston and John Vanderlyn. Allston exhibited frequently in Charleston, as did his friend, Vanderlyn, who was elected to the South Carolina Academy of Fine Arts in May, 1821, certificate being signed by J. S. Cogdell and J. Poinsett. Allston had studied with Benjamin West in London. Samuel F. B. Morse and Charles Leslie both had studied with Allston, and Morse showed the influences of West's ideas in his inclination towards historical paintings.

The miniaturist painter, Edward Greene Malbone, who knew Allston, West, Trumbull, Dunlap and Trott, was successful in Charleston, painting some two hundred works during his three month visit in 1801, and returning for a second productive sojourn in 1802. Malbone was a friend of the French painter, Jean Francois de Vallee, who produced miniatures in Charleston during the years between 1785 and 1815.

The parents of Thomas Sully, theatrical folk, were drawn to Charleston sometime around 1792 with the advent of the new theater. Sully's ties with Charleston were strong throughout his long

life. One sister, Harriet, married a Professor Porcher of that city. Another sister married a Frenchman, Mr. Belzons, and they moved to Charleston where Belzons set up a studio as a painter of miniatures. Sully studied with his brother-in-law for a short time, but the two men were not temperamentally suited to one another, and Sully left his studio rather quickly. At that point, he met his first gifted teacher, Charles Fraser. By 1818, Sully had painted more than one hundred portraits of Charlestonians, and he wrote of his friend and teacher:

> He was the first person that ever took the pains to instruct me in the rudiments of the art, and, although himself a mere tyro, his kindness and the progress made in consequence of it determined the course of my future life.[5]

Fraser had a long and successful life as a Charleston painter, teacher, and close friend of such artists as Allston, John Stevens Cogdell (who remained active in the long running efforts to establish a Charleston Academy). John Blake White, who studied for a time in London, encouraged fellow Charlestonians Wightman, Deaveaux and Irving to follow him to Europe.

During the first quarter of the century, included in the Charleston scene were painters Morse and his assistant, Henry Pratt, who later in life joined an exploring party on the Mexican border. Morse had family ties in Charleston through his uncle, Dr. James E. B. Finley.

Others whose faces and works were seen in the city at this time were John Wesley Jarvis, Samuel Waldo, Benjamin Trott, William Shields, Cephas Thompson, Alvan Fisher, Mr. Early (who exhibited a collection of paintings in Charleston and was Sully's partner in a Philadelphia gallery (see Sartain, *Memoirs*, p. 164) and, of course, Sherwood and the native son, Vanderlyn, the latter exhibiting in 1822 his Caius Marius, Ariadne, Danae and his panorama of the palace and gardens of Versailles to the delight of the art-loving Charlestonians.

By the mid-nineteenth century, Henry B. Bounetheau, Charles H. Lanneau and Samuel Osgood were active. Osgood, who will concern us later, was restless in the East and later moved to California where he remained until his death.

Raphaelle Peale worked in Charleston in 1823-24, advertising portraits, miniatures, still lifes and profiles on ivory, with a studio address at No. 45 State Street.

Besides the illustrious artists, Charleston had her unknowns, too: Augustus Simon, miniaturist, James Guild, Lewis Paduani, Manuel Cil (Spanish miniaturist and teacher), R. Gardner, a portraitist named Merchant, and the Scottish painter, James Thompson.

It was also home to Miss Martha Ann Honeywell, born without hands, but who did paper cuttings and needlework, holding the implements in her mouth.

John James Audubon first passed through Charleston in 1831 on his way to Florida. Apparently he was fond of the city, because he returned there often to visit and work. Audubon's sons, Victor and John, married Charleston girls, strengthening the ties.

Robert Mills, who has been called the first native born American architect, was a native of Charleston, and designed the monument to Baron de Kalb at Camden, South Carolina, which General Lafayette honored with his presence at the unveiling.

Famous as "The Pathfinder," John Charles Fremont spent his youth in Charleston, turning his Charleston College professors' tempers hot because of his pranks. He was an excellent scholar, when he set his mind to it, choosing Latin, Greek, astronomy and accounts of the lives of famous men as his favorite subjects. He also wrote poetry, some of which was published in the local newspapers. It was from Charleston that Fremont first sailed as a young man on a Navy sloop, the Natchez, in 1833, and from Charleston that he was ordered to Washington by Secretary of War Mr. Poinsett in 1838 to begin his extraordinary adult career of soldiering and exploring.

The daguerreotype was not missing from the Charleston ledger of artistic activities as we note from the *Courier*, February 25, 1841:

> . . . there are several individuals, now in this city, who practice the art. . . .[6]

and among those mentioned in the article are Charles Taylor, who was a pupil of Samuel F. B. Morse, a Dr. Ellet of South Carolina College, and Christian Mayr.

Joseph Pennell, daguerreotypist, schoolmate of Albert South-worth and a former pupil of Morse, went to Charleston sometime in 1844, supposedly to teach in a private school. He did not abandon daguerreotyping, however, for he ordered plates and cases to be sent to him in that city.

From New Orleans, Charles S. Cook appeared with the intention of studying art. Somewhere along his path, he succumbed to the fascination of the daguerreotype, as in 1850 he was exhibiting them in Charleston, and a year later took charge of Mathew Brady's New York emporium.

Charleston was education conscious. In addition to the College of Charleston, there were private academies in existence, such as that run by Isaac Harby, writer, teacher and newspaperman. According to his advertisement, he taught:

> the usual branches of an English education, viz. *Elocution, Arithmetick, Penmanship, Grammar, Geography*—also the *Latin and Greek Classics, Composition & the first Books of Euclid's Elements.*[7]

Probably, Harby's biggest competitor was the Charleston Academy, which covered foreign languages, teaching French, Italian, Latin and Greek, as well as the usual subjects: science, English and mathematics, and, not surprisingly, art.

The Hebrew Orphan Society, of which Harby was a distinguished member, supported a school and Myer M. Cohen ran a seminary until 1828, where he taught English and classical subjects. In addition there were the Free Schools which were public institutions.

There was a large and distinguished Jewish community in Charleston, of which Harby and Cohen were a part, and it produced not only merchants, but physicians, teachers, judges, bankers, lawyers, dentists, writers, and painters. Included in the last category were Joshua Canter, portrait painter and teacher who studied art in Copenhagen, moving to Charleston from Denmark in 1792, and Theodore Sydney Moise, who advertised in the local newspapers as a portrait painter. The latter must have felt that success in painting did not frequent Charleston, for he moved to New Orleans in 1843. In 1791, there had been an attempt to form an organization for art

and artists in Charleston. A second effort was made in 1816, when an exhibition of paintings on loan was held in the South Carolina Society Hall, sponsored by such artists as Cogdell, Morse, White, Canter, and others such as Thomas Middleton and William Gilmore Simms, newspaper editor, friend of the arts, and regular contributor to John Sartain's Philadelphia publication *Union Magazine of Art and Literature*.

In 1821, the struggling South Carolina Academy of Fine Arts was granted a charter:

> 'any individual professing any of the liberal arts . . . was eligible to membership . . . without subscription of money.' For artists the only stipulation was the presentation of a painting, statue, cast, model or engraving of their own production. Annual exhibitions were planned, artists and amateurs were to be invited to exhibit their own works and owners of fine pictures and other words of art to lend them.[8]

The cultural climate surrounding the founding of the new Academy was apparently an exciting one, as an amusing quote from the Charleston *Courier*, January 21, 1822, graphically demonstrates:

> Charleston abounds with attractive spectacles, which we will endeavor to classify. For persons of taste and imagination, there is Mr. Vanderlyn's Panorama of Versailles, Ariadne and the Golden Shower—Mr. Sully's Interior of the Capuchin Chapel—Mr. Peale's Court of Death. For persons of musical taste and science, Mr. Lewis' extraordinary concerts. . . . For amateurs of the graces of the person, Mons. Brozza's operatic dances. For the connoisseurs in attitude and agility, Mr. Blanchard's Olympic Performance. For the fancier of great things, an elephant and two Mammouth Hogs. For the fanciers of little things, a White Rat. For the amiable, a Tiger and a Lion. For the pacific, two Elks and a Deer—and for those who are tired of their reason—*Exhilarating* Gas. . . .[9]

The Academy was housed in a building of the classical style which was constructed especially for its use on a lot on Broad Street. It soon became evident that additional funds were necessary, and so a lottery was organized in collaboration with the Literary and Philosophical Society. It was an unsuccessful attempt to raise the needed money.

The Academy struggled along, much a part of the community, until its demise in 1830, offering the public works from the English school, paintings by Morse, Vanderlyn, Stuart, Jarvis, Waldo, Fraser, Fisher, the Canter brothers and Hill, as well as works attributed to Correggio, Rubens, Morland and others.

Upon the failure of the Academy, editor William Simms gave it a long obituary, July 22, 1830, in the *City Gazette and Commercial Daily Advertiser* (Simms made a last attempt in 1837 to found an Academy of Arts and Design, but it did not last beyond its first year).

Around 1838, Thomas Sully presented a replica of his famous portrait of Queen Victoria to the St. Andrews Society of Charleston, thus adding a new gem for the local viewers, who had been familiar with copies of Stuart's full length portrait of George Washington since 1835.

Artistic life continued without a formal organization until 1849, when:

> the South Carolina Institute 'for the promotion of ART, MECHANICAL INGENUITY, AND INDUSTRY,' was chartered, and sponsored an annual fair for many years afterwards. At the exhibitions drawings, statues, oil paintings, miniatures, copies and original pictures, photographs and daguerreotypes were shown next to rice machines, pumps, plows, jams and jellies.[10]

The Carolina Art Association was formed in 1858, and with it a gallery was established. Support was growing, and a small collection of paintings had been purchased as the nucleus for the envisioned permanent collection, when the great fire of 1861 struck Charleston, destroying a large part of the city, and many personal possessions. Anna Wells Rutledge wrote a melancholy account of what happened to many of the art treasures of Charleston:

> With the capitulation of the city, and its occupation by United States troops and accompanying freedmen, conditions tantamount to sacking prevailed. With few exceptions the parishes were devastated and plantation houses razed.[11]

I

Charleston—magnetic, charming, and at times lucrative—contained in her petticoats the threads of personal histories which came together in unsuspected times and places, involving people in relationships which had their beginnings in a common past. On April 27, 1815, Solomon Nunes Carvalho was born in Charleston, beginning another such thread.

On the day of Solomon's birth, John Charles Fremont was two years old. Mathew Brady had not yet been born. Samuel F. B. Morse was twenty-four, and Thomas Sully was thirty-two. James Hamilton was not to be born until 1819. Of these five, Fremont, Morse and Sully each hold a thread from the Charleston fabric. However, all of them will cross Solomon's path; each will have his far-reaching effect.

Solomon Nunes Carvalho came from a long line of Spanish-Portuguese Sephardic Jews who fled the Inquisition, migrating to the Canaries, Holland, London, the British West Indies, South America and the United States.

His paternal grandfather, for whom he was named, was a craftsman working in coral and amber in London from 1761 to 1784.

> The elder Solomon, despite his modest circumstances, instilled in his children a love of learning and refinement which went beyond the simple education they received in the congregational school maintained by the Bevis Marks synagogue of London. Two of these children Emanuel Nunes and David Nunes (the latter the father of our Solomon), demonstrated in both their vocations and their associations that they took their father's aspirations well to heart.[12]

Solomon's uncle, Emanuel, was appointed Hazzan of the Portuguese congregation in Barbados in 1798. From there he moved to New York where he was a tutor and a teacher in the school of Shearith Israel. In 1811, he became Hazzan of Beth Elohim Congregation in Charleston, and remained there until 1814 when he moved to Philadelphia. It is believed that in 1811, during his resi-

dence in Charleston, he brought his younger brother, David, to the United States.

> In Charleston, during the War of 1812, David saw service with the volunteers who defended the city against the British. He remained in Charleston after his brother's departure and married Sarah D'Azevedo,[13] daughter of an ancient Sephardic clan. . . . David made his living as a merchant, but engaged in a multitude of cultural and religious activities. He had a penchant for writing and composed several works which were never published, including a metrical translation into English of the Book of Psalms, and a five-act drama, 'Queen Esther,' which was never, to our knowledge staged. David was also a founder of the controversial Reformed Society of Israelites of Charleston, the first reform congregation in the United States; he served as a member of its Committee on Correspondence, and acted, without remuneration, as minister at its divine services. In 1827, shortly before his removal to the north, he was honored with election as lecturer of the congregation.[14]

With this short introduction we have an idea of the kind of family into which Solomon was born—a family which appreciated literature and drama, and the importance of religious conviction. In David, there is also the suggestion of the dogged individualism which will become most evident in his son, Solomon.

So far, no personal reminiscences have come to light regarding Solomon's early years. In his adult writings however, the appearance of warm, loving, and concerned emotions for his wife, children, relatives and friends, indicate that his own childhood was filled with much of the same love and warmth. In Carvalho's journal, which he kept thirty-eight years after his birth, he made the following entry on a cold, punishing night in the western mountains:

> I thought of the remark my good old mother made on a less inclement night, when I was a boy and wanted to go to play. 'I would not allow a cat to go out in such weather, much less my son.' Dear soul! How her heart would have ached for me, if she had known a hundredth part of my sufferings![15]

Solomon's education has remained a matter for speculation. It was assumed that he went to the Charleston College, but his name

does not appear on the enrollment records. In his *Introduction* of 1954, Bertram Korn writes:

> Concern for education was undoubtedly emphasized in his formative years. One source tells us that Solomon studied in the private schools conducted in Charleston by Isaac Harby, the ill-fated dramatist and leader of the Charleston Reform movement, and by M. M. Cohen. Solomon was to express throughout his life and in many ways the cultivation of his rearings: Latin and Greek quotations interspersed in his correspondence; a yearning and an ability to express himself in literary forms; a capacity for making lasting friendships with men of culture and grace.[16]

In a letter written to his friend, Rabbi Isaac Leeser, Solomon quotes from Virgil's *Aenead*, from the historian, Thucidides, and from Caesar, Horace and Euripides. His style is fluid and his temperament fervent. His wit is quick and sharp, his humor abundant.

As Solomon's uncles were rabbis, and his own father was involved with matters of religion and active in the movement for reform, it would seem strange if Solomon did not display a deep sense of reverence and obligation towards the Jewish community. He did, and in fact, it may be as a member of a congregation that his first signed writings appeared.

As for Solomon's art training, family tradition has assigned Thomas Sully the role of teacher, but this remains unsubstantiated. As we have seen, Charleston was a gracious hostess to many of the outstanding artists in America, some of whom were natives of that city. Since Charles Fraser taught Sully, it is possible that he also taught the younger Solomon, who was born three years before Sully's first successful visit to Charleston in 1818. If their paths were to cross, it would be at a later date. After Sully's productive stay, he returned to Philadelphia which became his permanent home, with occasional trips to Europe. However, he did return to Charleston in November of 1841, taking lodgings at the Charleston Hotel, and may have been working there until March of 1842.

In Philadelphia, Sully painted portraits of many outstanding members of the Philadelphia Jewish community, including the beautiful Rebecca Gratz. It is quite possible that Carvalho visited

the always helpful and hospitable Sully at his studio, and may have known Sully's son who was also a portrait painter, and who died quite young.

Besides Fraser, there were other artists in Charleston who functioned as teachers, such as Joshua Canter and the Spaniard, Manuel Cil. Canter had taught art at the College of Charleston, and in 1817, became drawing master at Harby's Academy.

Anthony and Nina Meucci ran a drawing academy in 1821. The Labatut family had a long history as teachers of art, offering instruction from the late 1700's into the 1840's, and Thomas Ferand, Jr., taught painting from 1803 until sometime in the 1840's.

Due to the combination of artists, teachers, and the flourishing cultural climate of his native city, Carvalho was well exposed to the works of the masters, as well as works by the famous artists of his day. His paintings show influences of both Gilbert Stuart and Sully, and also of the techniques of William Page, his contemporary, and a pupil of Samuel F. B. Morse.

It has been assumed that when Solomon's father moved north to Baltimore in 1828, his entire family went with him, remaining in that city until sometime in the 1830's or early 1840's, when we find Solomon and his sister, Julia, in Barbados. Solomon is recorded as being in Bridgetown in July, 1843, when he appears on the list of subscribers to the *Occident*, the journal on Jewish affairs sponsored by his friend, Isaac Leeser of Philadelphia, of whom Solomon painted a portrait sometime between 1843 and 1845.

In the following year Solomon's signature appeared in the *Minutes* of the Sunday School of Congregation Nidhe Israel, Bridgetown.

Although the Baltimore papers list several Carvalhos as residents until 1868, the Jewish burial register, Barbados, gives the deaths of Sarah Nunes, November 13, 1842, aged 19 years, and Benjamin Nunes, January, 1843, aged 15 years, children of David and Sarah Nunes Carvalho. There is no mention as to cause of their deaths.

In the *Minutes* of January 28, 1844, Solomon's father, David Nunes, is listed as present and active among the members of the Bridgetown congregation. As David was a merchant in the marble paper manufacturing business, and since he and his wife had rela-

tives in the Caribbean, it seems reasonable to assume that there was much traveling back and forth between Baltimore, Philadelphia, Charleston and the Island, perhaps with residency in all of those places at certain intervals. There were numbers of Carvalho relatives in such places as Surinam, Barbados and Martinique with names such as Lobo, de Fonseca, Nunes, Azevedo and Finzi. While it is possible that the older children lived with relatives while their parents remained in Baltimore or Philadelphia, it seems unlikely that the younger members of such a close family would remain apart for any length of time.

In Solomon's case, a suggestion is that he remained in Charleston after his family's departure, continuing his education and visiting his family either in the North or in Barbados, wherever they happened to be living at the time. If Solomon left Charleston with his family in 1828, he was only 13 years old, which makes several developments difficult to reconcile.

In 1834, Solomon was already working as a professional artist (his own claim). In 1838, he painted *from memory* the interior of the Beth Elohim Synagogue, which had burned in April of that year. (Italics mine.)

II

It is evident that Solomon was an exceptional youth, but could any 23 year-old man remember the interior of his early family religious home in the detail in which he depicts it in 1838, without seeing it again?

Solomon N. Carvalho's painting of the interior shows a lofty hall with a ceiling arched in the center; a balcony (for the women) on either side, with slender columns supporting the balconies and the horizontal ceiling above them; large windows with many lights, frames arched on top; a large handsome ark of carved wood (holding the sacred scrolls of the Law) on a square, roomy platform against the rear wall; and in the area in the center, between the rows of benches, not too close to each other, the reading-desk, covered by a blue cloth with a red center, facing the ark and, like it, on a roomy platform with a railing, reached by a few steps. This platform is round. An aisle, wide enough for processions, leads from one platform to

the other. . . . And the constitution of 1820 provided that Lyon Moses, for making a donation of a set of brass chandeliers in behalf of himself and his family, was to have a 'Public Misberach during life, and after death an escoba,' that is, during life a benediction and after death a prayer for the dead. (These chandeliers, no doubt, are those to be seen in Carvalho's painting.)[17]

The results of Carvalho's early studies with an unknown teacher are obvious in his careful solving of problems of perspective, and his analytical faculties. This painting was exhibited at the Jewish Museum in New York City in May of 1955. It is a pity that we must see the interior reproduced in black and white, as the color is delicate, giving a fine atmospheric quality.

After fire destroyed the synagogue in 1838, Solomon submitted his painting to the Trustees of the Congregation for such compensation as the Board may deem proper to allow.[18] The Board agreed, judged the painting to be neat and accurate,[19] and decided to send Solomon fifty dollars in payment.

The Beth Elohim Synagogue was rebuilt in the Greek Revival style, and has been in use since its dedication on March 19, 1841. It is described as being built

of brown stone, now covered with stucco, in a small green square, the building eighty feet in length, fifty-six feet in width, forty-six feet from the ground to the apex of the pediment, with six Doric columns—four feet in diameter—in front and a portico fifteen feet wide.[20]

Sometime after the synagogue was rebuilt, Solomon produced what appears to be an etching of the exterior, detailed to the wrought iron scroll work on the fence, and showing it to be a handsome building. With the print is the following dedication:

This print is Dedicated with Great respect to Judah A. Motta Esq. by his very obedient and obliged Friend: Solomon N. Carvalho[21]

To add strength to our suggestion as to Solomon's whereabouts after his family moved to the North, an unknown Carvalho painting was

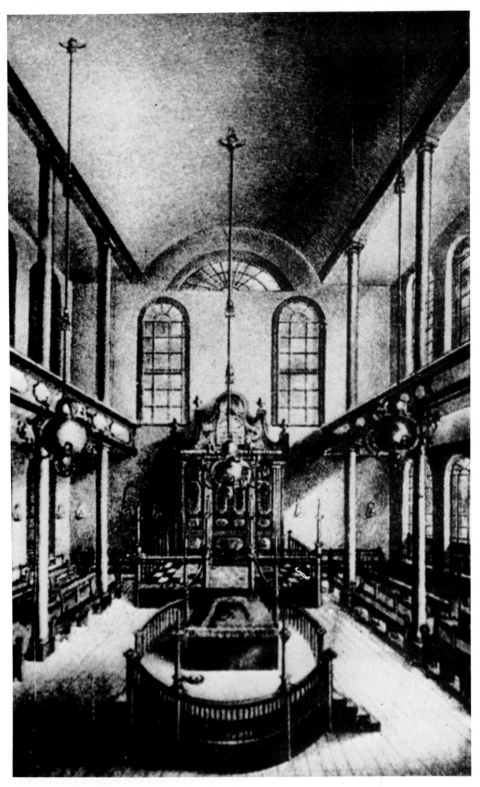

Interior, Beth Elohim Synagogue, 1838. o/c, 29½ x 24½. Beth Elohim
Congregation Charleston.

Exterior, Beth Elohim Synagogue, c. 1838. American Jewish Historical Society, Waltham.

discovered in a New York book and print shop in 1961. It was a portrait of Dr. David Camden DeLeon, surgeon, Confederate Army. Dr. DeLeon was born in 1813 into a distinguished family. His father was a respected physician. His mother was considered a brilliant woman, and came from an old Charleston family, Lopez-y-Nunez. Like Carvalho's people, DeLeon's family on both sides of his house came from the Indies.

The portrait, signed by Carvalho, portrays DeLeon as being perhaps as old as twenty-one years. On the back of the painting is an inscription which reads:

> Dr. David Camden DeLeon, Confederate Surgeon Gen. of Army. Graduated Penn. Medical College, Portrait done by his school friend of Charleston, S.C., Solomon Nunes Carvalho.[22]

Assuming that Carvalho and DeLeon were schoolmates, and knowing that they were about the same age, it would appear that the painting should be dated c. 1836.

Although the painting is signed by Carvalho, the inaccuracy of the inscription on the back of the canvas leads the writer to believe that Carvalho did not write it. According to the Alumni Records, University of South Carolina at Columbia, DeLeon steadfastly refused the post of Surgeon General of the Army. He did, however, serve as a surgeon in the Confederate forces.

There is no record as to DeLeon's Charleston education. However, since his mother was from a notable Portuguese family, it is quite possible that DeLeon attended the same schools as did Solomon.

DeLeon's face is round and softly modelled. He has the hint of a goatee and soft moustache and hair. His expression is serious, the eyes looking straight out at the viewer. There is a personal quality that leads one to believe that the portrait was done from an actual sitting, and not from any prior portrait. If this is the case, it is the earliest known painting by Carvalho, preceding the Beth Elohim work by two years.

Photographs show the brushwork as loose and free, particularly in the plain background. Canvas texture shows through in areas across the shoulders, indicating either a thin application of paint, or subsequent damage.

Since discovery of the portrait in 1961, Dr. DeLeon's likeness attracted a new owner. Recent correspondence indicates that, as of 1964, the portrait has been in the Jewish Museum, New York City.

On page 105 of his journal of 1853, Carvalho says in a letter to his wife:

> I must leave off my journal, as it is my usual hour for rifle practice; I have become quite an expert; at one hundred paces, I have hit the 'bulls eye' twice in five times, which is not bad shooting, considering I have had no practice since I was a member of a rifle volunteer company in Charleston, *some twenty years ago*. (Italics mine.)[23]

With this statement, Carvalho places himself in Charleston sometime around 1833, three years prior to the painting of DeLeon's portrait, and gives us Solomon's age as between twenty to twenty-two years.

An item which came to the writer's attention in August of 1971 is the following:

> We found his (Carvalho) name on a list of debts due Russell and Sass, Schedule B. of an indenture made July 17, 1840, between John Russell and Jacob K. Sass on Charleston, merchants, and Henry Gourdin, also of Charleston, merchant.[24]

We have established reason for believing that Solomon Nunes Carvalho remained in Charleston, and will consider in the next chapter his travels, some portraits of the 1840's, and the mid-century American taste.

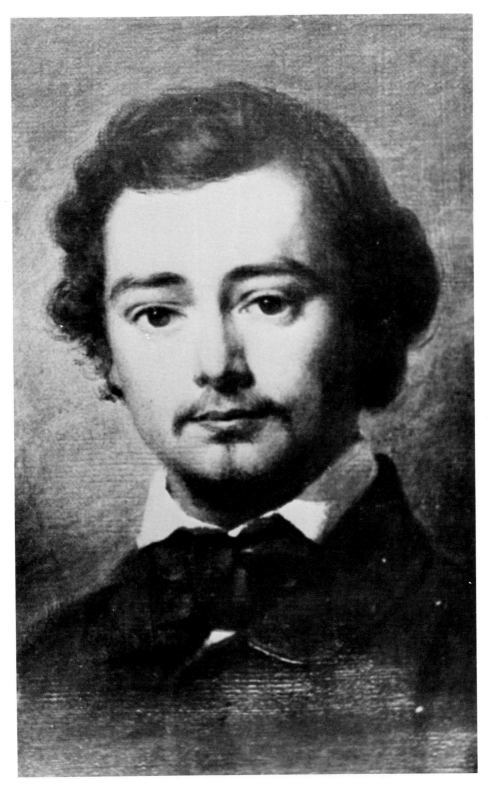

Dr. David Camden DeLeon, c. 1836. o/c, 14 x 15. Jewish Museum, New York City.

CHAPTER II

TRAVELS AT AN EARLY AGE

Sometime in the 1830's Solomon was in Barbados, working for his maternal uncle who was a merchant and had a number of trading vessels.

From this period of his life comes a story of heroism that has become a family legend. Carvalho was on board one of his uncle's ships which was caught in a savage storm. Unable to pull out of the gale, the ship was driven close to shore and wrecked. Solomon volunteered to swim ashore with one end of a stout line, the other end of which was attached to the wrecked ship. He fastened his end of the line to something strong and stable—perhaps a tree, and the line was then tightened, making a lifeline available for the passengers and crew to come safely to shore without being swept away.

While awaiting passage home, Solomon drew portraits of his fellow shipmates and local residents in order to earn money for the return trip.

Carvalho's obituary in the *American Hebrew* refers to this incident:

> At the age of 19 or 20, he went to the West Indies to his mother's brother, who was a large importer there. He traveled considerably for the firm and gained much information which was of value to him later in life. Three or four years later he started to return to America, but the vessel on which he was, was wrecked off the coast of Delaware. Through his efforts in

swimming ashore the lives of the passengers and crew were saved. All were cast ashore without money. It was here his knowledge of art came in good stead, and by drawing crayon portraits of people in the village where he was cast away he raised enough money to return to his home.[1]

It is not known exactly where the *American Hebrew* got the information that located this drama off the Delaware Coast; family tradition has always placed the spot somewhere in the Islands. However, with the knowledge that the restless young artist from Charleston traveled far on his uncle's vessels, the coast of Delaware is as likely a spot as any.

The obituary also states that Carvalho took his bride on a cruise to the West Indies for their honeymoon, and that the vessel on which they returned also was wrecked.

Neither of these brushes with tragedy was to deter Solomon from further travel. In fact, Carvalho broadened his range to include trips to the mid-Atlantic East coast, for in 1841, he was in Washington, D.C., where he sat for a silhouette by the well-known Augustin Edouart.

Plowing through his Edouart folios, Mr. Morse discovered the profile of Solomon N. Carvalho. Flourishing a palette and brush, he looks like the ubiquitous artist with long hair and tufted chin. It was taken in Washington, March 20, 1841, and autographed by the sitter in graceful gold writing.[2]

Augustin Edouart was in Charleston in 1845 and 1847, where he advertised his colored miniature daguerreotypes and silhouettes. Possibly, Edouart's connection with Carvalho was the impetus for the miniaturist's visits to that city; perhaps he and Carvalho experimented together in daguerreotyping.

This pattern of restless travel is a trait that remained constant almost to the end of Solomon's life. It proved an advantage in his case, sharpening his eyes to new places, persons and things, and feeding a romantic spirit—also nurtured by his family and his southern heritage.

When we examine the writings of Solomon Carvalho, we are gratified by his quick wit, humor and cultured background, as well

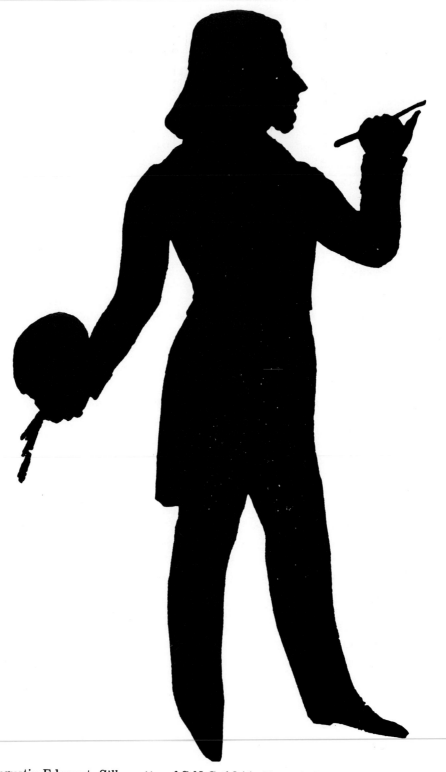

Augustin Edouart, *Silhouette of S.N.C.* 1841. Hannah London.

as an awareness of detail, a fondness for exactitude, and a psychological insight into his fellow human beings—all important attributes for a portrait painter.

The nineteenth century in America saw the rise of a strong middle class and a wider egalitarianism that placed art within the reach of the average man. A fair approximation of the temper of the time is a New Year's editorial of 1848:

> . . . we take advantage of the signs of the times to venture a few predictions. In 1848, the enormous disproportion of wealth between man and man, and class and class, shall be bridged over in the only effectual way—by the voluntary generosity and kindness of the rich; people shall no longer have any poor relations; poor seamstresses shall obtain comfortable incomes, through a general resolution among their employers to give them a due *proportion* of the profits which spring from their labor; and in general, those who *do the work* shall have their full share of the goods of life.[3]

With the introduction of commercial lithography in 1822, art works could be disseminated quickly and cheaply. Prints of such masters as Raphael, Poussin, Rubens and many others flooded the ready markets. Due to the printing press, reproductions of landscapes and seascapes, wallpapers, advertisements, books filled with art reproductions, dollar bills with likenesses and vignettes, etc. were circulated all over the vast country. With the expanding economy and increasing wealth, there was a greater demand for the parlor portrait (the earlier historical and biblical paintings went begging), and with bank accounts swelling from the fruits of their labors, Jones and Smith sought the dignity of seeing their likenesses painted for their children and grandchildren to view with admiration and pride.

With the exception of the Beth Elohim painting and print, Carvalho seems to have begun his career as a portraitist, not just because portraits were popular, but because he was interested in people. Apparently he ascribed to Gilbert Stuart's belief that "it was a marvelous and important thing to record personalities on canvas."[4]

About the time of his heroism at the scene of the shipwreck, Solomon Carvalho painted three portraits, which, unlike most of his later works, are signed and dated.

One, the sketch of an "Unknown Young Man," bears the date 1841. A portrait of his young cousin, Moses Finzi Lobo, was done in 1843; and a miniature "Self Portrait" is dated 1844. A fourth Carvalho work which portrayed Senator William C. Preston of South Carolina, is known to have existed in 1841 when it is

> . . . mentioned in the *Charleston Courier*, June 10, 1841, where Carvalho is described as . . . 'a native of this city, now pursuing his elegant art, we believe at Columbia, in this state.' We have no reproduction of this portrait and no record of its present owner.[5]

As of this date the last sentence still is true.

A fifth work, of uncertain date, but on stylistic grounds is c. 1840-44, is the portrait of Johavath Isaacs.

Johavath Isaacs was an ancestress of Miss Alice deFord, owner of the portrait at the time Bertram W. Korn's monograph on Carvalho was published in 1954. Since then, attempts to trace Miss deFord and the portrait have been unsuccessful. Thanks to Dr. Korn, we have a photograph of the work, and are indebted to him for his care and detective work. Were it not for his files, the portrait of Johavath Isaacs would be merely of passing interest.

The matronly Johavath regards us with an air of solemnity under her high bonnet with ruching around her face. A ruffled collar lies just below her comfortable chins, and a fringed shawl drapes softly over her shoulders. There is a hint that Solomon had been studying the works of Gilbert Stuart. The loose technique in the handling of shawl and dress is reminiscent of Stuart's portrait of Mrs. Perez Morton. Also Stuartesque is the emphasis upon psychological qualities as seen in the face, by the importance of the eyes and nose and in the placement of the figure against shadings of flat background.

The size of the canvas is not known, and it is a pity that we cannot see a color reproduction of the work. Even so, the painting holds its own under black and white reproduction, which is a stiff test for a painting.

The irregularity of human features is rendered with no attempt to flatter or romanticize. The lady is shown with her tight curls, one

Johovath Isaacs, c. 1840. o/c, Alice deFord.

Unknown Young Man, 1841. o/c, Dr. Bertram W. Korn.

eye larger than the other, nose lower on one side, mouth ready to smile, and drooping chin—a sympathetic honest face. In its directness, it has a limner-like quality, but technically is more sophisticated.

Of the three early works to which the writer refers as the "Barbados Portraits," the portrait of "An Unknown Young Man" is the earliest, done in the same year as the lost Preston portrait. It bears the signature, "Carvalho, 1841, Barbadoes, W.I." The beardless young man stares out from blank surroundings with a rather severe expression in keeping with the stiffness of the high stock which comes up around his jowls, bound below the throat by black tie and bow. At the chin line, the easy, sketchiness of the head ceases. The head sits somewhat unnaturally above the dark mass of coat which acts as a pedestal, leading one to believe that the body was done as a filler, either before or after the face was rendered.

The young man may be a relative of Carvalho, or he may be one of Carvalho's shipmates of the shipwreck saga. In any case, although the portrait seems to have been done in some haste, it is sensitive, showing not only the severity in the eyes, but also the look of fatigue in the hallows of the young man's cheeks and in the shadows under his eyes. His hair is fairly short and freely drawn, as are his sideburns. He appears to be about twenty-eight years of age, and as in most of Carvalho's portraits, the nose is prominent—a character-molding technique that Carvalho shares with Stuart.

The second of the Barbados works, dated 1843, is Solomon's charming portrait of his young cousin, Moses Finzi Lobo, apparently in his tenth year. Carvalho adored children, his own and everyone else's. In this he shares a trait in common with Sully.

A color transparency shows Moses' thick brown hair, parted in the middle, falling softly to the sides of his forehead, emphasizing the enormous dark eyes and patrician nose. His face is framed by a huge white collar which spills over his rust-colored shoulders like a cape. He appears to be seated on a sofa or chair, and flat grey ground behind him grows darker towards the upper part of the canvas. As in the portrait of "An Unknown Young Man," the features are sensitively drawn, with emphasis upon Moses' huge dark eyes, and their direct, solemn gaze. Carvalho used an even, pervading light on the faces of his sitters to emphasize the features, much in

Moses Finzi Lobo, 1843. o/c, 4 x 6½. Dr. Bertram W. Korn.

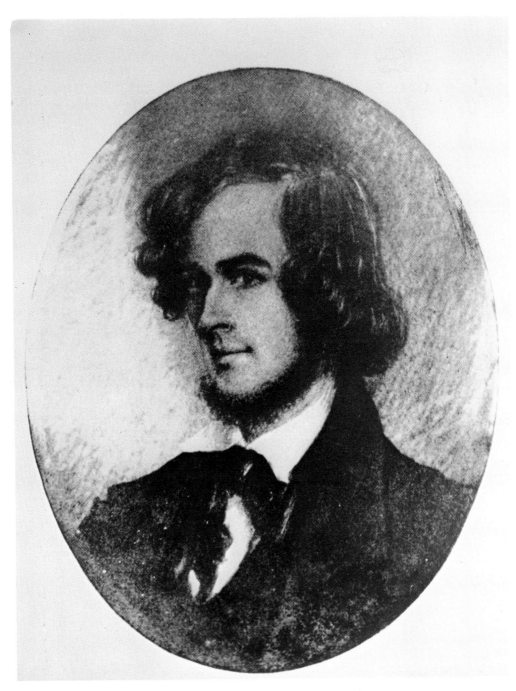

Self Portrait, 1844. miniature, Private Collection.

the style of Stuart, and Moses stands out against the whiteness of his collar and the light background.

The last, and latest of the Barbados portraits is a miniature "Self Portrait," dated 1844. Solomon, now twenty-nine years of age, depicts himself in three-quarter pose, his hair waving to his collar, some side locks falling softly over one cheekbone. He wears sideburns and beard, trimmed neatly to one length. A white collar juts up over a black tie which slants a bit to one side. There is a mischievousness in his sideways glance, and a hint of a smile—a romantic, altogether dashing view of a self-possessed adventurer, who doesn't mind his clothes a bit disheveled, and his hair somewhat windblown. Adventuring he must have been, since the words, "Sept., Granada," are scrawled on the back of the miniature.

I

Sometime in the early 1840's, Solomon tried his hand at a small piece called "Child With Rabbits," which somehow does not quite make it anatomically, though it has a certain charm. If not entirely successful as a painterly achievement, it did have a marked value in another area, as we shall see.

Like his elder, and perhaps one-time teacher, Samuel F. B. Morse, Carvalho could record with a sensitive, imaginative eye; but his works suffer when he attempts fantasy pieces.

"Child With Rabbits" is one such work. We have a small, plump lad who looks strangely like an Americanized, shiny-faced putto with a forehead much too high, and nose, mouth and chin squeezed in between fat cheeks. The nostril to the far side of the face is depicted as larger than the other, and sticks out as a dark, round hole.

The child's fat little arm appears out of a swirl of drapery, embracing baby rabbits. His chin hovers over two of the small beasts, but does not appear to rest on either of them. Nor is the leaning of his face against the enormous mother rabbit convincing. Anatomically, the mother rabbit seems correct, but we note how her big eye seems detailed and labored in comparison to the rest of her features. (This may be due to Carvalho's early work as a portrait painter.)

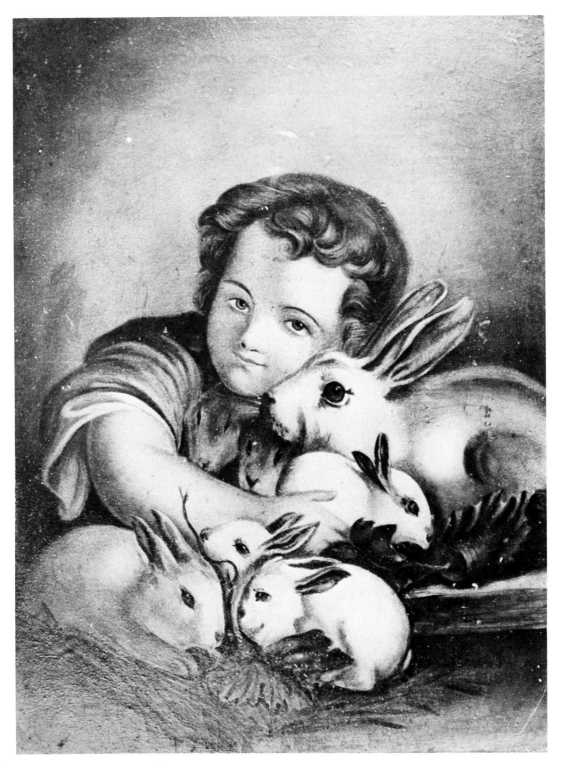

Child With Rabbits, c. 1840. o/c, Private Collection.

The two small rabbits under the boy's chin peer out more like masks than flesh and blood animals.

The three babies in the foreground present something of a problem in the front plane where the line of the leaf stalk causes one bunny to have a squashed nose, and carries into the frontward ear of another bunny, transforming it into a creature with the head of a rabbit and the body of a large leaf—a ridiculous conclusion, but there is no other way to translate it.

Despite its deficiencies, "Child With Rabbits" was destined to have a long, successful life, and it is with thanks to Dr. John A. Muscalus, of the Historical Paper Money Research Institute, in Bridgeport, Pennsylvania, that we know anything about the fate of the painting as having reached a larger audience. In 1969, Dr. Muscalus published another in his long list of publications about the history of printed bills. This was *Solomon Carvalho's Art On Paper Money Issued in the United States and Canada*. In his Introduction, page 2, Dr. Muscalus writes:

> Although specimens of Solomon Nunes Carvalho's art are in the possession of the Maryland Historical Society, the Solis Cohens, Ellen Osorio, and the Beth Elohim Congregation, it is very doubtful whether it is known among artists, numismatists and others that the *Child With Rabbits* . . . was used widely to embellish bank notes issued in the U.S. and Canada prior to 1866 and as early as the 1850's and that, therefore, Carvalho's art circulated from hand to hand among millions of people.[6]

Denominations ran from $1 to $10, and represented banks in Connecticut, Georgia, Massachusetts, Minnesota, Nebraska, New York, North Carolina, Pennsylvania and Canada.

In June of 1972, additional information from Dr. Muscalus gave the following news:

> . . . I was on the track of what to me was a very intriguing discovery: the rise of the "Boy and the Rabbits" on a bank note issued in Argentina. I landed it! We now have Carvalho on paper money of the Americas: U.S., Canada, and Argentina, the latter dated 1867. It was definitely of international interest and we have the notes to prove it![7]

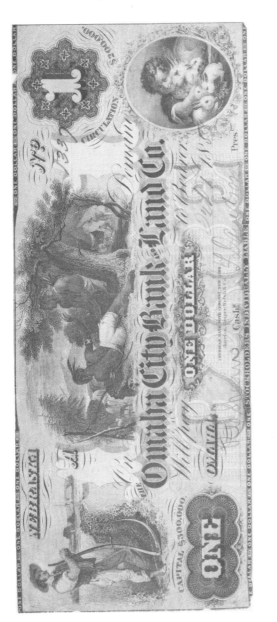

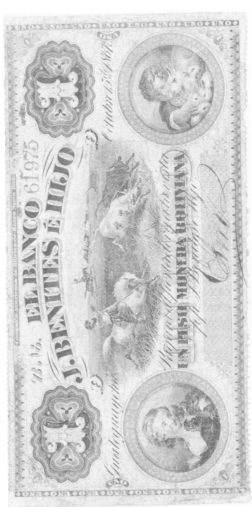

Child With Rabbits on paper money, Dr. John A. Muscalus.

"Child With Rabbits" snuggles into the corner of a paper bill rather successfully and is a good example of the art on paper money that was popular in nineteenth century America. It is proof that Carvalho's art was seen by many. One wonders whether or not *he* profited by it, financially.

The most recent discoveries of art works by Carvalho during residence in Charleston are a major oil on canvas, two miniatures, and a later photograph which may be by Carvalho.

The lush portrait of Miriam Woolf Hirsch, c. 1844, cousin of Solomon, is painted with the same mid-nineteenth century American idealization of womanhood, true of the portrait of Carvalho's wife, Sarah Solis, painted some twelve years later. Miriam's full mouth, as she leans towards the viewer, reminds the author of Carvalho's remarks from his journal about the "sweetness" of the mouth of "Fanny Littlemore," whose portrait he painted while in Salt Lake City sometime late in 1854 or early 1855. The drapery, billowing sleeves of Miriam's gown, emphasis on huge dark eyes and treatment of her fine dark hair, the view to (her) right from a window, are stock touches in many of Carvalho's portraits. The color palette is similar to that used in the portrait of Moses Finzi Lobo.

From this period comes the fine miniature of Miriam's husband, John Hirsch, which shows the straight-forward intent of Carvalho to render the character of the sitter in the Gilbert Stuart tradition as mentioned previously.

The miniature of An Unknown Young Man seems to be from an earlier period, and may be an unfinished work.

The photograph of c. 1853 of Miriam Hirsch and her two sons is believed to be by Solomon Carvalho.

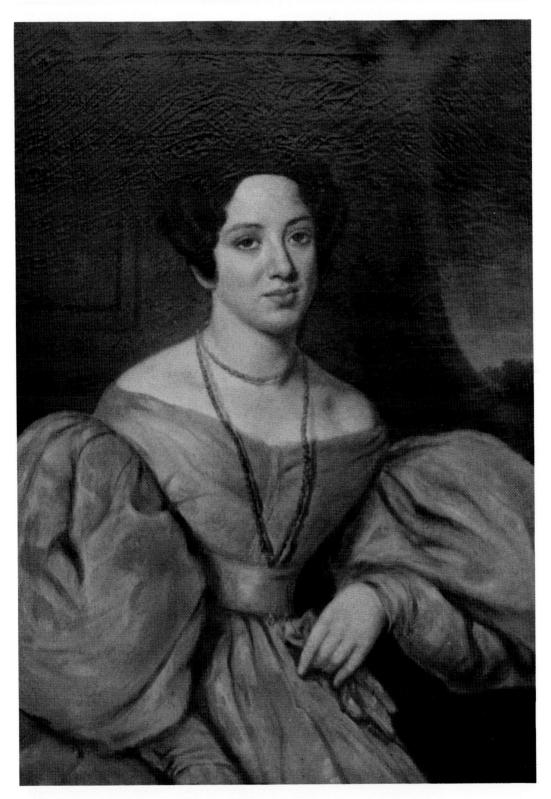

Miriam Woolf Hirsch, c. 1844. o/c, Marion H. Hirsch, Clearwater, Fla.

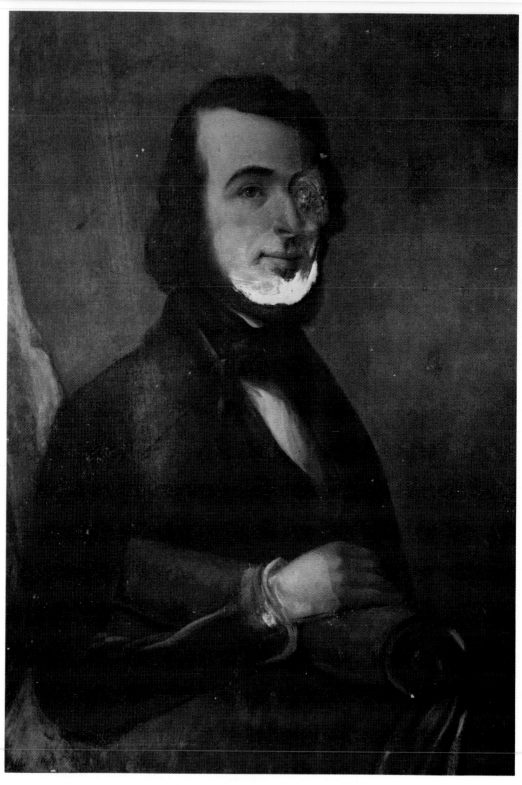

Self Portrait, c. 1849, o/c, 38½ x 30. Author.

Unknown Young Man, c. 1841. miniature.

Willard Hirsch, Charleston, S.C.

John M. Hirsch, c. 1841. miniature.

CHAPTER III

ESTABLISHMENT IN PHILADELPHIA AND BALTIMORE

In Philadelphia on July 16, 1845, Solomon, stricken with lover's disease, wrote the following letter to Solomon Solis, who resided in New York City:

Dear Sir:

Altho personally unknown, I take the liberty to address you on a subject of much moment, and importance to me. I shall try to explain my views and purport of this letter in as few words as possible.

I arrived here a short time since from Barbados, in company with my honored Parents and Sisters with whom you are already acquainted. Your good family with their usual hospitality received them as well as myself. Since which I have availed myself of their kind invitations and their society has afforded me much pleasure.

For your esteemed sister, Sarah, I have conceived other than mere commonplace feelings. Her amiability, sweetness of temper, together with a congeniality of disposition and I dare hope a reciprocity of sentiment, have awakened in my bosom feelings of a deep and ardent affection and as her guardian and Elder Brother, I deem it a duty I owe you, to acquaint you with my pretentions, and to obtain your sanction, that I may make her Honorable proposals of Marriage, the consummation of which would render me most happy.

To my Family connections, you can make no reasonable objections. My personal character, altho not entirely free from

all the little piccadeleos of youth still I hope displays some remains of those honorable feelings which have won for myself a respectable standing in Society. It is, of course, open to your strictest investigation and you would then be but only exercising the same perogative I should myself assume were I in your situation.

My pecuniary means are sufficiently ample to offer to a wife all the comforts and necessaries of life if not all its luxuries.

Should I be so fortunate as to receive your sanction to my suit, I need hardly say I will cherish for your Sister those feelings which I should wish a Husband to have for my own sisters.

Trusting that you may have arrived safely and that you may have a happy meeting with your loved family and friends.

I subscribe myself,

With much consideration

Yours Respectfully,

Solomon N. Carvalho

To Solomon Solis Esq.

New York[1]

Sarah Miriam Solis was a beautiful young lady coming from an old, established family with significance in American history. Her mother was Charity Hays, whose brother, Jacob, was High Constable of New York in 1772. David Hays, Jr., Jacob's grandfather, served in the Colonial Army during the Revolution. Fonseca was the middle name of Charity's husband, Jacob da Silva Solis, and through this house of Fonseca, Sarah Miriam Solis could trace her ancestry back to the kings of Portugal, Castile, Leon and Spain.[2]

A document of the family tree, measuring some 20 × 24 inches and written in Spanish on vellum, still exists. The original, which was duly subscribed and sealed, bore the date A.D. August 26, 1664.

Solomon's own roots were not without nobility, as the Marquis de Pombal is a name on the Carvalho ancestral tree.

From Solomon's letter, we may gather that prior conjecture as to his residence elsewhere than Baltimore or Philadelphia is correct, despite the fact that he was listed in the Philadelphia City Directories from 1835 to 1850, and in the Baltimore directory of 1831.

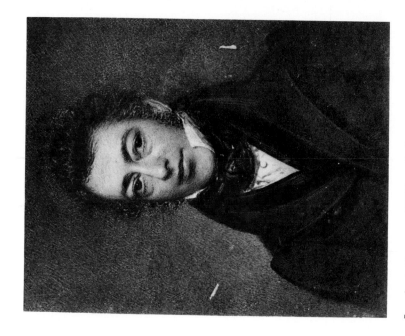

Jacob daFonseca DiSilva Solis

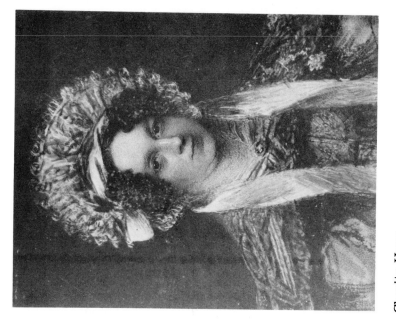

Charity Hays

Parents of Sarah Miriam Solis—wife of Solomon Nunes Carvalho

We may also assume that Solomon Solis had been abroad, perhaps to England, and had just returned to his home in New York.

In any case, Carvalho's suit for the hand of the beautiful Sarah was not in vain. His sincerity and painfully obvious affliction affected Sarah, as well as her older brother, Solomon Solis, and we find the following notice in *The Occident*:

> Married
>
> On Wednesday the 15th of October, at the residence of Mr. S. Solis, Mr. Solomon N. Carvalho, of Bridgetown, Barbadoes, and son of Mr. D. N. Carvalho, of Philadelphia, to Miss Sarah M. Solis, of this city, daughter of the late Jacob S. Solis.[3]

The ceremony was performed by Rabbi Issac Leeser, close friend of both families. As a wedding gift, Rabbi Leeser gave the young couple the holy book he had used for the ceremony, a copy of the first American Hebrew Torah, which he had edited and translated.

After their marriage and a honeymoon in the Islands, followed by the supposed second disastrous shipwreck on their return voyage, the young couple resided in Philadelphia. This city which had been an active cultural center was continuing in the 1840's to attract artists, writers, printmakers, daguerreotypists and visitors who walked the corridors of the Pennsylvania Academy.

James Hamilton, the American marine painter, was living and working in Philadelphia. In some respects, his background bears similarities to that of Carvalho. Hamilton was born in Ireland, brought to the United States when very young, and raised in Philadelphia. He was encouraged in his art by the alert and active John Sartain, and strongly influenced by the work of J. M. Turner. His Philadelphia teachers are not known to us; but Thomas and Edward Moran were two of his pupils. As in Carvalho's case, there are blank spaces in Hamilton's known history. There is a heroic legend in the Hamilton family which is reminiscent of Carvalho's early shipwreck incident. On one of Hamilton's ocean voyages, probably to England, the ship ran into a raging storm. Hamilton insisted on being tied to the mast in order to enjoy the storm in its wildness and fury, but was required by the captain to sign a release

of responsibility before he would give consent to such madness.

Hamilton had painted landscapes from the drawings of such explorers as Elisha Kent, and Kane, the famous Arctic explorer, and like Carvalho, had an adventurous, romantic spirit. Both men were to give in to the lure of the far West at a point in their lives. Hamilton settled in San Francisco where he died in March of 1878. Carvalho and Hamilton influenced each other in the arts at a later date, and it is more than a distinct possibility that the two men were friends, though we have no record of such a friendship.

In the Free Library of Philadelphia, Lewis Portrait Collection, is a photographic copy of a daguerreotype of James Hamilton, c. 1846-47. The portrait is by an unknown photographer, and further research has not produced his name. However, Hamilton is shown as a handsome, Byronesque figure, and the pose intent on freeing the character of the sitter is strongly in the style of Carvalho and may be Carvalho's work.[4]

There were many artists whose works were accessible in Philadelphia, some of whom would have tremendous influence on American art. One of these artists was Thomas Cole, who prowled the halls of the Pennsylvania Academy studying landscapes. Another was Thomas Doughty, who was working in that vein.

Manuel de Franca, Portuguese portrait painter, resided in Philadelphia during these years, and painted portraits of John Sartain and Mrs. Sartain. The Portuguese were inclined to be clannish people, and it would be unusual if Carvalho and de Franca had not known each other.

Joshua Shaw had, along with a reputation as a landscape painter and an inventor, a contentious character. He was associated with de Franco, and it is possible that through this connection, Shaw and Carvalho were acquainted.

At the same time, such artists as Thomas Sully, who had the same Philadelphia address for forty-four years; Thomas Buchanan Read; John Neagle, who married Sully's daughter; Bass Otis; Peter Frederick Rothermel; Cephas G. Childs; Sartain; the Birches (father and son); the descendants of Charles Willson Peale; and Hubbard, skilled young silhouette artist; were all working in the Friendly City. By mid-century, Philadelphia and Boston were forced to yield to New York as a center of the arts.

I

The introduction of the daguerreotype into America brought with it an instant wave of experimentation in the field, especially in the larger cities where the newspapers carried accounts of the nature of Daguerre's methods. The process was described as:

> . . . a sheet of copper was plated with silver, the silver surface being well cleaned and polished. The silver surface was then exposed, in a small box, to the action of iodine vapor at ordinary temperature until the surface assumed a golden yellow color, a step which took from five to thirty minutes. The sensitized surface (now known to be a film of the silver compound, silver iodide) was placed in a camera obscura, an instrument which had been known for several centuries. The sensitized metallic surface, according to Daguerre, was to remain in the camera obscura from 'five to six minutes in summer and from ten to twelve minutes in winter. In the climate of the tropics, two or three minutes should certainly be sufficient.' It was then withdrawn from the camera, but the most experienced eye could detect no trace of the drawing . . . an image was present (now technically called the latent image) but that it must be brought out by a subsequent process. . . . Daguerre's developing agent, however, was none of the solutions of the present day, but the liquid metal, mercury. That is, the daguerreotype plate with its latent image supported in a closed box was exposed to the action of mercury heated to 167 degrees Fahrenheit. The mercury vapor rising from the warm liquid metal 'developed' the image. Where the plate had received the most light a film of mercury was deposited; where no light . . . had fallen on the plate no mercury deposited. In order to remove the sensitive material left upon these areas, the developed daguerreotype plate was washed with the familiar solution of 'hypo' . . . the picture thus produced was washed with distilled water, dried and mounted under glass to produce the finished daguerreotype.[5]

By 1841, the daguerreotype had invaded the portrait field. The miniaturists suffered the most, but by and large, the portraitists were hardly damaged, though controversy attended the invasion. Some, like George P. A. Healy, used the machine to their advantage.

In his distinguished work on the daguerreotype in America,

Beaumont Newhall writes about the influence of photography on painting:

> A portrait painter usually takes all these matters into ac-
> count, and with his dozen or more long sittings, has time
> enough to make a careful study of how the character is worked
> out in the physiognomy, and to paint accordingly. But in
> daguerreotyping, the sitter has to employ this knowledge and
> exercise this judgment for himself. The comparison with the
> portrait painter was inevitable. Samuel F. B. Morse, himself a
> distinguished portraitist with the brush, had already pointed out
> that the daguerreotype should prove valuable to the artist. 'How
> narrow and foolish the idea which some express that it will be
> the ruin of art, or rather artists, for every one will be his own
> painter,' he wrote to his fellow artist, Washington Allston. The
> painter, Rembrandt Peale, however, expressed concern:
> 'Daguerreotype and photograph all have their relative merit;
> and as memorials of regard, are not to be despised. The task of
> the portrait painter is quite another thing—an effort of will,
> taste, mind and judgment . . . to render permanent the transient
> expression of character which may be the most agreeable.[6]

Despite the arguments pro and con, the stiff daguerreotype held up in the storm. Not to be relegated to the area of portraits, it soon invaded landscape painting, even science. The life-like latent image would soon be used with success by such artists as Healy, Charles Elliot Loring, James Hamilton, and by Solomon Carvalho, himself.

By 1841, exposure time for taking a daguerreotype had been reduced to seconds. Carvalho had been experimenting with the new process for some time, and had become quite proficient, as the self portrait, frontispiece c. 1846, shows.

As we saw him portrayed in the Edouart silhouette, and as he pictured himself in his earlier self portrait, Carvalho displayed a confident, dashing air, relaxed pose and a suggestion of wit and humor. He was a handsome fellow, indeed, and one rather suspects that he knew it.

Carvalho, in his experimentation with the daguerreotype, had been looking for a method of protecting the delicate plates from abrasion without the usual glass cover. In searching for a solution, he was in touch with his fellow inventor, Samuel F. B. Morse, who wrote the following note:

Professor Morse's best respects to M. Carvallo and accepts
with pleasure his polite invitation to dinner on Saturday, the
29th instant.
Washington Jany. 22, 1848.[7]

Morse's painting had been influenced to some extent by the
works of Gilbert Stuart, and mention has been made of a similar
influence on Carvalho's art. There are certain technical similarities
between Carvalho's paintings and those of Morse's student, William
Page, a contemporary of Solomon. It may be that Carvalho took
some lessons with the older Morse, à la his contemporary, Mathew
Brady, who had started out to be a painter, but who turned to
daguerreotypes under Morse's instruction. Brady affected Carvalho's
future most acutely at a later date.

In 1849, Solomon Carvalho, along with James Hamilton and
others, exhibited work in the annual exhibition of the Pennsylvania
Academy of Fine Arts. His address at that time was 144 Chestnut
Street, Philadelphia. In that exhibition were approximately 227
works, about 45 of which were by unknowns. To indicate the most
popular form of painting at that time, there were twice the number
of portraits as there were landscapes, and only nineteen seascapes
were shown. In addition to Carvalho's "Portrait Of a Gentleman,"
exhibited were eight seascapes by Hamilton, and works by such art-
ists as Andreas Achenbach, Washington Allston, Thomas Birch,
Canaletto, J. S. Copely, Delaroche, George Inness, Thomas
Doughty, Asher B. Durand, Henry Inman, Louis G. E. Isabey, John
Neagle, James and Raphaelle Peale, Rembrandt Peale, Poussin, Sal-
vator Rosa, Gilbert Stuart, Thomas Sully and many more. (See
Cumulative Exhibition Catalog, American Philosophical Society,
Philadelphia, 1955, ed. by Anna Wells Rutledge.)

Carvalho's "Portrait of a Gentleman" disappeared from view,
but may be a self portrait now in the collection of the author. If so,
it shows a rapidly maturing style—perhaps too mature to be given
such an early date, though Solomon's age, as depicted, seems cor-
rect.

The reddish-brown background is plain, in the style of Stuart.
Technically, it is painted with thin applications of subtle glazes,
producing warm, rich tones that seem not one color, but all colors

in suspension—a technique also used by Morse's pupil, William Page.

The colors reproduce the effects of light striking color and form, and the flesh tones are brilliant, although somewhat darkened by the old varnish which covers the entire canvas. Like Morse, Carvalho loved color. Rich tints of maroon and velvety brown move through the canvas, glowing, delicate and low key all at once.

Solomon's velvet jacket is a lush brown, becoming almost black around the shoulders. The only relief is a glimpse of his white tucked shirt and a brilliant button at the cuff of his sleeve.

It is not known whether or not Carvalho was right-handed. However, the distortion of his right arm which rests on the Victorian chair indicates that he may well have been. The arm is proportionately too short, and is too slender from the elbow to the hand (which seems normal).

The deep red of the velvet chair, the pink and red satin drape behind his right shoulder, and his maroon velvet vest all mingle with the richly glowing background.

Atmospherically and coloristically, this work indicates that Carvalho was well acquainted with Sully's paintings, and found Sully's insistence on the importance of the mouth equally compelling. It is a portrait of romantic leanings, reminiscent of the Byronic type of work done by such artists as Eicholtz, Healy and Jarvis.

Most of Carvalho's surviving known portraits are of men. Of the few that are of women, we shall see that they are not the refined ladies of Sully. Only one bears any resemblance to Sully's delicate damsels.

Carvalho does not use the hard outlines and metallic hues of neoclassicism, even in his biblical historical paintings. His works appear to be his own combination of certain classical ideas and applied skills, with the color, softness and viewpoint of a thoroughly romantic eye. In many ways, Carvalho holds a kinship with the earlier Charles Willson Peale. Both combined an insatiable intellectual curiosity with artistic gifts. Each one could be characterized as a Renaissance man; each was interested in anthropology, archaeology and botany. Both dug up the remains of mastadons. Carvalho and Peale both had an intuitive ability to be around when history was being made, and helped to make it.

CHAPTER IV

THE 1850's

According to the Philadelphia City Directories for 1849-50, Solomon's father, David Nunes Carvalho, was living at 148 S. Juniper Street, and his business, Marble Paper Company, was listed at 21 St. James Street.

David moved to Baltimore sometime in 1851, and according to records of the New York Historical Society, Solomon followed his father to Baltimore, taking Sarah and their two-year-old son, David, with him.[1]

The Jewish publication, *The Occident*, tells us that Solomon was an elected officer of the Philadelphia Hebrew Education Society during the years 1849 and 1850. During this time, the beautiful Sarah accompanied her husband in religious activities, learning the teaching methods of the equally beautiful Rebecca Gratz, whose Sunday School was famous.

Although he moved to Baltimore, the ever restless Solomon kept his contacts in both places, for in an issue of *The Occident*, 1851, he was writing articles in Philadelphia under the initials "S.N.C.," but the same issue carries a report by Solomon posted "Baltimore."[2]

Lord Baltimore's old city was not lively enough to hold Solomon's attention for long, however. By 1851, he and his wife and children were residing in his old habitat, Charleston, where he set up a studio for his artistic endeavors and became a zealous par-

45

ticipant in a religious controversy that had captured his fancy. Due to this latter activity, he became a member of the Shearith Israel Congregation, and was appointed to a special committee of that group in 1852.

There had been struggle within the Jewish community over the question of reforms ever since David N. Carvalho, Isaac Harby and other members of Beth Elohim Congregation had created the Reformed Society of Israelites in 1825. Shearith Israel was another synagogue in Charleston. It is interesting that when the New Orleans Jewish philanthropist, Judah Touro died, he left a considerable sum to Shearith Israel, but nothing to the Beth Elohim Congregation. By 1852, the struggle between the liberal and traditional factions had reached tempestuous proportions.

> Rabbi Julius Eckman, a moderate reformer who subsequently was to become the first rabbi to officiate in California, was removed from office on trumped-up charges, and there ensued a lengthy see-saw debate on the succession. Solomon, unlike his father in this regard, was opposed to radical reforms, although he was not a strict traditionalist. He attempted to secure the election for his friend, the Reverend Mr. Leeser, for he believed that only one of Leeser's national reputation and well-known ability could unify the bitterly divided community. He also wrote several lengthy articles for the *Occident* in defense of Eckman and accompanied them with documentary evidence to buttress his contentions. These articles . . . reveal a clear, forthright style and a mind bent on reasonableness.
>
> During this period, also, Carvalho was writing lengthy communiques to Leeser, giving details of the strategy of the liberals and the counter-strategy of the traditionalists.[3]

That Solomon Carvalho was extremely close to the Rev. Leeser is obvious in the following admonition to his friend, dated Charleston, 23 August, 1852:

> I have just read in the last Asmonean, handed me by a friend, Mr. H. Efeslau's attack upon you. I pray you not to *notice* or *advert to it* in any manner,—the letter bears the evidence of a man of low breed and a loose character. It is in truth a scurrilous thing.
>
> "Revocati animos, moestumque timorem mittite'—Virgil

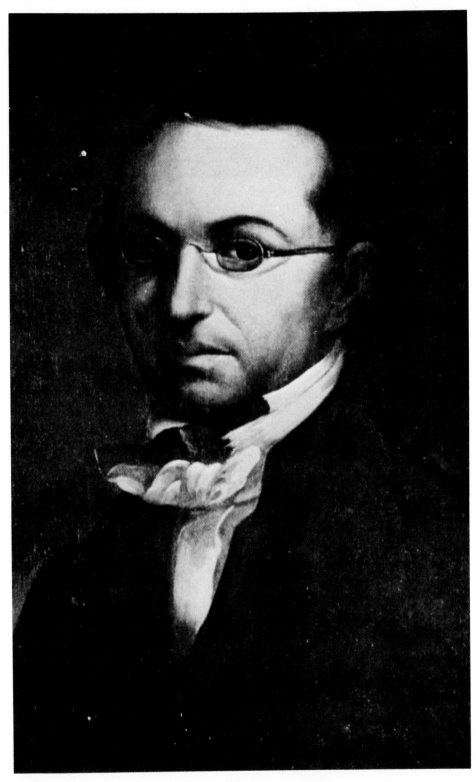

Rabbi Isaac Leeser, c. 1845. o/c. Maxwell Whiteman.

Aenead. Pericles is made to utter the following sentences and I
give them to you in the language of his historian Thucidides.

To be censured and maligned for a *time* has been the fate
of *all those* whose *merit* hath *raised them above the common
level*, but *wise* and *judicious* is the *man*, who enjoying the
superiority, despiseth THE ENVY.

This man M. H. Efeslau would like no better opportunity
than to be made famous *at your expense*. Treat him Mr. Lyon,
and his satellites with the supreme contempt they deserve.[4]

These fiery letters from Solomon to Leeser reveal a temper
which we seldom will see in him, and a passionate conviction of his
duty to do what was right. There is another side of his nature,
equally as strong, which is evidenced by personal remarks to
Leeser, such as the following with regard to his beloved Sarah:

I am anxious to learn if Solomon Solis has arrived in Europe. I
notice the arrival of the vessel he went out in and . . . Asia 10
days after his arrival, but we have rec'd no letters and Dear
Sarah is very unhappy, if you know the real state of his health
please let me know and *enclose it to Mr. Levin if unfavorable*,
as all my letters are delivered at my residence and I do not
wish my wife to be too suddenly informed of any ill news,
which I hope there will be no occasion for.[5]

The above quote ended a letter from Carvalho to Leeser dated April
20, 1852. In July, another letter to Leeser mentioned his surprise on
hearing of the sudden marriage of S. Solis. The gentleman in ques-
tion must have been in a fair state of health to have taken what
seemed, to Solomon, a rather drastic step. (What the Reverend
Leeser thought about it remains unknown.)

Solomon's lengthy communications and efforts to be a friend,
trouble shooter and reporter in the midst of the religious controversy
must have had some calming effect. In February of 1852, Leeser
made a trip to Charleston where he was given an inscribed gold
watch procured by a committee made up of Solomon Carvalho,
Nathaniel Levin and S. Valentine. Solomon, accustomed to exten-
sive, detailed efforts, wrote the long report about the testimonial
ceremony in honor of Leeser at the Synagogue of Shearith Israel.

. . . Mr. Leeser was conducted to the centre of the Synagogue, opposite the hechal, where he was received and welcomed by the committe above named.[6]

Mr. Levin, who was Chairman of the committee, gave a welcoming address, testimonial, thanks and blessings of the congregation. Carvalho goes on with his description of the scene:

> During the delivery of the above address, Mr. Leeser was much affected, and replied to the remarks in an eloquent and impressive manner; but at times his feelings so overpowered him, that his voice was scarcely audible. His remarks were entirely unprepared, he being neither aware of the nature of the testimonial to be presented, nor of the character of Mr. Levin's address; what follows, therefore, must be taken more as the substance, so far as memory serves to recall the same, than the actual words spoken on the occasion—one sufficiently embarrassing to excuse even a confused manner of speaking, and not permitting either speaker or hearers to recollect with perfect accuracy the expressions actually employed. . . .[7]

This is Carvalho's way of excusing the emotions that he succumbed to in the excited atmosphere of the synagogue—emotions which were perfectly compatible and understandable, considering the Portuguese and Spanish blood in his veins. He had a temper, he was loving and lovable, he was loyal, and he was also truly sentimental.

In spite of his apologies, Solomon finished his report of Leeser's remarks to the congregation in which Mr. Leeser deplored the schism in the community, and begged for a union and healing of the breach. He thanked his friends for the gestures and gifts, and asked them to guard his reputation from evil tongues (about which Carvalho had already written him warning). The report was ended by a short paragraph and signed "S.N.C."

Although Solomon's activities on behalf of the Jewish community were considerable, he had not been neglecting his artistic career.

I

In the mid-nineteenth-century, people interested in a painting learned of a suitable artist by word of mouth, by examples in the

homes of friends, or by answering a newspaper advertisement, the cheapest and best method for an artist to get more publicity. On February 3, 1851, the *Charleston Courier* carried the following ad:

> . . . his familiarity as a professional artist with the philosophical principles of light and shadow, enabling him to combine the study and practice of both to great advantage. An exquisitely delicate and life like fancy sketch in oil, which he has just completed, is attracting the admiration of his visitors, and considered by many good judges among them to be a highly successful effort, in the delineation of a difficult subject, altitude [*sic*] and expression. MR. CARVALHO's rooms are open at all hours of the morning and afternoon for the inspection of ladies and gentlemen desirous of seeing his specimens and *improvements in the arts*.[8] (Italics mine.)

Carvalho also advertised his services as a daguerreotypist during this time.

There is no further mention of the subject of the "delicate and lifelike fancy sketch in oil." However, it is believed to be a painting called "The Lovers" which has always hung in the home of a Carvalho family member.

The work had suffered damage through the years, with cracking and peeling of the surface pigment, and a long tear which had been patched at some earlier date. It has been relined and restored, and photographed in time for inclusion in this study.

"The Lovers" is indeed a romantic and "fancy" work and, as in the "Child With Rabbits," Carvalho's flights into the realm of the imaginary do not result in a convincing image; again the problem centers upon the treatment of the human anatomy.

The handling of light and shadow is skillful, and Carvalho's touch with foliage, flowers and billowing drapery is lyrical and sure (points that we will return to in discussing works from a later period).

There seems to be a lack of tension between the young man and the pensive young lady, who is seated on a carved garden bench. Her pallid face and hair style are strongly suggestive of the works of Thomas Sully, in particular his portrait of Fanny Yates Levy, now in the Corcoran Gallery of Art, Washington, D.C.

The young man's face is strange, almost a caricature, and

The Lovers, c. 1848-50. o/c, 37 x 30. Private Collection.

rather feminine. His arm rests somewhat unnaturally across his lady love's shoulders.

The young woman's neck and long, swanlike drooping shoulder seem distorted; the treatment of the huge flower at her bosom, together with an apparent mashing together of her breasts makes her appear to have been singularly deformed. Her legs and feet, with elegantly pointed shoes, appear too long for her body. However, it is a pleasant painting—a typical, romantic nineteenth-century period piece, despite the incongruities. On the back of the original canvas were found the following stamps:

> Wm. A. Wisong, Artists, Painters, Daguerreotypists Depot
> N. 2N. Liberty St., Baltimore
> At the top of the canvas was:
> Goupil & Co., Artists C—ou—mi (obliterated by a stain), B66
> Broadway, New York

In July of 1848, Goupil, Vibert & Co. of Paris, opened a branch gallery in New York, where they displayed the works of those French painters they held in esteem including Vernet, Delaroche and Ingres.

Carvalho's canvas may have been bought from Mr. Wisong, and later framed by Goupil & Co.

II

The Occident carried a long and interesting commentary on Solomon's further artistic activities during his residence in Charleston. It gives us a detailed description of an important painting, (which has long disappeared from view) and also an idea of the psychological and religious climate against which Carvalho fought in painting historical biblical works.

> While we were last winter at Charleston, Mr. Carvalho showed us the *unfinished* picture of Moses Interceding for the Israelites on Mount Sinai. (Italics mine.) We confess that we have no great prediliction for any graphic representation, where the sublimity of the subject must leave the most gifted pencil far behind the truth of the reality. We may have a picture in our mind, it is true, representing *beautifully* the highest ideal

but this beauty and truth will invariably vanish when our thoughts are to be sketched on canvass, or vent given them by articulate words. We appeal for the latter to all who have made public speaking their study and business; and we believe that they will all verify our assertion that no audible sounds can portray the breathings of the soul. The enthusiasm of holy thought, in its highest efforts, is only for the thinker himself; the contact with the world without dissipates much, if it does not annilhilate the whole, of the sublimity of the inspiration. If this is the case with words, which are, so to say, within our momentary grasp, how much more must it be with a picture, where the sketch must first be made, and then the idea laboured out for days and months, by adding light and shade, and filling up the outline to the completion of the design. Hence, we did not encourage Mr. C. much in his labour . . . and then we feared for the reputation of our friend, that he might not succeed to embody his conception of the character of our great legislator.[9]

At this point it is interesting to note that Carvalho painted in the historical biblical vein at all. True, he was preceded in this field by such men as West, Morse, fellow South Carolinian Washington Allston, Copely, Trumbull and Peale. However the first real Western stirrings of Jewish painting probably began in England in the area of portraiture, there being the old commandment: "Thou shalt not make any graven images," much less adornment of the synagogues. Carvalho's attempts to paint historical biblical works perhaps revealed the new feelings of freedom and expansion which were part of the New World, and especially of the nineteenth century. He is an ancestor of those gifted American Jewish artists of our twentieth century.

Despite the critical viewpoint of the *Occident* author in the article of 1852, in that same article, (written nearly a year after showing of the then unfinished painting), he makes a somewhat grudging admission:

It is, therefore, with sincere pleasure that we present the following extract from the *Charleston Standard* of November 26th, and to express at the same time the hope that Mr. C. will not be satisfied with what he has done, but endeavor to advance yet farther, by close study and the imitation of the masters of the pictorial art, in his profession, so as to leave

mementoes behind him which will challenge admiration, and elicit a universal expression of approval from those who are able to judge and have the talent to appreciate what is lovely and beautiful in the arts:

S. N. Carvalho's Original Painting of the Intercession of Moses for Israel.—in justice to our artist, we have devoted some time to the examination of this picture, recently exhibited at the South Carolina Institute. 'Tis seldom we are called upon to inspect an original historical or Scriptural picture, executed by a native artist, and when one of the above character emanates from the studio of a Charlestonian, possessing, as it does, evident marks of genius in the conception and composition, correct and easy drawing, and a decided practical illustration of the power and effect of colour and light and shadow, as well as the important consideration of telling its own story in the most comprehensive manner, we cannot withhold our need of praise from the enterprising artist. We avail ourselves of some explanatory remarks by a contemporary:'

'The subject is from Exodus, ch. 32, 7 to 15 vs.; And the Lord said unto Moses, Go, get ye down from the Mount; thy people have corrupted themselves, they have made themselves a molted calf, and have sacrificed to it, and have worshipped it. Now, therefore, let me alone, that my wrath may wax hot against them, and that I may consume them. . . . Moses is represented standing with one hand raised to Heaven, the other pointing to Israel, on the plain below, just visible through the rising clouds of thick smoke, with which the Mount is surrounded. A back view of the figure is given, which is draped in white. The thick clouds are all below him; he is supposed to be on the summit of Sinai, between earth and heaven. The two tables of the Testimony are resting at his feet; they are written correctly, we are told, in the original Hebrew. He is barefoot, as he stands on holy ground, and also by express command. The Jews, when they approach the sanctuary, on certain occasions, take off their shoes,—indicating that they leave all earthly thoughts behind them. No better arrangement of the figure could have been chosen, to illustrate, correctly, the text; as immediately afterward (Exodus 32:15), Moses turned and went down from the Mount. His drapery is white, emblematic of the purity of his motives. He is in the full vigour of life, with dark hair and beard, in opposition to the general manner of rendering this difficult subject, which is generally with white beard, and as an old man. . . . The easy attitude and careless flowing drapery, indicate the suddenness with which the great legislator

conceived the idea of entreating his God to remember the cov-
enant he had made with Abraham, Isaac, and Jacob, and to
change his determination of destroying the people; while the
brilliant light beaming down on the figure is very effectually
rendered. This subject portrays an event which gave the ten
commandments to man, forming, also, the basis of laws that
govern all civilized nations. The picture possesses much in-
terest, and we hope to hear of its having been purchased in
Charleston, at a price alike commensurate with its merits, and
remunerative to the artist. Our opinion of the talents of Mr.
Carvalho has been strengthened by those of others with whom
we have conversed, and also by the Committee of the South
Carolina Institute, on Painting, who *last year* awarded him a
Diploma and Silver Medal for Ideal Painting. (Italics mine.)
We wish him success in his future labours.'[10]

In 1852, according to our *Occident* reporter, ''The Intercession of
Moses'' painting was unfinished. It has been stated by writers such
as Elzas and Rutledge that this is the painting which was awarded
the Silver Medal. However, its unfinished state added to the com-
ments of the unknown critic, above, seems to disqualify it. It seems
that it was still another biblical historical painting that won the
medal for Carvalho. ''The Intercession of Moses for Israel'' has
long since disappeared, perhaps a victim of one of the great Charles-
ton fires of 1838 or 1861.

The admonitions from his *Occident* critic did not subdue the
determined, spirited Solomon one bit, for he was hard at work on
another Moses painting entitled ''Moses Before the Ama-
lekites.'' Again, Moses is portrayed in white, with brown hair and
beard. Having already led his people out of Egypt, he is a man of
many years. From Exodus 17:8-14, we read what Moses is doing in
this painting:

> Then came Amalek and fought with Israel at Raphidim.
> And Moses said to Joshua, 'Choose for us men, and go out,
> fight with Amalek; Tomorrow I will stand on the top of the hill
> with the rod of God in my hand.' So Joshua did as Moses told
> him, and fought with Amalek; and Moses, Aaron, and Hur
> went up to the top of the hill. Whenever Moses held up his
> hand, Israel prevailed; and whenever he lowered his hand,
> Amalek prevailed. But Moses' hands grew weary; so they took
> a stone and put it under him, and he sat upon it, and Aaron and

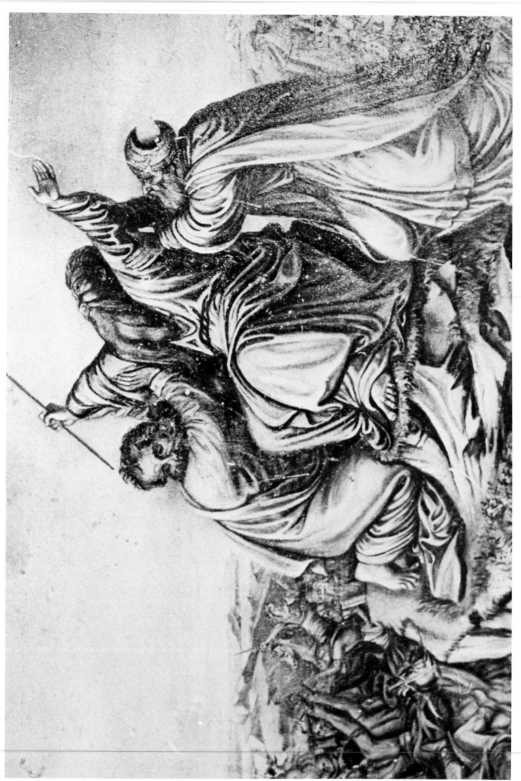

Moses Before The Amalekites, c. 1852. o/c. Private Collection.

Hur held up his hands, one on one side, and the other on the
other side; so his hands were steady until the going down of the
sun. And Joshua mowed down Amalek and his people with the
edge of the sword.[11]

In Carvalho's depiction of the scene, we see Moses sitting
upon a rock, God's rod in his hand, while Aaron and Hur each hold
up one of Moses' arms. One companion looks up into Moses' face,
while the other views with horror the battle scene below. There is a
frightful confusion of fallen men and rearing horses. Carvalho's
close attention to the works of earlier classical painters such as
David and Poussin is evidenced by the painting's pyramidal con-
struction, hard contours and sculptural drapery.

The eye moves with ease through the painting from the group-
ing of the three main figures, down to the scene of the battle, back
into the distant landscape, and around to the front plane, drawn to
the face of Moses. Anatomically, this work far surpasses Carvalho's
"fancy" pieces, and it may be that he made plaster models of the
three major figures from which to work—not an uncommon practice
in his day.

His handling of the landscape and the folds of the drapery indi-
cate that the painting is of the same era as "The Lovers." How-
ever, it is a much stronger work. This may be due to Carvalho's
sincerity in his Jewish faith, his literary background and his dogged
determinism to succeed, despite some small opposition from his
Jewish critic. In his historical painting, he is developing his skills
and it is a pity that we cannot study "The Intercession of Moses,"
as well.

III

Two existing paintings from the early 1850's are Carvalho's
portrait of his father's niece, and a fruit still life, both of which
merit examination.

Blue-eyed "Little Miss Carvalho" looks over her shoulder,
rather disarmingly, from under an enormous brown hat. The style of
painting is somewhat reminiscent of Solomon's "Child With Rab-
bits," although more sketchily treated. Miss Carvalho's shoulders

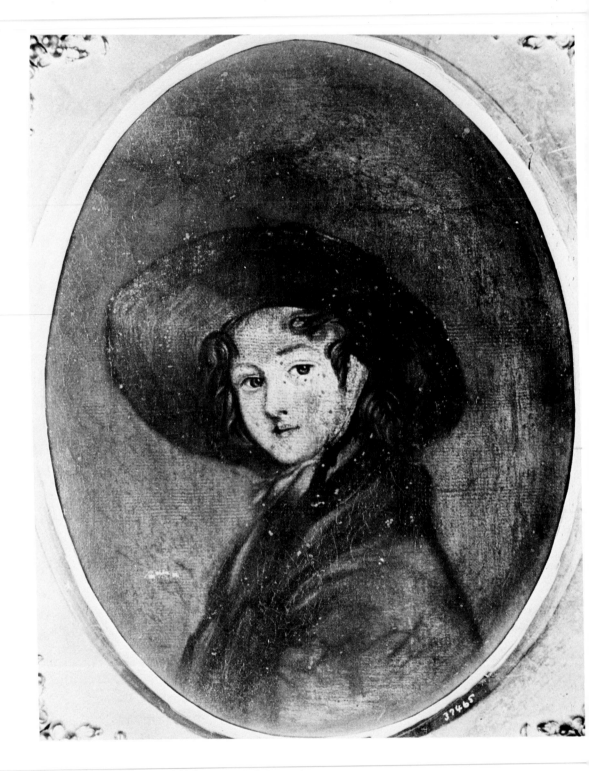

Little Miss Carvalho, c. 1850. o/c, 13 3/8 x 11 3/4. Maryland Historical Society.

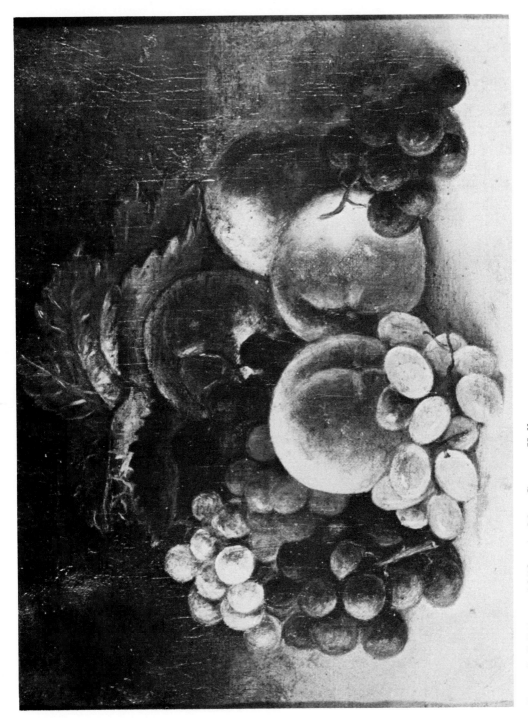

Fruit Still Life, c. 1850. o/c. Mrs. George Keller.

and chest seem much too large for her head, reminding one, again, of a base such as that of the "Unknown Young Man." However, Carvalho has developed a better composition. In this case, the wide brim of her hat balances the heavy massing of form. The young lady's brown hair falls softly over the shoulders of her brown coat, and she is placed against a solid brown background.

The eye moves around the oval painting with ease. The eyes and nose are prominent, as in the portrait of young Moses Finzi Lobo. In this case, the artist also has emphasized the mouth: Miss Carvalho appears to be a young lady who knows her own mind, and might let one know it. Inscribed on the back of the canvas is: "D. N. Carvalho. Our niece. VKA."[12] The young lady's name is not known, but the last initial may indicate that she was a member of the Azevedo family of Barbados.

The fruit still life, one of the rare signed works, is a gentle piece, painted with a respect for form, texture and inner life. It has an almost brooding quality. Carvalho had respect for the physical properties of even the smallest things in life; in this work he also shows a sensitivity towards their spatial relationships. It seems obvious, from studying this painting, that Solomon had looked long and hard at the works of the Peale family, perhaps Ruebens Peale, in particular.

The still life is of simple composition. The edge of the table makes a horizontal line at the bottom of the picture and the fruit is built up in a pyramidal construction. Carvalho loved color, and it is unfortunate that we can not have a color reproduction of this only known surviving still life.

IV

In March of 1852, the artist engaged in a revealing correspondence with H. H. Snelling, editor of the *Photographic and Fine Art Journal*. Although Carvalho had been experimenting with methods of protecting daguerreotypes for some time, the *Journal* published an article, immediately prior to the March correspondence, with regard to an invention to replace glass covers over daguerreotypes. Carvalho took issue with Snelling's report, as we shall see from the following exchange.

(Snelling) We took occasion in our last to notice an article from the New York Tribune announcing an important discovery of a substitute for glass, and to express the opinion that it was nothing more than an old invention revived. We were led to these remarks from private information received in this city, and we disclaim any allusion to the subject of the following letter, for we were not aware and [sic] Mr. Carvalho was meant by the article. We had reference to another case entirely. We give Mr. Carvalho's letter entire in justice to him. We would state, however, that Mr. Anthony now has for sale a similar article, and before we express any opinion in regard to the merits of either we should like to see Mr. Carvalho's tested.

Heretofore, various substances have been used to effect the same object but without avail. The article offered by Mr. Anthony is the best we have ever seen or heard of, but from the impartial tests it has had since he received it from France,—where it was invented—he is not fully prepared to recommend it strongly for the purpose intended. We are of opinion, however, that it is a good article for preserving the picture; it certainly gives it a softer and more pleasing tone although it injures somewhat its distinctness.[13]

This conciliatory letter by Snelling admits that the device being offered by Mr. Anthony is not an American invention, and thus sets the stage for the proud Carvalho's testy letter.

(Carvalho) H. H. Snelling, Esq.—Dear Sir, In your Photographic Art-Journal for this month, I observed that you have copied an item from the Tribune, relating to a discovery by a gentleman of Charleston, of a process for enamelling Daguerreotypes. You have also appended an editorial notice thereto on which I shall take the liberty to say a few words. It is not my province to dictate to the Editor of a Scientific Journal the course he should preserve when claims for discoveries of improvements are made in or connected with the art, which is the subject of his labors, by persons far removed from the city from which the publication, emanates, but it is the privilege of all, and particularly my duty as the individual evidently pointed at in the article referred to, to comment on the editorials,—even this I will forego as I am under the impression that if you had been rightly informed on the subject, you would not have written anything to emanently calculated to injure me. I therefore shall only give you a few items for your future government, with respect to my discovery.

Imprimis. I NEVER PURCHASED IT, nor had I the first idea from any person on the subject. I have arrived at the present perfection of a highly transparent enamelled surface to daguerreotypes, precluding the necessity of glass covering, by a long continued series of experiments. If the discovery is not new it only exemplifies the old adage or proverb, 'there is nothing new under the sun.' I HAVE NEVER REVEALED TO ANY ONE HOW MY ENAMELLED SURFACE IS PRODUCED; I have never made experiments for it in the presence of a second person, and my laboratory is under lock and key. I have only allowed THREE pictures to go out, one in the possession of the editor of a paper here who gave me his word not to let it go from him except to be seen in his presence, the other two my brother has taken to Europe, previously, however, he exhibited them at my request to several gentlemen in Philadelphia.[14] I have personally shown them to several operators in Charleston who think it a valuable discovery, and they have never seen or heard of it before.

If it is an old process revived, your informer must be in possession of my process—where and how did he obtain it?—from whom did I purchase it?—and how much did I give?—I should like to know his name.

I have been before the public as an artist FOR OVER EIGHTEEN YEARS, and have borne with becoming modesty and fortitude the flattering as well as CANDID expression of criticism which my paintings have deserved, and for this discovery I am willing to undergo the same ordeal, but I would rather wait for such severe remarks until my pictures by the process are BEFORE the public.

I have not written this officially, but you can make use of it or any part of it if you think proper. Your Journal was handed me for perusal, I never have seen it before, and the scientific character of several leading articles has induced me to request you to consider me as one of your subscribers.—I am respectfully, S. N. Carvalho
Charleston, March 23, 1852[15]

This is an interesting account in many ways. Carvalho answers the challenge, pointing out that the invention is his own, and with what could be construed as a sarcastic dart at Mr. Anthony, declares that he certainly did not "purchase the invention." He declares that he has been an artist "for over eighteen years," which would place his professional beginnings at around age nineteen. He compliments

the scientific achievements of a journal new to him, and places his name on the subscriber list. He indicates that he is on friendly terms with the editor of a Charleston newspaper and that his work has traveled to Europe.

CHAPTER V

NEW YORK, 1852-1853

In 1851, Mr. George S. Cook had been making daguerreotypes in Charleston. The previously mentioned issue of the *Photographic Art Journal* carried an amusing account about a runaway horse which dashed headlong into Mr. Cook's emporium. The extent of damage is unknown, and Mr. Cook (or his employees) apparently was too dumbfounded to make a picture of the frantic beast.

Mathew Brady, whose eyesight was failing, departed to London in July of 1851 to attend the World's Fair, after having enticed Cook to come to New York from Charleston to manage one of the three Brady studios.

At the time of the runaway horse incident, Cook may have been on a short leave from his duties in Brady's New York studio to attend to his own business in Charleston. Carvalho's letter to Snelling refers to several operators working in Charleston, and Cook may have been one of those who saw Solomon's invention.

In New York the photographic arts were in a state of growth, exchange and excitement. A Mr. Litch, formerly employed by Jeremiah Gurney, migrated to England where he opened a studio in company with a certain Mr. Terry, "the latter gentleman well known in South America."[1]

Mr. Kelsey left New York City to open a studio in Rochester. As old faces departed, new ones moved into the panorama of studios that fronted on such popular streets as Broadway and

64

Leonard—faces of such artists as Mr. Lawrence, B. Brady, Hartmann and others.

Disasters contributed their share of changes. Fires swept through studios belonging to D. E. Gavit, Jeremiah Gurney and Jesse H. Whitehurst. The studio of Mr. Clark in Ithaca suffered the same fate.

It is ironic, indeed, that fire should be the culprit in the destruction of the apparatus of Daguerre, the man who began it all; in the loss of the extensive Vance Collection; and in the demise of the Smithsonian Institution's collection of the important works of John Mix Stanley. Also destroyed by fire was the collection of C. E. Watkins, pioneer California photographer whose library included "work of nearly all the early daguerreotype artists of those days."[2] Fire would have a devastating effect upon Carvalho in later years.

In 1852, Brady's main studio was at 205 Broadway. His biggest rival, Jeremiah Gurney, was doing a brisk business at 347 Broadway, in the gallery formerly owned by Jesse Whitehurst.

> There was another newcomer to Broadway's photography row within the next few months. Brady undoubtedly saw him, S. N. Carvalho, a brisk young man with a short black beard, probably the first American to penetrate America's Wild West with a Camera.[3]

What was Carvalho, eight years Brady's senior, doing in New York? Did he have his own studio, and if so, where?

Solomon's correspondence with Snelling in regard to the varnishing invention explains Carvalho's appearance in New York at this time. Further investigation reveals that the process was a success, for the *National Magazine* carried the following announcement:

> A valuable discovery with regard to daguerreotypes has been made by Mr. S. N. Carvalho, an artist of Charleston, South Carolina. It has been hitherto necessary to enclose daguerreotypes in cases, and cover them with glass, as the least friction destroyed the work of sun and shadow. Mr. Carvalho has discovered a perfectly transparent enamel insoluble by all ordinary agents, a thin coating of which being spread upon a daguerreotype, it may be carried about without other protection,

or sent by post to any part of the world. The enamel produces no perceptible effect upon the picture.[4]

This notice infers that innumerable tests had been made upon the invention by Carvalho, up to and including mailing the enameled plates, probably to England. In any case, it seems that the invention was valuable. Jeremiah Gurney availed himself at once of the services of the inventor.

> Transparent Enamelled Daguerrotypes—J. Gurney, Daguerre-otypist, No. 349 Broadway, corner of Leonard St., having completed his arrangements and entered into an engagement with Mr. S. N. Carvalho, the discoverer of the above beautiful and highly important process, takes this method to inform his patrons and the public generally, that Mr. Carvalho may be found at his gallery, No. 349 Broadway, where he is prepared to enamel Daguerreotypes of all sizes, whether taken at the gallery or elsewhere.[5]

Mr. Snelling, determined to have the last word, persisted in his earlier discussion concerning the merits of Mr. Anthony's process versus that of Mr. Carvalho. The report goes on to say:

> From what we have seen, these specimens do not possess any superior advantage over those by the process described on page 111, Vol. 11, of this journal.[6]

It would be interesting to know how much money Gurney made from the new service to his customers, and what salary was paid to Solomon for processing his own invention.

As for Mr. Anthony, he manufactured some ingenious items, one of which would be used by Solomon Carvalho a short time later.

At some point before October of 1853, Carvalho met John Charles Fremont, by then known as the great Pathfinder. How they met and who introduced them is a matter for conjecture.

Fremont induced Carvalho to accompany him as artist and daguerreotypist on his fifth and final expedition to the West. Why did Fremont choose the dark-eyed, restless man from Charleston over some contemporaries with more experience, such as Cook,

Dobyns, Langenheim, the Shew brothers and Whitehurst?

The threads in the Charleston fabric now begin to make a pattern. Samuel F. B. Morse, painter, scientist and inventor, visited Charleston because of family ties in that city. It was probably he who introduced his younger colleague, Solomon, to John Fremont, also of Charleston. Fremont had attempted daguerreotyping the American landscape on his expedition of 1842, but had failed. This time, he wanted an expert. The two men were ideally suited to work together on the fifth expedition; undoubtedly, Morse knew it and engineered their meeting. He was a frequent visitor in the home of Senator Thomas Benton, Mrs. John Fremont's father, and had painted a portrait of Mrs. Thomas Benton in the days when he still did portraiture. Thus, he knew both sides, both personalities.

There have been extravagant claims that Solomon Carvalho was the first official photographer to accompany an exploring party anywhere in the world, and the first Jew to cross the Rockies. First Jew *with a camera*, he might have been.

However, Emanuel Lazarus may claim the accolade as the first Jew to cross the Rocky Mountains. Thanks to the research of Beaumont Newhall, we now know that Carvalho was not the first official photographer.

> Edward Anthony was the first to serve as an official photographer on a government survey. When Professor James Renwick of Columbia College was appointed by the President chairman of a commission to survey and explore the northeast boundary of the United States and Canada, he invited his former pupil, Anthony, to accompany him and take daguerreotypes of terrain. On March 28, 1842, the commission submitted its report together with supporting documentation, including 'copies of some daguerreotypes.'[7]

Humboldt had written his conviction that photography was invaluable for recording the truth that resided in nature. John Fremont had read Humboldt's *Cosmos* in 1853.

> Perhaps influenced by this official acceptance of daguerreotypes as topographical documents, Colonel John Charles Fremont took a camera with him on his first government expedition to explore the Oregon Trail from the Mississippi to

Wyoming. Charles Preuss, the German cartographer of the expedition, noted in his diary on August 2, 1842: 'Yesterday afternoon and this morning, Fremont set up with daguerreotype to photograph the rocks; he spoiled five plates that way. *Not a thing was to be seen on them*. (Italics mine.) That's the way it often is with these Americans. They know everything, they can do everything, and when they are put to a test, they fail miserably.' Five days later Fremont again failed. Preuss commented: 'Today he said the air up here is too thin; that is the reason the daguerreotype was a failure. Old boy, you don't understand the thing, that is it.' No record exists of Fremont's daguerreotypes—nor any other reference to them.[8]

As Newhall points out, no other reference to Fremont's daguerreotyping activities survives. However, if he did attempt such, and there is no reason to doubt Preuss's word that he did, it is quite likely that Fremont did not know the technique for developing what we now know as the latent image . . . in which case, anyone who examined blank plates certainly would consider them a failure.

Inspired by Humboldt's enthusiasm, Fremont decided to use a camera on his fifth crossing of the continent in 1853, but wisely decided to leave photography to a professional, Solomon Nunes Carvalho, after a competition with a Mr. Bomar, photographist

> The daguerreotype process was already threatened by the negative-positive process, and Fremont did not know which technique would be better suited to the rigors of mountain travel.[9]

At the same time that Fremont would be making his fifth journey, Isaac I. Stevens would be traveling to Washington State, taking John Mix Stanley along as official photographer; Commodore Perry would be sailing for Japan, with E. Brown, daguerreotypist, and William Heine, a Dresden artist, who would produce many lithographs and wood engravings based on Brown's daguerreotypes.

Carvalho made a decision:

> On the 22nd August, 1853, after a short interview with Col. J. C. Fremont, I accepted his invitation to accompany him as artist of an Exploring Expedition across the Rocky Mountains. A half hour previously, if anybody had suggested to me,

the probability of my undertaking an overland journey to California, even over the emigrant route, I should have replied there were no inducements sufficiently powerful to have tempted me. Yet, in this instance, I impulsively, without even a consultation with my family, passed my word to join an exploring party, under command of Col. Fremont, over a hitherto untrodden country, in an elevated region, with the full expectation of being exposed to all the inclemencies of an arctic winter. I know of no other man to whom I would have trusted my life, under similar circumstances.[10]

The restless and romantic Solomon was ready to go, and his excitement leaps from the page.

We are indebted to him for his journal. As the only account of the fifth expedition, it is an invaluable source of information for Western Americana.

CHAPTER VI

JOHN CHARLES FREMONT AND THE FIFTH EXPEDITION

Carvalho left New York on September 5, 1853, after spending ten hectic days purchasing the necessary daguerreotype equipment, painting materials, and certain preserved food supplies (such as eggs, milk, cream and coffee, sealed in tin,) which were being sent along by a supplier, one Mr. Alden, for testing under varied conditions. Carvalho assured his friends in the trade that his daguerreotypes would be a success.

Fortunately for us, Carvalho kept a journal and had instructed his wife to keep all letters that she would receive during his absence. From these sources, he later reconstructed his account of the journey for publication.

It was Fremont's intention to write a book about the fifth expedition, complete with plates made from Solomon's daguerreotypes. The book never was written; but for that, and the daguerreotypes, we will save another chapter.

Near the beginning of his journal, Carvalho wrote:
To make daguerreotypes in the open air, in a temperature varying from freezing point to thirty degrees below zero, requires different manipulation from the processes by which pictures are made in a warm room. My professional friends were all of the opinion that the elements would be against my success. Buffing and Coating plates, and mercurializing them, on the summit of the Rocky Mountain, standing at times up to one's middle in snow, with no covering about save the arched

vault of heaven, seemed to our city friends one of the impossibilities—knowing as they did that iodine will not give out its fumes except at a temperature of 70° to 80° Fahrenheit. I shall not appear egotistical if I say that I encountered many difficulties, but I was well prepared to meet them by having previously acquired a scientific and practical knowledge of the chemicals I used, as well as of the theory of light: a firm determination to succeed also aided me in producing results which, to my knowledge, have never been accomplished under similar circumstances.[1]

The modest Solomon had a perfect right to be pleased with his successes; some of the "circumstances" were difficult indeed: frozen hands and feet, sometimes going through heavy snows and rough terrain for twenty-four hours without any kind of nourishment, and towards the end, illness, despair, and almost no protection for the feet, as shoes had worn thin and bare.

Carvalho traveled to the previously arranged meeting point, St. Louis, by stage. The coach proprietor, member of a prior Fremont expedition and full of admiration for the great explorer, carried the heavy cases containing the precious equipment without charge.

Solomon is exasperatingly lax about noting times and dates. He does not say how long it took him to reach St. Louis; but he arrived, sometime around noon.

> Col. Fremont was at Col. Brant's house, where I immediately called. The Colonel was very glad to see me; he had telegraphed several times, and I had been anxiously expected. We left that same afternoon in the steamer F. X. Aubrey, for Kansas. On board, I found Mr. Egloffstein, the topographical engineer, Mr. Oliver Fuller, and Mr. Bomar, the photographist. Our Journey was somewhat protracted by the shallowness of the water in the river, and we did not arrive at Kansas until the 14th (of September).[2]

Upon landing in Kansas territory, they met Mr. Palmer and several other gentlemen who had joined the exploring party. The first camp of the Fremont group was set up near Westport, a few miles inland from the river. In the meantime, Carvalho and Mr. Bomar, who were staying in a hotel, engaged in a contest to see

whether Carvalho's process, or that of Mr. Bomar, was best suited
for the expedition.

> Mr. Bomar, proposed to make photographs by the wax
> process, and several days were consumed in preparing the
> paper, etc. I was convinced that photographs could not be made
> by the process as quickly as the occasion required, and told
> Col. Fremont to have one made from the window of our room,
> to find out exactly the time. The preparations not being entirely
> completed, a picture could not be made that day; but on the
> next, when we were all in camp, Col. Fremont requested that
> daguerreotypes and photographs should be made. In half an
> hour from the time the word was given, my daguerreotype was
> made; but the photograph could not be seen until the next day,
> as it had to remain in water all night, which was absolutely
> necessary to develop it. Query, where was water to be had on
> the mountains, with a temperature of 20° below zero? *To be
> certain of a result*, even if water could be procured, it was
> necessary by his process, to wait twelve hours; consequently,
> every time a picture was to be made, the camp must be delayed
> twelve hours. *Col. Fremont finding that he could not see im-
> mediate impressions*, concluded not to incur the trouble and ex-
> pense of transporting the apparatus, left it at Westport, together
> with the photographer. (Italics mine.)[3]

This particular paragraph has caused mixed comment among
historians as far as Carvalho's part in the contest is concerned. The
independent Solomon does seem satisfied with the results and ac-
cusations of deliberate manipulation of the contest with Bomar out
of jealousy are entirely out of character.

In 1939, Charles Macnamara of Ontario, Canada, wrote a sym-
pathetic view of the incident entitled "The First Official Photo-
grapher," (S. N. Carvalho) in which he explained the wax process
as being

> . . . an improvement on Fox Talbot's calotype process, which,
> as is well known, differed fundamentally from daguerreotypy in
> producing a negative from which any number of positive prints
> could be made—the leading principle of all modern
> photography . . . but the principal difference was the prelimi-
> nary waxing of the paper to reduce grain and facilitate printing.
> For some years the process competed with daguerreotype, but

popular taste had been formed on the beautifully fine Daguerre image and did not take readily to the rather coarse and grainy calotype picture . . . Colonel Fremont's reason for deciding against the wax process does not seem a valid one. There was no instantaneous need for the pictures. They were intended to illustrate the future report of the expedition, and it would not have mattered if their completion had been delayed for months, to say nothing of twelve hours. And to acquit Carvalho of intentional misrepresentation, it must be supposed that he did not understand the wax process when he asserts that it would have been necessary to delay the camp twelve hours every time a photograph was made. It is not on record that the fully sensitized paper would keep indefinitely, but it was good for some days at least.[4]

For Fremont, "some days at least," would not have been good enough.

Professor Richard Rudisill, in his latest book, *The Mirror Image*, has a different point of view is so far as understanding the wax process was concerned:

Bomar evidently did not understand his process well, since no such length of processing time was standard for any photographic medium in use at the time.[5]

Mr. Macnamara makes the error of calling Carvalho the first official photographer, a notion which has persisted until Beaumont Newhall's recent book on the history of the daguerreotype.

He makes further error in assuming that Carvalho did not understand the wax process. As an inventor with experience in that field and a good scientific background, he understood.

While it is true that there was no "instantaneous need for the pictures," Macnamara draws a mistaken conclusion, for there *was* an instantaneous need to *know that a picture "took."* (Italics mine.) This need weighed heavily on Col. Fremont's mind. If we are to believe Carvalho's account, Fremont expressly desired this immediate visual confirmation.

This was, after all, a scientific expedition financed, most probably, by Thomas Benton and by Fremont himself. We must remember the history of the previous Fremont expeditions. In 1852,

Congress had ordered several routes to be explored for the tracks for the Pacific railway. Five different routes were designated, and five different parties were chosen for each route. Fremont was overlooked by Jefferson Davis, then Secretary of War. Thus, with his own funds and the assistance of his family, Fremont became a freelancing explorer, after purchasing the latest scientific equipment in Paris. Undoubtedly, he was bitter over the rejection by his government; his father-in-law, Senator Benton, openly was. Fremont's fourth expedition of 1848-49 ended in misfortune, and he had not finished the trail that he had been following between the 37th and 38th parallels. He still believed that this route was the best, and so decided to take the same trail again, only this time in the dead of winter to test all difficulties. This time also he was to rely on himself and his latest new instruments as guides. (Fremont had blamed the guide on the fourth journey for the horrors which he and his men had suffered). With these considerations in mind, and recalling Preuss's account of Fremont's own failure with daguerreotype on the expedition of 1842, it is evident that the anxious Fremont did indeed have reason for wanting to *see* pictures *instantaneously*, so that he would *know* that a complete, visual record existed as proof of the testimony of his final report. Moreover, as a seasoned explorer, Fremont may have had good reason for feeling that Mr. Bomar's paper and equipment were too delicate to survive the beating the daguerreotype apparatus would take. He also may have known that the photographic technique would not reproduce as faithfully the haze effects of mountainous terrain. In any event, the burden was placed upon Solomon.

Sometime around the 21st of September, the party camped at the Shawnee Mission, about eleven miles from Westport, where a Mr. Max Strobel, who had left another expedition, appeared in camp and asked to join Fremont's group. Fremont had been ill that day, and decided to return to Westport for medical attention, taking Strobel with him. The rest of the men, under the command of Mr. Palmer, went on to meet the Delaware Indians who would become members of the exploring party. Carvalho's journal reads:

> 27th—to-day we met our Delawares, who were awaiting our arrival. A more noble set of Indians I never saw, the most of

them six feet high, all mounted and armed cap-a-pie, under command of Captain Wolff, a 'Big Indian,' as he called himself. Most of them spoke English, and all understood it. 'Washington,' 'Welluchas,' 'Solomon,' 'Moses,' were the names of some of the principal chiefs. They became very much attached to Col. Fremont, and every one of them would have ventured his life for him[6]

Carvalho was drinking in the joys of nature during these early days of the journey. The morning of the first day that they camped on the open plains, he got up at dawn, saddled his horse, and rode from the camp, wanting to get an unobstructed, private view of the sunrise.

I found the weather perfectly clear . . . made my way through the long grass, for a considerable distance, before I perceived any inclination on the part of the majestic king of day to awake from his royal couch. Gradually the eastern horizon assumed a warmer hue, while some floating clouds along its edge, developed their form against the luminous heavens. The dark grey morning tints were superseded by hues of the most brilliant and gorgeous colors, which almost as imperceptibly softened, as the glorious orb of day commenced his diurnal course, and illumined the vault above; a slight rustling of the long grass, caused by a deliciously pleasant zephyr, which made it move in gentle undulation, was all that disturbed the mysterious silence that prevailed. . . . My heart beat with fervent anxiety, and whilst I felt happy, and free from the usual care and trouble, I still could not master the nervous debility which seized me while surveying the grand and majestic works of nature. Was it fear? no; it was the conviction of my own insignificance, in the midst of the stupendous creation; the undulating grass seemed to carry my thoughts on its rolling surface, into an impenetrable future;—glorious in inconceivable beauty, extended over me, the ethereal tent of heaven, my eye losing its power of distant vision, seemed to reach down only to the verdant sea before me. . . . Still life, unceasing eternal life, was everywhere around me . . . the grass, glittering in the morning dew in the untrodden surface. I will onward, and trust to the Great Spirit, who lives in every tree and lonely flower . . .[7]

These few words reveal Carvalho's intensity, his depth of ob-

servation, and his exalted experience of God in nature, a pantheistic, joyous vision of the eternal spirit in every living thing. His response is indicative of the nineteenth-century American notion of a romantic communion with nature, paralleled in art and literature by the landscape paintings of Cole and the writings of the Transcendentalists, especially Emerson and Thoreau. We shall witness Carvalho's reactions to the land again and again, but all was not to be beauty and light.

While the party was encamped awaiting Fremont's return, Solomon was having problems with the packing baskets that carried the daguerreotype apparatus. After riding into the nearest town to purchase what little could be found in the way of food supplies, he learned of a blacksmith's shop, some ten miles away, where he could obtain tools and material with which to make stout boxes. One of the Delaware Indians had ridden with him.

> When we arrived at the blacksmith's house, the proprietor was absent. His wife . . . prepared dinner for us, and gave us the run of the workshop, where I found a saw and hatchet; with these instruments I made the boxes myself, and by the time they were finished, the blacksmith returned. He refused to receive pay for my dinner, but charged for the nails, raw hide, etc. . . . I gave some silver to the children, and mounting our horses, with a huge box before us on our saddles, we slowly retraced our way to camp, where we arrived at dark. . . . I never shall forget the deep mortification and astonishment of our muleteers when they saw my boxes. All their bright hopes that the apparatus would have to be left, were suddenly dissipated. . . . I have every reason to believe that my baskets were purposely destroyed; and but for my watchful and unceasing care, they would have been rendered useless. The packing of the apparatus was attended with considerable trouble to the muleteers, and also to the officer whose duty it was to superintend the loading and unloading of the mules. . . . Complaints were continually being made to Col. Fremont, during the journey, that the weights of the boxes were not equalized. Twice I picked up on the road the tin case containing my buff, & etc., which had slipped off the mules, from careless packing—done purposely; for if they had not been fortunately found by me, the rest of the apparatus would have been useless. On one occasion, the keg containing alcohol was missing; Col. Fremont sent back after it, and it was found half emptied on the road. I

am induced to make these remarks to show the perseverance and watchfulness I had to exercise to prevent the destruction of the apparatus by our own men.[8]

A letter finally arrived from Colonel Fremont, carried by Mr. Strobel, saying that the Colonel was going back to St. Louis for further medical attention. The party's orders were to move camp to the Saline fork of the Kansas River, under the command of Mr. Palmer. Fremont's letter mentioned that there would be abundant game for food, especially buffalo, and that he hoped to join them in a fortnight.

The men packed up, loaded their mules, and moved on to Salt Creek, as Fremont had ordered. Carvalho's letters, written while awaiting Fremont's return, describe the various game animals and the sumptuous meals consumed by the party, so extravagant that he worried about their shrinking food supply, as everything killed was eaten, and no provisions were being cured and stored.

He gives a detailed description of an Indian game which the Delawares taught him, what kind of substitutes he had found for the tobacco he was used to smoking in his pipe, and, making reference to the increasingly cold weather, says that his hands were becoming calloused from using the axe when it came his turn to chop the firewood.

He also makes an interesting allusion to a certain conversation:

> Tis very strange how fallacious ideas of mankind obtain stronghold in the minds of those who should know better. *The night previous to leaving home*, I was asked how I could venture my life with such a man as Col. Fremont? 'A Mountaineer'—'an adventurer'—'a man of no education.' (Italics mine.)
>
> If you ever see Mr.—and Mrs.—, please say to them, that the character of Col. Fremont as a gentleman of 'high literary attainments,' 'great mental capacity,' and 'solid scientific knowledge,' is firmly established in my own mind. . . . My estimation of character is seldom wrong. I may have been imprudent in undertaking this journey, which already 'thunders in the index,' and on which I shall have to encounter many personal difficulties; but, if I felt safe enough to impulsively decide to accompany him, without personally knowing him—how much safer do I now feel from the short time I have known him.[9]

This positive assertion tells us that Carvalho and Fremont had not known each other in Charleston. Unfortunately the careful Carvalho does not identify the mysterious Mr. and Mrs. X.

Solomon's admiration for Fremont was so great that while all were sitting around a campfire one night, discussing the various names of men likely to be placed before the country for the presidency, he nominated Colonel Fremont.

> It was received with acclamation, and he is the first choice of every man in camp.[10]

For the next few pages of his journal, Solomon described the attributes of the country in scientific and poetic detail, mentioning kinds of trees, grapes, game of all kinds, soil which he tested, grasses, and the discovery of coal deposits, some of which were visible on the earth's surface.

He tried the waters of the Kansas River for finishing his daguerreotypes, but called it

> . . . turbid and unfit, and had to preserve many of my plates until we approached the crystal streams from the Rocky Mountains, to finish them.[11]

Meanwhile, Colonel Fremont's illness kept him longer in St. Louis, and the men continued to camp at Salt Creek. The men must have gone through stages of boredom, and one among them turned to thievery, an amusing story which Carvalho titled "Brandy *versus* Poison," and recounted with high good humor.

> Previous to leaving New York, I had two tin flasks made, to contain about a quart each, which I intended to have filled with alcohol for daguerreotype purposes. At Westport, I purchased a quart of the best quality of old cognac, filled one of them for medicinal purposes, and carefully packed my flask in my daguerreotype boxes. One day during our camp at Salt Creek, one of our Indians being ill, I opened my flask and pouring out about an ounce, replaced it. I noticed, however, that a chemical action had taken place, turning the brandy exactly the color of ink. One of our mess saw me open my box and appropriate a portion of the contents of the bottle; I am not certain but that I tasted it myself.

The next day I had occasion to go to my box, when to my utter astonishment, my flask of brandy was gone. I immediately suspected the very person who afterwards proved to be the thief. Keeping my loss a secret, at dinner I carefully watched the countenances and actions of the whole party, and the effects of liquor were plainly visible on the person of this man.

'How excellent,' said I, 'would a bottle of old cognac be as a digester to our tough old buffalo bull.—Gentlemen, how would you like a drop?' 'Bring it forward by all means, Carvalho. You have, I verily believe, Pandora's box; for you can produce everything and anything at a moment's notice, from a choice Havana to old brandy.'

'With your leave, gentlemen, I will procure it. I have two flasks exactly alike; one contains poison, a mixture of alcohol, and some poisonous chemicals for making daguerreotypes; the other contains the best brandy to be had on the Kansas River.'

I went to my box, and turning up my hands with an exclamation of surprise, announced to the mess that the 'bottle containing the poison, and which I laid on the top of my box last night, is missing.' Like Hamlet I looked into the face of the delinquent, and I never shall forget his expression when I remarked that 'the liquid in the purloined flask was poison, and perfectly black, and although it would not kill immediately, an ounce will produce certain death in 48 hours.' . . . The thief was discovered, although he nor any one else knew that I detected him. The next day I went to my box again, and in its proper place, I found my brandy flask about half full . . . when I discovered it, I showed it around and also the color of the contents, and told them it was not poison but 'good old brandy.' I tasted a little, and divided it among the party.[12]

By October 20th, Fremont still had not arrived back in camp. Solomon had become an experienced washerman, wringing out his duds in the tainted waters of the Kansas River. He also had become the camp's white medicine man, having cured Captain Wolff, the chief of the Delawares, of severe back and head aches by administering calomel and Epson salts, followed by strong arrowroot tea brewed from stock which the devoted Sarah had stowed away in Solomon's trunk. The attention endeared Carvalho to the great chief, but did not spare him a thorough ribbing at the hands of Wolff a bit later in their adventure.

Due to imprudence, the commissary was nearly empty—a fact

that Carvalho had foreseen and noted almost one month previously. There was a possibility that they would have to send to Fort Riley for more supplies, in which case, Solomon told Sarah that he would send along a package of letters to be forwarded to her, and which she was to keep "from public eye."[13]

In the meantime, the camp had been visited by storms of rain and sleet and lowering temperatures. At the same time, the men suffered discomfort to their eyes and nostrils, the heavy atmosphere due to prairie fires, about which Carvalho wrote with clarity.

On the 25th of October, Solomon went on his first buffalo hunt, and killed a lumbering animal after chasing it for nearly five miles, only to discover that it was an old bull instead of a cow. On his arrival back in camp, hours later, he received a solemn teasing from Captain Wolff, who claimed that "Carvalho no kill buffalo."[14]

Carvalho insisted that he had slain the animal, and when the Indian chief saw that Carvalho had had enough, he said:

> When Capt. Wolff kill buffalo, he cut out the tongue. Indian shoot buffalo, bring home tongue. Carvalho no bring buffalo tongue; he no kill buffalo.[15]

Before this powerful logic, Solomon was forced to retreat.

By the fifth day after Carvalho's buffalo hunt, the prairie fires had reached alarming proportions, and all expressed concern for Colonel Fremont's safety, since he had to pass through the burning brush to reach his waiting party. That night, Carvalho took the night duty and made the following observation in his journal:

> A breeze had sprung up, which dissipated the smoke to windward. The full moon was shining brightly, and the piles of clouds which surrounded her, presented magnificent studies of 'light and shadow' which 'Claude Lorraine' so loved to paint.[16]

In this notation Solomon reveals the name of one of the early masters whose works he had studied. During the long weeks that the men were camped at Salt Creek, Carvalho had been trying to make daguerreotypes of the buffalo herds which ranged the immediate vicinity. He was not successful in obtaining clear close views, as the

herds were in motion. However, he claimed to have taken success-
ful pictures of distant herds.

In the *Memoirs* of John Charles Fremont, written many years
after the fifth expedition of 1853-54, among the many plates is an
engraving entitled "Buffaloes Escaping From A Prairie Fire."

A special exhibition of the paintings of James Hamilton was
held at the Brooklyn Museum in 1966. Hamilton was essentially a
marine painter, but he also copied drawings and daguerreotypes of
Western and Arctic scenes. In that special exhibition was a painting
of 1856, oil on wood, entitled "Buffaloes Escaping Prairie Fire."

In the *Memoirs* of her husband, Jessie Benton Fremont made
the following remarks:

> During the winter of 55-56 Mr. Fremont worked con-
> stantly at Mr. Brady's studio aiding to fix these daguerre pic-
> tures in their more permanent form of photographs. (glass plate
> negatives) Then at our own house, I made a studio of the north
> drawing room, where a large bayed window gave the proper
> light. Here for some months Hamilton worked on these views
> reproducing many in oil; he was a pupil of Turner and had
> great joy in the true cloud effects as well as in the stern moun-
> tains and castellated rock formation. The engravings on wood
> were also made under our home supervision; by an artist young
> then, a namesake and grandson of Frank Key. . . . From these
> artists their work was passed to artist-engravers of the best
> school of their art. Darley also contributed his talent. Some pic-
> tures he enlarged into india-ink sketches, and from his hand
> came the figures in many of the plates.[17]

In the *Memoirs*, then, we have an engraving of buffaloes, made
from a Carvalho daguerreotype, and an oil painting which derived
its inspiration from the same source. The added figures are probably
by Darley. It is not known how many of the original Carvalho
daguerreotypes of Indians and western landscape were circulated
around the country as the basis of engravings by other artists.

I

To return to the waiting explorers at Salt Creek, their fears fi-
nally were allayed when they saw Colonel Fremont charging

Buffalos Escaping From a Prairie Fire. Engraving from Fremont Memoirs.

James Hamilton, *Buffalos Escaping From Prairie Fire.* Mr. Ben H. Eaton.

through smoke and fire into camp, followed by the Indian who had gone back to St. Louis to guide him to the camp site. With them were Doctor Ober, a huge man who would stay with the party for a while as physician, and Fremont's cook. The anxious men were so enthusiastic that they fired their rifles in salute.

After getting the camp in traveling order, the party made its way across scarified land and traveled for several days before reaching Big Timber, a part of the Arkansas River, finally stopping at Bent's House, where they replenished their shrunken supplies.

According to the following extract from a letter published in the East, Carvalho's account of the imprudent use of food supplies was no exaggeration:

> . . . Lord Fitzwilliam, who returned a few days ago from the plains, informs us that he arrived at Bent's Houses, situated about two miles below the River de los Animos, a tributary of the Arkansas, at the Point of Rocks in the Big Timber, on the same day that Col. Fremont left, but did not see or speak to him. . . . His party, before he overtook them, had consumed most of his provisions—at least that portion most desirable for the Plains—and he was compelled to recruit in horses and provisions at the Bent's Houses. The impression was, that his men who had been encamped at Salt Creek some time before his arrival, had destroyed most of his provisions for the journey.[18]

This imprudence no doubt cost the Colonel a great deal, and all of the men were to regret their indulgence later.

Before leaving Bent's House, Solomon rode out one day with the good Doctor Ober to take daguerreotype views of Pike's Peak, but the descending haze obstructed the intervening space, and he was forced to pack up his equipment without having a single success.

By now the temperatures were below freezing, and the men were camping at night on open prairie, with no timber available for firewood. They found a substitute, however:

> I was busily engaged in making my daguerreotype views of the country, over which I had to travel the next day. On looking through my camera I observed two of our men approaching over a slope, holding between them a blanket filled

with something; curious to know what it was, I hailed them, and found they had been gathering 'dried buffalo chips,' to build a fire with. This material burns like peat, and makes a very hot fire, without much smoke, and keeps the heat a long time; a peculiar smell exhales from it while burning, not at all unpleasant. But for this material, it would be impossible to travel over certain parts of this immense country. It served us often, not only for cooking purposes but also to warm our half frozen limbs. I have seen chips of a large size—one I had the curiosity to measure, was two feet in diameter.[19]

Near that part of the Arkansas River known as the Big Timber, was a large Cheyenne village in which Carvalho spent many hours taking daguerreotypes.

I made a picture, first, of their lodges, which I showed them. I then made one of the old woman and papoose.[20]

In the Library of Congress is a faded daguerreotype of Indian lodges of the type used by the Plains Indians. In James Horan's words:

It may be one of the Carvalho daguerreotypes of the first [sic] Fremont expedition and one of the earliest pictures ever taken of the American West.[21]

Carvalho's account of his visit to the Cheyennes continues with a description of their jewelry:

The squaws are very fond of ornaments; their arms are encircled with bracelets made of thick brass wire—sometimes of silver beaten out as thin as pasteboard. The princess, or daughter of the Great Chief, was a beautiful Indian girl. She attired herself in her most costly robes, ornamented with elk teeth, beads and colored porcupine quills—expressly to have her likeness taken. I made a beautiful picture of her.[22]

In John Fremont's *Memoirs* is a plate entitled "Cheyenne Belle." Although engraved and signed by another artist, the original for the plate undoubtedly was Carvalho's daguerreotype of the Indian princess, and she is depicted in a traditional photographic pose.

Indian Village, 1854. Daguerreotype. Library of Congress.

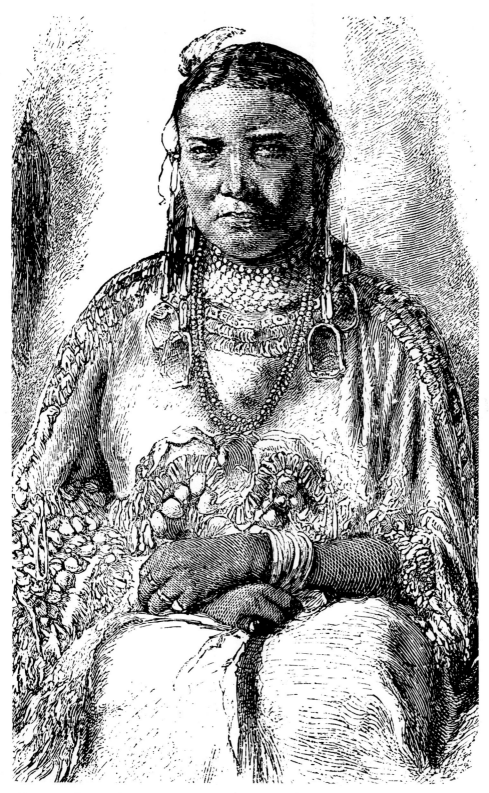

Cheyenne Princess, Engraving from Fremont *Memoirs*.

After I had made the likeness of the princess, I made signs
to her to let me have one of her brass bracelets. She very reluc-
tantly gave me one. I wiped it very clean, and touched it with
'quicksilver.' It instantly became bright and glittering as
polished silver. I then presented her with it. Her delight and
astonishment knew no bounds. . . . My extraordinary powers
of converting 'brass into silver' soon became known in the vil-
lage, and in an hour's time I was surrounded with squaws en-
treating me to make 'presto, pass!' with their 'armlets and brass
finger rings! . . . My 'lucifer matches,' also, excited their as-
tonishment; they had never seen them before; and my fire
water, 'alcohol,' which I used, also to heat my mercury-
—capped the climax. They wanted me to live with them, and I
believe if I had remained, they would have worshipped me as
possessing most extraordinary powers of necromancy. I re-
turned to camp *with a series of pictures*. (Italics mine.)[23]

Solomon was fascinated with the Cheyenne Indians, and his
observations and descriptions of their culture make equally fascinat-
ing reading. He noted in detail their scalp dances (the Pawnees and
Cheyennes were at war at this time), their music, strange and dis-
cordant to his ear; their lodgings, food and division of work.

By this time, Fremont seemed to be well over his illness and
Dr. Ober was sent back to St. Louis. Due to the extreme cold, Car-
valho found that he could not use his oil paints, so he sent them
back in Dr. Ober's care.

It would have been most helpful if Solomon had provided us
with more detailed, descriptive information with regard to his artis-
tic activities. In referring to his oils and brushes, he intimates that
he had been using them, but no mention is made to how or where.

The Fremont party traveled along the Arkansas River to the
mouth of the Huerfano, following it until they came to the Huerfano
Valley. The sensitive Solomon again reacted to the vast silence of
nature:

. . . which is by far the most romantic and beautiful country I
ever beheld. Nature seems to have, with a bountiful hand,
lavished on this delightful valley all the ingredients necessary
for the habitation of man; but in vain the eye seeks through the
magnificent vales, over the sloping hills, and undulating plains,
for a single vestige to prove that even the foot of an Indian has

ever preceded us. Herds of antelope and deer roam undisturbed through the primeval forests, and sustain themselves on the various cereals which grow luxuriantly in the valley. But where are the people? Were there ever any inhabitants in the extraordinarily fertile country? Will the progress of civilization ever extend so far in the interior?[24]

Today we read that last sentence, shake our heads and, perhaps, sigh. If Carvalho could read today's newspapers, scientific journals, ecological brochures, with their bombardment of knowledge regarding population explosion, expansion, pollution and food shortages, he would be incredulous, not to mention dismayed. He was full of appreciation for the pure air of that lush valley, along with its other attributes. If the hot-blooded Portuguese painter, with his spiritual reaction to the sublime in nature, could stand on that same spot today, we undoubtedly would witness a most provocative outburst of feelings.

In the lush Huerfano Valley, Fremont divided the party, leaving Carvalho with four of the men and the mules carrying the daguerreotype apparatus, while he went on ahead with the rest of the men, horses and mules. He had requested Carvalho to make several views of the Huerfano Butte, a huge pile of granite rising like a giant marker some five hundred feet into the air.

> To make a daguerreotype view, generally occupied from one to two hours, the principal part of that time, however, was spent in packing, and reloading the animals. When we came up to the Butte, Mr. Fuller made barometrical observations, in order to ascertain its exact height.[25]

In Fremont's *Memoirs* is an engraving of the Huerfano Butte which probably was copied from Carvalho's daguerreotype. The figures of men and horses may be the added work of Darley.

After taking daguerreotypes of the Butte, Carvalho found that he and the men were four hours riding time (or about twelve miles) behind the advance party. They followed Fremont's trail until night, when they were forced to stop. It was an exceedingly uncomfortable twenty-four hours for all concerned—Carvalho's group had all the blankets and buffalo robes of the entire camp loaded on their mules; Fremont's party had all the food. Next morning, after all were to-

Huerfano Butte, Engraving from Fremont Memoirs.

gether, Carvalho and his companions were treated to a breakfast of buffalo and venison.

The expedition moved on to the foothills of the Rocky Mountains, approaching Sand Hill Pass, where they found and shot an enormous black bear. It provided food for the entire camp for several days, though Carvalho ate sparingly, noting that the meat was too greasy for his taste.

The next day, Carvalho and Colonel Fremont went to Roubidoux Pass,

> . . . from the summit of which I had the first view into the San Louis Valley, the head waters of the 'Rio Grande del Norte.' On the opposite side forty miles across are the 'San Juan Mountains,' the scene of Col. Fremont's terrible disaster on a former expedition. He pointed out to me the direction of the spot and with a voice tremulous with emotion, related some of the distressing incidents of that awful night. I made a daguerreotype of the pass with the San Louis Valley and mountains in the distance.[26]

The explorers traveled up the San Louis Valley, crossing the Rio Grande del Norte, entered the Sarawatch Valley and continued to travel along that valley until they came to the Cochotope. Though Carvalho makes no mention of making daguerreotypes at this location, he must have done so, for later he produced an oil painting entitled "Entrance to the Cochotope Pass, Rocky Mountains."

Near the camp site, a journey of a day or so, Solomon and Fremont had an important discussion:

> Near by our camp, a rugged mountain, barren of trees, and thickly covered with snow, reared its lofty head high in the blue vault above us. The approach to it was inaccessible by even our sure-footed mules. From its summit, the surrounding country could be seen for hundreds of miles. Col. Fremont regretted that such important views as might be made from that point, should be lost, and gave up the idea as impracticable from its dangerous character. I told him that if he would allow two men to assist me in carrying my apparatus up the mountain, I would attempt the ascent on foot, and make the pictures; he pointed out the difficulties, I insisted. He then told me if I was determined to go he would accompany me; this was an un-

usual thing for him and it proved to me, that he considered the
ascent difficult and dangerous, and that his superior judgment
might be required to pick the way, for a misstep would have
precipitated us on to the rugged rocks at its base; and it also
proved that he would not allow his men or officers to encounter
perils or dangers in which he did not participate.[27]

The two then proceeded to load upon themselves the daguerre-
otype apparatus and other scientific equipment, and after some
three hours of hard struggle up the steep slopes, through deep snow,

> . . . we reached the summit and beheld a panorama of un-
> speakable sublimity spread out before us; continuous chains of
> mountains reared their snowy peaks far away in the distance,
> while the Grand River plunging along in awful sublimity
> through its rocky bed, was seen for the first time. Above us the
> cerulean heaven, without a single cloud to mar its beauty, was
> sublime in its calmness.
>
> *Standing as it were in this vestibule of God's holy Temple,*
> *I forgot I was of this mundane sphere; the divine part of man*
> *elevated itself, undisturbed by the influences of the world. I*
> *looked up from nature, up to nature's God, more chastened*
> *and purified than I ever felt before.* (Italics mine.)[28]

In 1971, Richard Rudisill expressed his opinions regarding
Carvalho's reaction:

> The language Carvalho uses to describe his sensations in
> facing nature suggests the transcendental experience of Emerson
> in a form appropriate to great distances which defeat the keen-
> ness of sight. His sense of the wonder of the landscape is of a
> part with Thomas Cole's enthusiasm and the spiritualizing im-
> pulses Mrs. Clara Moreton Moore derived from contemplating
> Niagara Falls. As Emerson wrote of becoming a vast transpar-
> ent eyeball, ultimately fusing part and parcel with God, so Car-
> valho experienced a committment to the overriding spirit of na-
> ture, yielding himself up to it completely in trust.[29]

But this is only half of the picture, for Carvalho carried his
spiritual reaction to its completion:

> Plunged up to my middle in snow, I made a panorama of
> the continuous ranges of mountains around us.[30]

Thus, the spiritual reaction provided the thrust for the artistic, sensuous fusion of man with God in nature. Rudisill describes it further in his own terms:

> . . . Carvalho's act of making his panorama of daguerreotypes comes as the necessary completion of the experience. The pictures render the experience permanent and verifiable. They are the remaining token of the exalted spiritual event, to preserve visually the intensity of the direct experience for contemplation later.[31]

Thus, the artist, put into permanent form his transcendental experience of "unspeakable sublimity" and linked himself to such landscape painters as Cole.

While Carvalho was engaged in making his daguerreotypes, Fremont occupied himself with making barometrical and temperature notations, and examining geological formations. Afterwards the two men made a slow descent from the peak to warm themselves before the camp fire and get something to eat.

On New Year's Day, 1854, dinner was horse soup, fried horse steaks, and for dessert, Carvalho's

> . . . incomparable blanc mange. 'Six gallons of *bona fide*, nourishing food, sweetened and flavored! . . . it disappeared in double quick time. The whole camp had a share of it; and we were all sorry that there was 'no more left of the same sort.'[32]

The resourceful Solomon had been holding in his trunk preserved eggs, which were the yolks prepared as a paste with sugar, and milk which also was mixed with powdered sugar, both mixtures being sealed in their separate tins. With the sweetened eggs and milk, and an addition of arrowroot, these three items were boiled in six gallons of water, making the blanc mange. Though Carvalho says that his dessert was a surprise, unknown even to Colonel Fremont, surely the cook must have been an accomplice, for a six gallon kettle was difficult to come by.

The temperature dropped, and the snow became deeper and, as is obvious from the above menu, the expedition was falling into difficult times: they were forced to kill their horses for food.

They had some good fortune when they came across a Utah In-

dian village, where Fremont's party exchanged blankets, knives, cloth, etc., for horses and venison. As night was coming on, and Fremont intended to travel very early the next morning, Carvalho unpacked his apparatus and made several daguerreotypes of the village and surrounding countryside.

The next days of travel were fraught with difficulties. There were occasional unfriendly Indians, and at times Carvalho, utilizing his knowledge of Spanish, acted as interpreter. Just as the party had to undertake the dangerous crossing of the Grand River, the eastern fork of the Colorado, Carvalho's horse went lame. Their food supply had reached such desperate straits that Colonel Fremont had all of his men, white and Indian alike, made a pact that no one would turn to cannibalism.

> . . . If we are to die, let us die together like men. He then
> threatened to shoot the first man that made, or hinted as such a
> proposition.[33]

At that point, Carvalho was struck by the full realization of the dangers involved, and looking about him at white men, Indians and Mexicans, standing in the snow with heads bowed, recognized himself as one of the actors in the drama.

Food was so much on the men's minds, that it became painful to watch as the cook doled out small portions of horse meat to each one. A beaver provided some respite from the monotony on one occasion. On another, one of the Delawares brought in a large porcupine which provided a meal for everyone in camp except Carvalho, who refused to eat it, thinking that it looked revolting, fat, and much like pork.

Carvalho had been continuing to daguerreotype the terrain. However, the shortage of nourishing food was making the entire party weak. Shoes were worn thin; the men were mostly on foot, and frostbite was a growing problem. They had lived on horse meat for fifty days, and the supply was giving out.

At one point, Carvalho, alone on the trail, took from his pocket miniatures of his wife and children, and said that that one last glance gave him the determination to go on. He knew that if he stopped in the snow, he would go to an eternal sleep.

At last Colonel Fremont gave the order to cache all the equip-

ment, putting the men on the pack animals, as a last resort. Nothing was to be carried except clothing necessary for protection from the bitter weather. A place was dug out in the snow, the large buffalo lodge which they had been carrying was laid out, and everything placed in it, including scientific instruments, the daguerreotype apparatus, pack saddles, blankets, spare gunpowder, etc. Then the snow was piled carefully on top, and on top of that, brush to hide the spot from marauding Indians.

Shortly before the emaciated party reached safety, Carvalho's good friend and companion, Oliver Fuller, died. Carvalho, himself very ill, became more and more despondent. He admits that upon reaching the Mormon settlement of Parowan, he could not help crying, and fell down, exhausted, upon the snow.

II

While Fremont's party was struggling to live long enough to reach a settlement, there were grave apprehensions about their fate expressed in the East, as we see from the following extract from a letter published in *Cummings' Evening Bulletin*:

Utah—Suffering of Fremont's Expedition, The Goliah arrived yesterday morning from San Diego having left that port on the 6th inst. Among her passengers is Mr. Babbitt, from Utah, who left Salt Lake City on the 4th February, on his way to Washington. . . . Mr. Babbitt brings news of Col. Fremont's party. From a friend who was passenger with Mr. Babbitt, we glean a few of the facts connected with the affair. It will be remembered that Fremont started nearly two months since to demonstrate the possibility of the Central Railroad Route by traveling it in winter. He took with him about 20 men. He reached the Rocky Mountains with little difficulty, but after crossing near the Middle Part, his way was full of great trials . . . they had suffered actual starvation. . . . The party had lost seven men by death, of which two cases were ascribed directly to starvation, and the others to the consequences of cold and unhealthy diet. . . . Portions of his (Fremont) intended route is entirely unexplored, and the exploration at this time of year, with a party reduced by disease and suffering, is a rash undertaking.[34]

The extravagant number of deaths must have set some members of the Philadelphia community on dismal edge. The writer of the report is unknown; however, he gives Fremont a sharp slap on the wrists, and the tone of the entire column seems designed to injure Fremont's reputation.

In order to allay the fears of the anxious Philadelphia families and friends of the exploring party, S. Solis, Carvalho's brother-in-law, published a letter in that same Bulletin, dated the following evening:

> Col. Fremont's Expedition
> To the editor of the Evening Bulletin:
> Sir: As some members of the community may feel anxious for the safety of Col. Fremont's party, subjoin extract from a letter received yesterday, dated Mormon Settlement, February 9, 1854, from Mr. S. N. Carvalho, the gentleman attached to Col. Fremont's party as daguerreotypist:
>
> 'The party,* after enduring every privation, have retraced their steps and arrived at Salt Lake City in a dreadful condition, having lived fifty days on horse flesh, and for the last forty-eight hours has been without food of any kind. . . . They had lost one man by cold. . . . That he himself was now staying at the house of an English family, and receiving every kindness and attention from them.'
>
> Respectfully,
> S. Solis

John Fremont was quick to follow up with a letter of reassurance. However, it was not until April that the letter arrived in Washington, where it was printed in its entirety on April 12th.

> It gives us great pleasure to insert the subjoined letter from Col. Fremont, not only because it contradicts the exaggerated reports of deaths sustained by his party and assures us of the intrepid explorer's own safety, after his two months bold journey through the mountain wilds in mid-winter, but because his success seems fully to have established the favorable nature of the central route for a railroad in winter as well as summer:
> 'Parawan, Iron County, Utah Territory

*I presume the whole party he meant.[35]

February 9, 1854

My Dear Sir: I have had the good fortune to meet here our friend, Mr. Babbitt, the Secretary of the Territory, who is on his way to Washington, in charge of the mail and other interesting despatches, the importance of which is urging him forward with extreme rapidity. He passes directly on this morning, and I have barely a few moments to give you intelligence of our safe arrival and of our general good health and reasonable success in the object of our expedition.

The winter has happened to be one of extreme and unusual cold. Here, the citizens inform me, it has been altogether the severest since the settlement of this valley. Consequently, so far as the snows are concerned, the main condition of our expedition has been fulfilled. . . . We went through the Coochatope Pass on the 14th December with four inches—not feet, take notice, but inches—of snow on the level, among the pines and in the shade on the summit of the Pass. This decides what you consider the great question, and fulfills the leading condition of my explorations; and therefore I go no further into details in this letter. . . . Until within about a hundred miles of this place we had daguerreotyped the country over which we passed, but were forced to abandon all our heavy baggage to save the men, and I shall not stop to send back for it. . . . I lost one, Mr. Fuller, of St. Louis, Missouri, who died on entering this valley . . . and will be buried like a soldier, on the spot where he fell. . . .

sincerely and affectionately,

John C. Fremont'[36]

The letter is too long to be repeated here. It is noted that Fremont speaks with pleasure upon seeing Mr. Babbit, and due to the bitter report as published in the *Cummings' Evening Bulletin*, one wonders what information Mr. Babbitt could have given his traveling companion on board ship that could have provoked such an injurious tale about Fremont and his men. Babbitt was carrying not only letters and reports from Fremont, but also documents from the exploring party led by Captain Gunnison. In his position as the Secretary of the Territory, it seems unlikely that Babbitt would be such an irresponsible person as to distort truth. Perhaps only Babbitt's unknown shipmate carried a cudgel against the great Pathfinder as did the person who allowed such an exaggerated report to appear in print.

In his letter, Fremont says that he does not intend to stop to send back for the heavy baggage, which included the daguerreotype apparatus, and presumably, the plates. However, in a second communique to the *Intelligencer*, dated Wednesday, June 14, 1854, he says:

> . . . I desire to offer to your paper for publication some general results of a recent winter expedition across the Rocky Mountains, confining myself to mere results, in anticipation of a fuller report, with maps and *illustrations* which will necessarily require some months to prepare. . . . (Italics mine.) Along this line the elevation was carefully determined by frequent barometrical observations, and its character exhibited by a series of daguerreotype views, comprehending the face of the country almost continuously, or at least sufficiently so to give a thoroughly correct impression of the whole . . .[37]

Thus, it appears that Fremont did retrieve the plates. From estimating by reading Carvalho's journal, and from Fremont's remarks, the number of daguerreotypes taken was probably around three hundred.

Fremont left Carvalho in the capable hands of the Mormons, and went on towards California.

The Delaware Indians apparently went back to St. Louis, for in the *Intelligencer* of Monday, June 12, 1854, there appeared the following account:

> From the *Missouri Democrat* of June 7: an "Indian account of the Fremont expedition mentioning it as 'very agreeable,' except for the loss of one of their Delaware members as they came up the Mississippi."[38]

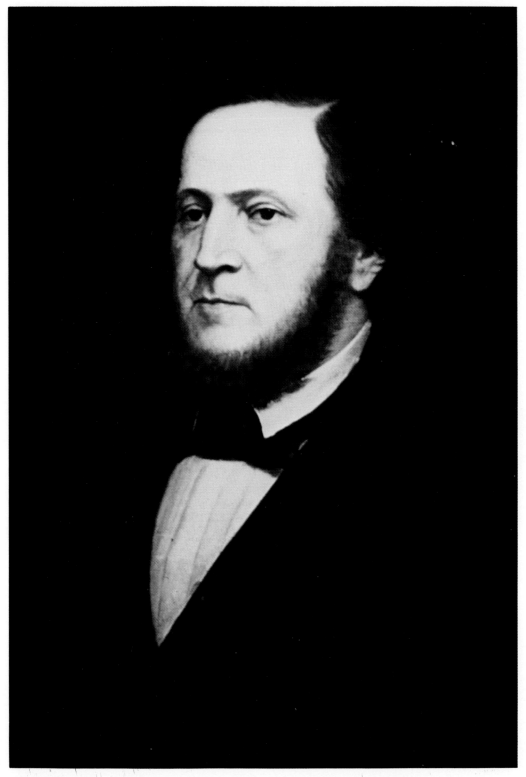

Brigham Young, c. 1854. o/c, 24 x 31. Church of Jesus Christ of Latter Day Saints, Salt Lake City.

Warka, Indian Chief, 1854. o/c, 28 x 23. Thomas Gilcrease Institute, Tulsa.

CHAPTER VII

UTAH TERRITORY

On the twenty-first of February, 1854, Fremont left Parowan to continue his journey to California. The ailing, emaciated Carvalho, who had been mistaken for an Indian upon his arrival in the small settlement because of his unkempt, matted hair and darkened, leathery face, was put into a wagon and carried to Salt Lake City, accompanied by Mr. Egloffstein, whose condition was almost as bad. By March first, the two exhausted men had been settled comfortably at Blair's Hotel.

Lt. Beckwith, officer on one of the government-financed expeditions, was in Salt Lake City at this time, and invited Carvalho and Egloffstein to dine with him at the home of E. T. Benson, the famous Mormon apostle. At a later date, Carvalho accepted an invitation to board with Benson and his family before finally leaving Salt Lake City.

Beckwith apparently was much taken with the versatile artist and explorer, offering whatever services he could to help refurbish Solomon's lack of supplies, including

> a supply of painting materials, which I could not have procured elsewhere, and by the use of which, I was enabled to successfully prosecute my profession, during my residence in that city.[1]

The local merchants also were kind to Carvalho, helping to fit

99

him with a suitable wardrobe, as what little he had was barely decent, and hung upon his thin body. He remarked in his journal that he was comfortably settled, and grateful to all for their friendship and courtesies, including Governor Young, who had greeted him with great kindness, and offered Solomon the use of his extensive library (Young evidently had respect for Carvalho's religion; he ordered matzos baked for him at Passover).

> I received a good deal of marked attention from his excellency, Governor Young; he often called for me to take a drive in his carriage, and invited me to come and live with him, during the time I sojourned there. This invitation I refused, as I wished to be entirely independent to make observations. I told Brigham Young that I was making notes, *with a view to publish them*. He replied, 'Only publish facts, and you may publish as many as you please.' (Italics mine.)[2]

During the weeks that Carvalho remained in Salt Lake City recuperating from his illness, he journeyed about the town and surrounding countryside, making copious notes and detailed observations in his journal. He was especially interested in the Governor's residence,

> . . . a large wooden building of sufficient capacity to contain his extensive family—nineteen wives and thirty-three children. . . . I made a *daguerreotype view of it*, and also a drawing. (Italics mine.)[3]

This matter of fact remark by Carvalho is the only mention that he makes of a daguerreotype apparatus during his residence in Salt Lake City. We might assume that it was the Fremont equipment that had been cached in the snow, except for an entry made a short time later in his journal with reference to a remark made by an Indian chief, who said that he sent men to retrieve the goods, but they had been gone thirty days and had not yet returned. The apparatus may have been part of Beckwith's supplies; in any case, Carvalho never speaks of taking daguerreotype views in that city again.

In the month of April, a grand ball was held prior to Governor Young's annual inspection of the Mormon settlements in southern Utah. Carvalho, an honored guest at this magnificent affair, opened

the ball at the Governor's invitation, with one of Young's wives as his partner. He was full of admiration for the ladies in attendance, in particular,

> a Mrs. Wheelock, a lady of great worth, and polished manners; she had volunteered her services as a tragedienne, at different times during my visit to Salt Lake, at the theatre, where she appeared in several difficult impersonations; I think she excels Miss Julia Dean in her histrionic talent. I had the pleasure of painting Mrs. Wheelock's portrait in the character of 'Pauline,' in 'Claude Melnotte.'[4]

Solomon, much as he admired the Mormons, did not approve of the Mormon marriage system, and much of the latter part of his journal is devoted to observations of their practices. One young husband and wife took matters into their own hands and circumvented the system, telling Carvalho their story while sitting for portraits.

Fanny fled from Utah to New Orleans, to avoid a forced marriage. Terry Littlemore followed her. They were married and subsequently returned to Salt Lake City where Fanny could then live peacefully under the protection of her husband.

> This history was volunteered during the time I was occupied in painting her own, and her husband's portrait; I was not bound to secrecy, the parties immediately interested, are all residing at present in Utah. I became afterwards personally known to them, on my journey to Parowan. . . . Fanny, at the time I saw her, was the most beautiful woman in Utah. Her eyes were dark hazel, a classical nose, high forehead and luxuriant black hair. Her teeth were beautifully white, while her lips and mouth were 'rich with sweetness living there.' She was the mother of two children, and was 28 years of age. . . .[5]

Sometime early in May, the fully recuperated Carvalho decided that it was time to leave the hospitable people of Salt Lake, and was determined to reach California by the southern route taken by Fremont in 1843, which he "wanted to illustrate with *views*." (Italics mine.)[6] In his journal he itemized his wardrobe and provisions, which included one riding mule and tack. Leaving with him from Salt Lake City were twenty-three Mormon missionaries and their

leader, Parley Pratt, who were making the Sandwich Islands their eventual destination, hoping to convert the natives there. The entire party was scheduled to meet Governor Young and his entourage at Provost City.

Besides Carvalho's "view" of the Governor's residence and drawing of same, we know of several portraits which he painted:

> I painted several portraits in Great Salt Lake City; among them were two of Gov. Brigham Young; one of Lieut. General Wells, General Ferguson, Attorney General Seth Blair, Apostle Woodruff, Bishop Smoot, Col. Ferrimore Little and lady, Mrs. Wheelock, and several others.[7]

In 1971, a portrait of Brigham Young was discovered in the uncatalogued collection of art of the Church of Jesus Christ of Latter Day Saints, Salt Lake City.

In studying black and white photographs of this painting, some of which were cropped areas enlarged for examination of details, the immediate Carvalho works that came to mind were the portraits of Dr. David Camden DeLeon, and George Murray Gill. Carvalho's abilities of psychological interpretation are evidenced as early as 1836 in the DeLeon portrait. Gill's likeness, done twenty-three years later, demonstrates a similar empathy between sitter and artist.

Young's beard has the same softness as the treatment of DeLeon's hair. Emphasized is the strongly lighted face, prominent nose and strict lines at the corners of his mouth, true of nearly every known Carvalho portrait of men.

In studying the Brigham Young portrait in color, it was found that the same palette was used as that in Carvalho's portrait of Moses Finzi Lobo.

The careful attention to Young's white shirt collar, stock and coat is typical of Carvalho's work, as is the plain background and pose. The interpretation of strong character in the face, together with other considerations of style and color, made the attribution of this portrait to the hand of Solomon Carvalho an appealing conclusion. However, there was question, as indicated in the following extract of a letter from Ms. Cathy Gilmore, Office of the Church Historian, June 26, 1972:

As for the portrait of Brigham Young that we have been interested in, I went to the storage area and gave it a thorough inspection. After comparing it with a number of other paintings, I feel sure that it was painted by an artist named Enoch Wood Perry, Jr. It is identical in style, method stretching, canvas, etc., with other paintings we have by Perry. I am disappointed as it would be exciting to find a Carvalho.

For a number of reasons I think that it likely that if any of Carvalho's works are still in Utah, they will be found and identified. Interest in Utah art is definitely on the increase. . . . The Church is also involved with our photographing project and regularly finds new pieces. Within a year we will have an appropriate facility for storage and study which will facilitate work with the many unidentified works we own.[8]

It is hoped that as the search continues, some of the missing Carvalho portraits will be uncovered. Meanwhile, the Brigham Young work has been cleaned and identified by the initials "S.N.C." in the lower right hand corner, thus verifying the writer's original opinion.[9]

I

Returning to Carvalho and his journal, we find several paragraphs devoted to descriptions of the many mineral lakes around Salt Lake City. He notes that mica mines abounded in the area and the transparent mica was used as window glass in some of the houses.

Around the eighth of May, Solomon reached the town of Petetnit, or Payson, where he joined Governor Young and his party, breakfasting with the Governor and one of his wives the following morning.

On the 10th of May, Carvalho rode with Governor Young to the town of Nephi, about twenty-six miles from Payson, where they were to have an interview the following day with Warka, the Utah Indian Chief. Young's mission was to make a peace treaty with the chiefs of the various tribes, following the massacre of Captain Gunnison by Indians of the Parvains (Gunnison was one of the leaders of one of the five government expeditions). Carvalho noted in his journal that the Indians had been shot, their villages and animals pillaged by American emigrants to the West, and the massacre of Cap-

tain Gunnison was an open demonstration of revenge. A government Indian agent had been sent to obtain a truce until Young could arrive to make personal commitments for a peace treaty.

The party which traveled to Warka's village was an impressive cavalcade, with one hundred wagons and teams, and about fifty men on horseback. When they arrived before Warka's camp, Governor Young sent word that he was ready to give the Chief an audience.

> Wakara (as Solomon spelled it) sent word back to say, 'if Gov. Young wanted to see him, he must come to him at his camp, as he did not intend to leave it to see anybody.'[10]

When this message was delivered to Governor Young, he gave orders for the whole cavalcade to proceed to Warka's camp, saying:

> If the mountain will not come to Mahomet, Mahomet must go to the mountain.[11]

Solomon accompanied Young and his council into Warka's lodge, where they found the Utah chief seated on his buffalo robe, with a colorful blanket around him. With Warka were some fifteen old chiefs including Ammon, Squash-Head, Grosepine, Petetnit, Kanoshe, the Parvain Chief, a San Pete chief, and other distinguished Indians.

Warka made room for Governor Young to sit beside him on his robe, with Carvalho and the other members of Young's party fitting themselves into the circle.

Solomon's journal makes interesting reading, and he soon learned that parleying with aroused Indians took more than one day to settle accounts; for all the other chiefs made emotional statements except Warka, who told Young that he would not speak that day, but would consult with the great spirit, and speak the following day. While the conference was in progress, Carvalho made sketches of Warka and Kanoshe.

The next morning, Governor Young distributed presents throughout the camp, including ammunition, blankets and a considerable number of fat oxen, the latter being a most pleasing sight to the Indians.

The council resumed, and then Warka made his speech:

Wakara has heard all the talk of the good Mormon chief. Wakara no like to go to war with him. Sometimes Wakara take his young men, and go far away, to sell horses. When he is absent, the Amerecats come and kill his wife and children. Why not come and fight when Wakara is at home? Wakara is accused of killing Capt. Gunnison. Wakara did not; Wakara was three hundred miles away when the Merecat chief was slain. Merecats soldier hunt Wakara, to kill him, but no find him. Wakara hear it; Wakara come home. Why not Merecats take Wakara: he is not armed. Wakara heart very sore. Merecats kill Parvain Indian chief, and Parvain woman. Parvain young men watch for Merecats and kill them, because Great Spirit say—'Merecats kill Indian;' 'Indian kill Merecats.' Wakara no want to fight more. Wakara talk with Great Spirit; Great Spirit say—'Make peace.' Wakara love Mormon chief; he is good man. When Mormon first came to live on Wakara's land, Wakara give him welcome. He give Wakara plenty bread, and clothes to cover his wife and children . . . Wakara talk last night to Payede, to Kahutah, San Pete, Parvain—all Indian say, 'No fight Mormon or Merecats more.' If Indian kill white man again, Wakara make Indian howl.[12]

After this strong speech by Warka, the peace pipe was passed around, and the council disbanded. The Governor's party remained in camp until the next day, giving Carvalho time to paint a portrait of Warka, as well as likenesses of Squash-Head, Baptist, Grosepine, Petetnit and Kanoshe, the latter chief having special fascination for Carvalho.

On May 12th, Carvalho found himself at the Seveir River, where he made sketches of the surrounding country, and on the following day he went into the Parvain camp, as he was anxious to paint a more complete portrait of their chief, Kanoshe.

I found him well armed with a rifle and pistols, and mounted on a noble horse. He has a Roman nose, with a fine intelligent cast of countenance, and his thick black hair is brushed off his forehead, contrary to the usual custom of his tribe. He immediately consented to my request that he would sit for his portrait; and on the spot, after an hour's labor, I produced a strong likeness of him, which he was very anxious to see. I opened my portfolio and displayed the portraits of a number of chiefs, among which he selected Wa-ka-ra, the

celebrated terror of travellers, anglicised Walker, (since dead).
He took hold of it and wanted to retain it. It was, he said
'wieno,'—a contraction of the Spanish 'bueno'—very good.[13]

In this portion of his journal, Carvalho has mentioned some six,
perhaps seven, sketches and portraits of celebrated Indians of that
day. These likenesses were still in his hands when he reached San
Francisco some time later. Then they disappeared.

In September of 1971, as a result of an inquiry to the Thomas
Gilcrease Institute of American History and Art, the Carvalho por-
trait of Warka, Utah Indian Chief, was found hanging in their col-
lection. A color reproduction of the painting was used by the Utah
State Historical Society for the cover of their "Utah Historical Quar-
terly," Spring, 1971, vol. 39, no. 2.

Though Carvalho spoke of Warka as being an old man, in this
portrait he appears to be in his middle years. His jet black hair and
ruddy skin glow against the emerald green blanket and brilliant red
scarf at his neck. It is a strange portrait, perhaps haunting. Though
the face is determined there seems to be a sadness in the chief's
eyes. The portrait is typically Carvalho in the strong lighting on the
face, the prominent nose and sharp lines at the mouth. There is a
brooding quality, an understanding and an empathy that marks it as
the statement of a brother. This was not the idealized savage of Cat-
lin, nor the bloodthirsty devil of Bodmer. Indeed, Carvalho had a
strong affection for the Indian chief who would be his guide over
nearly two hundred miles of barren desert. The fate of the other In-
dian works remains unknown.

After leaving Kanoshe and his people, Carvalho rode to Fill-
more, where he made views and sketches of the countryside, and
for the next miles of travel, noted details in his journal about in-
sects, sulphur lakes, geological formations, and examinations he
made of mineral compounds in the soil.

At the base of the Warsatch Mountains, he was nearly over-
come by gases from a sulphur lake—a place where, as Warka told
him, bad spirits dwelled. Withdrawing to purer air and higher al-
titude, Solomon did a sketch of the lake and surrounding mountains.

On May 17th Carvalho found himself back on the same trail
over which they had come to painfully into Parowan on February

6th. The memory of the ordeal brought tears to his eyes, and he finally calmed himself enough to make a drawing of that pass, and also the pass at Little Creek canyon where Lt. Beale had entered Little Salt Lake Valley, a few months previously.

Further on the trail they came to a place called Red Creek canyon. Carvalho, intent on the steep walls rising above him, made an interesting discovery:

> . . . there are very massive, abrupt granite rocks, which rise perpendicularly out of the valley to the height of many hundred feet. On the surface of many of them, apparently engraved with some steel instrument, to the depth of an inch, are numerous hieroglyphics, representing the human hand and foot, horses, dogs, rabbits, birds, and also a sort of zodiac. These engravings present the same time–worn appearance as the rest of the rocks; the most elaborately engraved figures were thirty feet from the ground. I had to clamber up the rocks to make a drawing of them. These engravings evidently display prolonged and continued labor, and I judge them to have been executed by a different class of persons than the Indians, who now inhabit these valleys and mountains—ages seem to have passed since they were done. When we take into consideration the compact nature of the blue granite and the depth of the engravings, years must have been spent in their execution. . . . Some of the figures are as large as life, many of them about one-fourth size.[14]

In our day of scientific exploration and theorizing as to the origin and movements of man across the face of the earth, this 1854 notation should provoke the curiosity of an archaeologist.

During these days of travel, Carvalho's path in following the Governor on his tour had taken him in a circular pattern, and he arrived back in Parowan late on the 17th, leaving the next morning to ride to Cedar City, eighteen miles to the south, where he had a strange experience.

After getting a good night's sleep he arose early, and taking his sketchbook, roamed the streets of the town. He saw a man pacing up and down, apparently in great distress, and approaching him, asked what was the matter. The man told him that his only child, a girl of six, had died suddenly in the night, and pointed towards the door of his house. Carvalho went in:

Sketch of a Dead Child, 1854. American Jewish Historical Society, Waltham.

Laid out upon a straw mattress, scrupulously clean, was one of the most angelic children I ever saw. On its face was a placid smile, and it looked more like the gentle repose of healthful sleep than the everlasting slumber of death. Beautiful curls clustered around a brow of snowy whiteness. It was easy to perceive that it was a child lately from England, from its peculiar conformation. I entered very softly and did not disturb the afflicted mother, who reclined on the bed, her face buried in the pillow. . . . I commenced making a sketch of the inanimate being before me, and in the course of half-an-hour I had produced an excellent likeness. A slight movement in the room caused the mother to look around her . . . I apologized for my intrusion . . . tore the leaf out of my book and presented it to her, and it is impossible to describe the delight and joy she expressed at its possession. She said I was an angel sent from heaven to comfort her. She had no likeness of her child.[15]

The suffering of the parents over the death of their child touched Carvalho deeply, and no doubt he was thinking of his own dear children and his wife at that moment, as they had been apart for a long, long time. Solomon tried to give words of comfort, and left the house, unseen by the father who continued his grieved pacing.

The next day, as Carvalho was getting ready to depart in the wagon he found a basket

filled with eggs, butter, and several loaves of bread, and a note to my address containing these words—'from a grateful heart.'[16]

II

On the 22nd, Carvalho left Utah for San Bernadino with Warka and a number of persons besides the twenty-three missionaries.

He continued his journal, although he was veiled and goggled much of the time against the fine dusty clouds that surrounded them in that arid country. His notes are a literal survey of geological, topographical and botanical entries—his scientific mind and eyes were aware and at work during those difficult days, and his response to the landscape was consistently romantic and spiritually inclined:

We started for the Rio Virgin, the approach to which, was through the most beautiful and romantic pass I ever saw; it is a natural gorge, in a very high range of mountains of red sandstone, which assume, on either side, the most fantastic and fearful forms; many look as if they were in the very act of falling on the road . . . as you are about to emerge from this pass, through the opening of the mountains, I beheld the valley of the Rio Virgin at sunset, bursting upon me in all the glory and sublimity of a perfect picture.[17]

The dry, weary travelers straggled into San Bernadino on the afternoon of June 9th. Carvalho remained in that location for three days, and then rode his mule the forty-five miles to Los Angeles. It took him twelve hours. He was fascinated with the Californian ladies with their long dark hair and dark eyes, their elegant dress; but

Alas! for the morals of the people at large; it was the usual salutation in the morning, 'Well, how many murders were committed last?' . . . almost every night while I was there, one murder, at least, was committed. It became dangerous to walk abroad after night.[18]

Upon reaching San Francisco some days later, Carvalho's curiosity led him into one of the large gambling establishments, which he viewed with dismay, as he did the beautiful women dealing the cards. He devoted one entire paragraph to the Californians' practice of borrowing money at usurious interest rates.

Apparently, although Solomon felt quite well and strong after his sojourn in Salt Lake City, the ordeal of those long days before reaching safety had weakened him more than he realized, for at San Francisco he was taken ill with brain fever, and put to bed at the ranch of one Don Manuel Domingues, a Spaniard of noble blood.

After his recovery, Solomon painted a large portrait of the gentleman, showing him holding in hand the title to his large stretch of property. He also painted portraits of Donna Gracia, Domingues' wife, and one of their daughters.

Don Manuel and Donna Gracia had a large family, all handsome people, and during Carvalho's visit with them, they entertained frequently with dinners, dancing, and music.

Solomon was curious about a mound of earth on Don Manuel's ranch, and during his geological examinations he dug up mastadon remains, among which were four huge teeth, in good condition, the largest weighing six pounds. Two of the teeth he presented to the State Geological Society, the other specimens went to Mr. Trask, the state geologist, who was to ship them from Carvalho. Apparently, Solomon had been in touch with Fremont at this time, for he said:

> I have never seen a report of my present to the society, and when I met Mr. Trask at San Francisco, they had not yet been shipped. . . . I regret very much that I allowed them to leave my own possession, as *I promised one of the teeth to Col. Fremont*, and, in consequence, have not been able to fulfill it. (Italics mine.)[19]

In the final pages of his journal, Carvalho noted that while in Los Angeles, he painted portraits of Don Pio Pico, ex-governor, and "several other gentlemen."[20] He also mentioned the brothers Samuel and Joseph Labatt, who evidently were merchants in Los Angeles, and probably related to the Charleston Labatts, whom Solomon knew, or knew of.

With that, Carvalho's journal ends, and to find further information about his activities in California, we must turn to newspaper sources, and to the research of Justin G. Turner, Los Angeles, who has done studies of the pioneer Jews of Los Angeles.

> Carvalho was the first prominent Jew to appear in Los Angeles. His experiences gained from his familiarity with Jewish institutions in Charleston, Baltimore and Philadelphia, were of great assitance in organizing the Hebrew Benevolent Society. In recognition of Carvalho's services, the Society passed the following Resolution:
> 'Resolved, that the thanks of the meeting be tendered to S. N. Carvalho for his valuable services in organizing the Society and that he be elected an Honorary member; also that these proceedings be published in the Occident.'[21]

An article about Carvalho, as artist, was carried in the *Los Angeles Star* in 1854:

We have been much gratified by a visit to the studio of Mr. Carvalho. We noticed his arrival here a fortnight ago, since which he has been induced to remain and paint several portraits. The picture of Don Pio Pico, Ex Governor, is the most perfect specimen of the art of portrait painting we ever saw. We also saw unfinished portraits of the celebrated Utah Chiefs Walker, Grospapine, Squash Head, Petenet; also portraits of Chiefs of the Pau van, San Pete, Pah Utahs, Piede and Digger Indians, drawn from life by Mr. Carvalho during his journey from Salt Lake—also a large number of views illustrating the whole country. *We understand that Mr. Carvalho intends to publish them with his journal of the route as soon as he returns home.* (Italics mine.) Those who want a superior portrait, would do well to take advantage of this opportunity. Mr. Carvalho has also ordered the apparatus for taking Daguerreotype Likenesses, which will enable him to satisfy the tastes of the most fastidious.[22]

Thus, at this date, Solomon evidently did not have daguerreotype equipment, which still leaves the puzzle of what equipment was used to take a "view" in Salt Lake City, "views" between Utah and California, if we are to translate the "view" as meaning daguerreotype?

A further curiosity stems from the fact that in Fremont's *Memoirs,* steel engravings of Indians from the above mentioned tribes are abundant; but nowhere in Carvalho's book are there such portraits.

In August of 1854, the *Star* carried another article of interest:

We call the attention of our readers to a Raffle of Three Original Beautiful Paintings, by Carvalho, the celebrated artist. There are only eighty chances, and three prizes, therefore one ticket may draw either. The tickets are for sale at the Bella Union Hotel, and the pictures may be seen at the Daguerrean Gallery over the New Tiende de China.[23]

The Tiende de China was the name of the Labatt brothers' retail store, and Carvalho had set up his studio on the second floor, which had been vacant. This time, he opened shop with a partner, in August of 1854:

Sky Light Daguerreotypes

Messrs. Carvalho and Johnson have recently fitted up the upper rooms of the Tiende de China for this purpose. Daguerreotypes taken in all styles. Particular attention is paid that none but first rate pictures emanate from this establishment. Pictures taken after death, if required. Portraits in oil and Daguerreotypes copied in the first style of the art. A reception room has been arranged expressly for the ladies. The public are invited to call and examine specimens.

Carvalho and Johnson[24]

The partnership of Carvalho and A. M. Johnson broke up some time in September of 1854. Johnson left for San Francisco and Carvalho remained in Los Angeles, eventually taking passage from there back to the East.

Of the paintings and daguerreotypes produced by Carvalho and mentioned in this chapter, the whereabouts of all of them are unknown with the exception of the Warka portrait, the sketch of the dead child, and the portrait of Brigham Young.

In his most recent book on the history of the daguerreotype, Beaumont Newhall makes a statement which sums up the feeling:

Curiously, and to the despair of the historian, not one daguerreotype is known to exist from those that were taken under even more difficult conditions by the handful of daguerreotypists who accompanied official government expeditions and exploring parties to little-known parts of the country.[25]

Indeed, Carvalho's worn plate in the Library of Congress may be the only survivor.

CHAPTER VIII

THE GRAND CANYON AND OTHER SCENES

By mid-nineteenth century, the preeminence of landscape painting was a recognized fact in Europe and in the United States. Landscape in America became identified with the presence of God, which was in turn identified with the Good. Thus, the observer would be, indeed, should be, purified by contact with God in Nature.

'We distinguish the announcements of the soul, its manifestations of its own nature, by the term Revelations,' wrote Emerson. 'These are always attended by the emotion of the sublime. For this communication is an influx of the Divine mind into our mind.' Sublimity is also an important word in nineteenth century terminology. By the time Emerson was writing, it had been largely transferred from an esthetic to a Christianized mark of the Deity resident in nature. Indeed in the gradual fusion of esthetic and religious terms we are given an index of the appropriation of the landscape for religious and ultimately, as we shall see, for nationalistic purposes. Science, so prominent in the nineteenth century consciousness, could hardly be left out either. Landscape, according to James Jackson Jarvis, was 'the creation of one God—his sensuous image and revelation, through the investigation of which by science or its representation by art men's hearts are lifted toward him.' Science and art are both cited here as routes to God; and this continued attempt to Christianize science was made urgent by the growing stress it was placing on the traditional interpretations of God's

nature. It was hoped that art's interpretive capacities would rec-
oncile the contradictions science was forcing on the nineteenth
century mind.[1]

Carvalho's emotional and pantheistic response to the sublime in
nature, as previously noted, makes him a brother of the Transcenden-
tal movement of his day.

> Emerson bade the landscape painter omit the details, the prose
> of nature, and give us only the spirit and the splendor, the sug-
> gestion of a fairer creation than we know. Here as in Europe
> the artist claimed imaginative freedom; but America modified
> that freedom with the old moral and pious obligations of her
> own *Puritan* past. (Italics mine.)[2]

In his western landscapes, Carvalho gave "only the spirit and
the splendor" which Emerson required, but his was a suggestion
with a difference. Solomon had neither the Puritan heritage of some
of his fellow landscape painters, nor the European training of such
artists as Thomas Cole, Asher B. Durand, Thomas Doughty, John
Casiliear, Kensett, Rossiter, and Bierstadt.

Though Carvalho surely had studied the works of earlier Euro-
pean landscape painters, and had seen those of the Americans Cole,
Durand and Doughty, his own inner personal communion with na-
ture and his God enabled him to express the loneliness, the feeling
of distance and uncomposed space, and the golden light of the
American West. His landscapes have a visual quality which speaks
of the future of America in terms of the benign emptiness of the
waiting land.

Carvalho painted "The Grand Canyon of the Colorado" shortly
after his return to the East, preceding Bierstadt's work by four,
perhaps five years. He painted two pictures of the same subject, the
second copy being much larger in size. In November of 1969, the
following information was received about the first "Grand Canyon"
painting:

> . . . it was given to us when we lived in the country—and we
> did have it hung. It was completely destroyed by vandals-
> —slashed with a knife or some sharp instrument and destroyed
> beyond any hope of salvation . . . it was just shreds, and that

was about eighteen years ago. The picture was fairly large, but extremely somber and did not bear any relationship to the Grand Canyon as we know it. It was in the very dark colors—not a spot of sunshine—rock color—anything except browns, ochres, misty diffused light—and neither a happy nor an overwhelming landscape . . .[3]

From the same source came Carvalho's self-portrait and another work yet to be discussed. From seeing the condition of these two paintings upon arrival, with their heavy coats of yellowed, dulling varnish and some overpainting, it is possible that the "Grand Canyon" was dark and without light due to the same circumstances, underneath which, it may have been a brighter Grand Canyon, after all. Unfortunately, we shall never know.

Family tradition assigned the location of the second "Grand Canyon" painting to the Smithsonian Institution or one of the government buildings in Washington, D.C. However, query letters were answered in the negative: according to Smithsonian curators the painting had never been in their collection and they had no knowledge of its whereabouts.

The only reference to the second "Grand Canyon" is in a letter of 1865, from S. N. Carvalho to his relative, Dr. J. Solis-Cohen, sometime in May of that year:

My dear Doctor,
 I sent you (by?) Express, the oil portrait of your dear Mother, also some (.) and your (father?).
 I hope you will like the picture, I think I have produced a good (likeness in?) a sitting. I have placed (it in) an old frame which will answer until you obtain a new one. I have just (completed) a very large painting (that being) the Grand Canyon of the Colorado River (6000 feet from tableland to river) where the party of Major (P . . .) is supposed to have been lost.
 I consider it my best picture. Dimensions (are) 50 × 60 inches. I have not decided what to do with it . . .[4]

The second "Grand Canyon" has never been found. It may be in the basement of some government building in Washington, dusty and forgotten, or lost from memory and unrecorded in a back storage bin of some museum.

I

By the middle of the nineteenth century, studies in physics, optics and properties of color were of considerable importance, from which the phenomenon of Impressionism would soon evolve. That Carvalho was deeply aware of these studies is obvious from his own words:

> The contrast of the colors of prairie flowers, as they are thrown carelessly on nature's carpet, is truly wonderful; the greatest harmony prevails—you see the yellow and purple, green and red, orange and blue, arranged always in juxtaposition, producing the primitive colors of a ray of light, through which medium only we are able to distinguish them.
> The ancient masters always produced harmony in their pictures because they closely studied nature; at the same time, they could not have known the science of colors, as there is no work extant on the theory of colors, when Raphael or Titian lived. Modern researches have discovered the reasons why nature is thus harmoniously beautiful in all her varied dresses. The works of modern artists, therefore, should be always correctly delineated, as they not only have the same nature to study from as the ancients had, but science has assisted them with theoretical problems, founded on scientific investigations, in the different branches of National Philosophy.[5]

Sorting materials on loan to the author, an interesting letter was found, written by a relative of Carvalho:

> Uncle C. was an American painter, self-taught. He went West on the Fremont expedition and brought back wonderful pictures in wonderful colors—which were criticised as being made up—but later with the years and the opening of the west—and the going out there of different American artists and their bringing back paintings of color—Cavalho [sic] was vindicated.[6]

There are seven known Carvalho landscapes, in addition to the lost "Grand Canyon" painting. There is a black and white photograph of one. The exhibition listings of the Maryland Historical Society and the National Academy of Design, are sources for three others.

The first landscape to be considered is called simply "Western

Western(?) Landscape, c. 1842. o/c, 18 x 13¼. The Misses Solis-Cohen, Philadelphia.

Entrance To The Cochotope Pass, c. 1854-55. o/c, 15 x 18. Mrs. Marvin Jacoby, Ft. Washington, Pa.

Landscape." However, the obvious artistic and technical inadequacies of this work as compared with two other works dated between 1854 and 1856, forces the author to question whether this is a western scene at all. More likely, it is a much earlier work dating around 1843, painted while Carvalho was in Barbados and traveling through the islands near Martinique.

There is obtrusive foreground massing of forms. Contrasting planes carry the eye back in strips to small mountains which seem to be disappearing in a haze. This work does not have the crispness of detail or brightness of color which appear in later Carvalho western landscapes. The unexpected appearance of a tiny figure standing near a small building beside a road which leads the eye into the picture, is a feature unique to this work.

Written on the frame of the second landscape to be considered is, "Entrance to the Cochotope Pass, Rocky Mountains, From Nature by S. N. Carvalho." Although this wording indicates that Carvalho painted the work directly from nature, it is not possible, unless he returned to that location after passing through it the first time with Colonel Fremont. As Carvalho himself tells us, he sent his oils back to St. Louis in the care of the good Doctor Ober, and he had no paints and brushes again until he was given a supply by the kind Lt. Beckwith in Salt Lake City. In the days that Carvalho followed Governor Young on his tour of Utah, it is conceivable that he did go through the Cochotope Pass a second time. It is also conceivable that he took daguerreotype "views" of the Pass, and painted the landscape from the photograph.

In this work of 1854-55, Carvalho shows a considerably developed skill in landscape painting. His color is lightened, and the land gains a sense of mood and grandeur.

The color is the golden light of the western canyons, not the greying gradations of the European landscapes. Carvalho is interested in the effects of light and shadow, and communicates distance through modifications of light, and variation and consistency of air.

In the foreground, the fir trees and rocks are treated with as much care as the details in the middle and distant grounds. Solomon notes the structure of rocks, building up his masses and balancing stresses, establishing an equilibrium throughout.

It is a waiting world, one that invites the viewer in and in this respect it is interesting to conjecture whether or not Carvalho had studied the works of the Chinese landscape painters.

In the *Memoirs* of John Charles Fremont is a photograph of an oil painting which bears such technical similarities to the landscape mentioned, that it must be attributed to Carvalho's hand. Although the title has been given as "Standing Rock," (probably by Jessie Fremont), it could also be "Sand Hill Pass, or the pass at Little Creek Canyon." (It is known that titles of plates used in Fremont's text were changed to suit place of insertion into the text.) It may well be the missing "Entrance to the Valley of St. Clare, Between Utah and California."[7]

In 1970, thanks to a collector who haunts the Kennedy Galleries in New York City, another Carvalho landscape was discovered. Kennedy Galleries kindly supplied a black and white photograph of the painting, which is a panoramic view. At the same time, an answer to a query letter to the Oakland Museum, California, disclosed that they had recently purchased the same painting, and it was a part of their Kahn Collection. A color slide was ordered. It is a magnificent view of the Rio Grande River, c. 1854-55, measuring approximately $3' \times 3\frac{1}{2}'$.

As in his painting of the Cochotope Pass, the color is the subdued golden pinks of the western mountains, and the sky hangs over the thrusting crags and precipices of the canyons, reflecting their color.

The panoramic view and bone-bleached tree are typical pictorial devices of nineteenth century landscapes. Receding space often was emphasized by a prominent foreground object, especially a boulder or a dead tree. One can almost breathe the transparent air; the river is a reflecting basin of glass. Stumps and broken limbs in the foreground receive the same attention as the individually painted leaves sprouting from the sloping embankment.

Carvalho has balanced masses, detail, and play of light and dark to achieve the balance and integration of the scene which seems uncontrolled by human intelligence. It is a joyous, harmonious waiting world. It may be the Rio Virgin mentioned in Carvalho's journal: "The most beautiful and romantic pass I ever saw."

Landscape, photograph of oil painting from Fremont, *Memoirs*.

Another landscape entitled "Sunset on the Los Angeles River," was exhibited at the Maryland Historical Society. Its whereabouts are unknown.[8]

In 1862, Carvalho exhibited yet another western scene in the National Academy of Design, entitled "Moonlight on the Rio Virgin." Its whereabouts also are unknown.

A landscape which was done in 1867, late in Carvalho's painting career, shows that he took his earlier comments on the scientific studies of color seriously. "Two Fishermen at the Edge of a Stream," signed and dated "S. N. Carvalho, 1867," evokes a feathery, loose softness reminiscent of Carot and strong influences of Impressionist technique. Whether or not Solomon had reached this point through his own experimentation, or whether he had seen early efforts of the French painters who would arouse the world in the 1870's, is difficult to answer. However, his notations on the subject of color were made in 1854. Since it appears that Solomon was rather a loner in his art, it is quite possible that he had developed a style of impressionism on his own.

The photograph of the painting is in the picture collection of the American Jewish Archives. The location of the scene is unknown, as is the whereabouts of the painting. We will come back to this work in a later chapter.

CHAPTER IX

FREMONT FOR PRESIDENT

Exactly when Solomon took passage back to the East is not known. However, he eventually joined his family who awaited his arrival in Baltimore.

According to the Baltimore directories, S. N. Carvalho was listed from 1850 as "daguerian" until late in the 1850's, when his listing changes to "portrait painter," or "artist."[1]

In 1856, he is listed in the Maryland Historical Society's list of "Members, Artists' Association of Maryland," as living at No. 35 S. High Street, and holding office of Corresponding Secretary of the Association.[2]

The earliest knowledge that we have from Solomon about his activities after reaching Baltimore is from a letter he wrote to H. H. Snelling, who had requested information about Carvalho's photographic experiences on the fifth expedition. The date of letter indicates that it was written soon after Solomon's return home:

> To H. H. Snelling Esq.
> Dear Sir:—I am very sorry I am unable to respond to your request for the particulars of my tour with Colonel J. C. Fremont, in his late Exploring expedition across the mountains, *not having taken any private notes*. (Italics mine.) But this much I am at liberty to say that I succeeded beyond my utmost expectations in producing good results and effects by the Daguerreotype process, on the summits of the highest peaks of the

Rocky Mountains, with the thermometer at times from 20 to 30 below zero, often standing to my waist in snow, buffing, coating, and merculializing plates in the open air.—In nearly every instance Barometrical, and Thermometrical observations were obtained at the same moment, with the picture. This time given to each examample [*sic*] was also noticed and marked on the plate. I requested permission from Col. Fremont who readily afforded the means to made these observations, and they may account for the very great difference of time, which it took to make pictures, under apparently the same combination of circumstances. All these observations have been carefully noted and will be published for the benefit of the scientific world, in Col. Fremont's forthcoming Journal, which these pictures will serve in some measure to illustrate.

I had considerable trouble with the iodine, which under ordinary circumstances requires 80° Fht. before it will part with its fumes. I had to use artificial heat in every instance, I found it necessary to make up in quantity for the loss of temperature. I generally employed Anthony's Anhydrous sensitive, and my boxes during a continual use of five months only required replenishing four times, notwithstanding they were opened every time I made a picture, to arrange it smoothly at the bottom. The coating-boxes were made expressly for my use on the Expedition by E. Anthony Esq., and I cheerfully recommend the use of similar ones for like purposes. Notwithstanding the earnest prognostications of yourself and my professional friends, both in New York and Philadelphia, that under the difficulties I was likely to encounter on the snow capped mountains,—I would fail, I am happy to state that I found no such word in my vocabulary although I had not much youthful, or physical strength to bring into the scale.

I am Dear Sir, yours truly,
S. N. Carvalho[3]

This is a curious letter indeed, for Carvalho had kept a record of the fifth expedition through his letters and notes to himself. In the Preface to his book, he mentions that the portion which deals with the time that he left Salt Lake City for California is a fairly detailed, daily account taken verbatim from his records. He had stated in his own words that he intended to publish his account. What was the reason for Carvalho's careful evasion?

In his biting letter to H. H. Snelling in 1852, Carvalho defended his good name and his process for varnishing daguerre-

otypes, and noted the name of Mr. Anthony, whose process was in competition with his own. By the time Solomon left New York in 1853 to join Fremont in St. Louis, he and Mr. Anthony were on very good terms. Carvalho ordered Anthony's equipment "expressly for his use" on the fifth expedition.

Solomon's cheerful praise for Mr. Anthony's products, and his equally cheerful claim that he had not failed in his tasks, while withholding information from Snelling, may have been designed to needle Mr. Snelling a little bit.

However, that was not the entire picture. Carvalho did not want particulars published before Fremont's book was in print. According to family recollections, Solomon had made an agreement with Fremont that the first published account of the expedition would be written by Fremont, and that the daguerreotypes would appear for the first time in that book. Carvalho undoubtedly pinned great hopes for his future fame on the publication of his work in a volume by so eminent a celebrity as the great Pathfinder.

That the precious daguerreotypes survived the journey, we know from Jessie Fremont's words:

> And though new conditions and difficulties made many embarrassments, yet almost all the plates were beautifully clear, and realized the wish of Humboldt for 'truth in Nature.' These plates were afterward made into photographs by Brady in New York. Their long journeying by mule through storms and snows across the Sierras, then the searching tropical damp of the sea voyage back across the Isthmus left them unharmed and surprisingly clear, and so far as is known, give the first connected series of views by daguerre of an unknown country, in pictures as truthful as they are beautiful.[4]

We already have read Jessie Fremont's account that she turned a northern-oriented drawing room in the Fremont home into a studio, and that Hamilton and Key were working there, preparing the materials for publication. Mr. George Childs, who was publishing the account of Kane's arctic explorations, was to bring out Fremont's book sometime in 1856.

Why was there no Fremont book? And when Carvalho's account was published, why was none of his own work included, in

particular, the Indian portraits, sketches and views done to accompany the daily journal that he kept after leaving Salt Lake City? He was on his own then, and surely these art works would not necessarily be bound from publication by a prior agreement with Fremont.

The Fremonts had been living in the roomy Benton House in Washington. in the spring of 1855, the elderly Mrs. Benton died, and Jessie was pregnant with a fourth child. To add to Jessie's distress, the Benton house burned suddenly to the ground, destroying her father's entire library and literary efforts. Fremont, busy traveling between New York and Washington, with trips in between to California to check on his Mariposa property, sent Jessie to Nantucket for the summer.

I

A presidential election was underway in the midst of troubled times for America. *Uncle Tom's Cabin* had been read by millions and the demands of the abolitionists thundered through the halls of Congress. The opposition hammered out its objections in those same chambers, and the shock waves were felt around the land. One consequence of the growing turbulence was the founding of the Republican Party—the Peoples' Party.

Fremont had always been a popular, rather romantic figure to the people, and suddenly he found himself their choice as the presidential candidate for the Peoples' Party. Besides being the right age, he was gallant and daring; the waves of enthusiasm rose around the country.

Abraham Lincoln, then a young new face across the land, was campaigning for Fremont in Iowa and in September of 1856 he wrote:

> It would be very pleasant to strike hands with the Fremonters of Iowa who have led the van so splendidly, in the grand charge which we hope and believe will end in a most glorious victory. All thanks, all honor to Iowa! But Iowa is out of danger, and it is no time for us, when the battle still rages, to pay holyday visits to Iowa . . .[5]

At the Republican Convention in June 1856, Fremont won the

nomination in an atmosphere tingling with emotion and excitement. It was only the beginning.

John Bigelow, New York reporter for the *Evening Post* and much a part of the movement to see Fremont nominated for the presidency, wrote a book which was designed to help swell the popular sentiment for Fremont during the hard campaign year of 1856.

> Among the Colonel's companions of this trip was S. N. Carvalho, Esq., of Baltimore, who went as artist of the expedition.
> We have been permitted to inspect his journal and memoranda of the most striking incidents of this most perilous and eventful journey.[6]

In his book on Fremont, the great explorer, Bigelow quoted many extracts from Carvalho's account.

It was probably through Carvalho's contact with Bigelow, that the artist's collection of letters and notes were put together and published in time for the great campaign. Unfortunately, in dealing with the same firm that published Bigelow's book, he ill-advisedly accepted a total payment for his book rather than a royalty arrangement—the book was reprinted four times after the original issue. Apparently Carvalho had nothing to say about either the daguerreotypes or his sketches. By this time the daguerreotypes had been made into photographs by Brady, with Fremont himself working with Brady in his studio for a time to accomplish this end. They were eventually put to further use as engravings by masters of the art for book plates.

Jessie Fremont acknowledged that the materials for Fremont's book were packed carefully and under her constant guard, since

> . . . The year of '56 gave no leisure however for writing; what could be done without too much demand on Mr. Fremont was carried forward, but he alone could write and that was no time to be looking back. Private affairs had been so much interfered with and necessarily deranged by the Presidential campaign, that the work proposed to be written and published was unavoidably delayed, and the contract finally cancelled, Mr. Fremont reimbursing Mr. Childs for all the expenditures made in preparation.[7]

By 1856, Solomon Carvalho added his name to the list of notaries campaigning for Fremont. According to Morris Schappes, Carvalho was

> . . . especially known among the Jewish Republicans campaigning for Fremont.[8]

In a rather acid letter about Solomon's activities, written on September 11, 1856, by his nephew, we are given a report of one Fremont rally:

> . . . S. N. Carvalho, Esq., is trying to be 'some sumptious' here. For the first time in his life, he last night addressed a crowd on 3rd Avenue in favor of Fremont. I was not there as I did not know that there would be such *eminent* and *popular* speakers there. Enclosed is the *lengthy* notice of the immense assemblage from today's 'Tribune.' When he came home last night after the meeting he said that upon his introduction to the crowd by the *chairman*, they gave him three cheers for 'Carvalho,' the Fremont Expedition Artist, 'Hip! Hip! Hurray!' I expect the crowd was composed principally of apple women, newsboys, market loafers (the meeting was in front of the 3rd Avenue market) and other similarly select Fremonters. His book is now in print by Derby & Jackson, Publishers, and will be out in about two or three weeks. I have the manuscript and read portions of it, which portions are all very well written, as he can write better than he can speak . . . and is 400 pages long, and is to be *illustrated*, the illustrations being by himself. He says he received $300 for it. . . . He is stopping at our house, and 'sports around' like a good fellow, as he has sold a picture for $50, and has received the money; and I expect will spend every cent of it before he returns to Baltimore. He smokes about a dozen *four cent* cigars daily and takes his *dinners down town* at some fashionable restaurant, and talks and acts like a millionarie. He intends to *dedicate* his book to 'Mrs. Jessie Fremont,' having received her majesty's most gracious permission. The publishers offered him either $300—or *5 cents* per volume on all that were sold; which was the price they paid Bigelow for his 'Life Of Fremont'; of which over 30,000 copies have already been sold, thus realizing to . . . the author, more than $1500 and Uncle C. says that the only original material in Bigelow's whole book was the extract that Uncle C. gave him from his 'private' journal of the Expedition; the rest being all copies from different works;—while the

whole of Uncle C's book is original. . . . It would astonish you to hear him talk *now* in favor of Fremont, after having heard his conversation on his return from California. Alas! Money! Money!—He says if Fremont is elected he will have the Office of Collector of the Port of Baltimore, or anything else he wants, and is wanting me to speak in favor of Fremont also. But it's no go! In this quarter! I go for Fillmore . . .[9]

Due to the trying circumstances of those campaign months for the Fremonts, it seems odd that Carvalho's book came out without even one of his daguerreotypes, Indian portraits or sketches of western landscapes as plates. Though the two drawings that are inserted into the text bear the names of Dallas and Orr, engraver and printer, is it possible that they came from Solomon's pen, originally?

It is peculiar, in this writer's opinion, that Carvalho dedicated his book to Jessie rather than to John. Besides admiring Jessie's strength and courage perhaps he realized her influence. Maybe Carvalho sensed that Fremont's book was becoming less and less a certainty, and that Jessie might intervene to permit release of the plates to him for publication. In any case, Carvalho was a man of his word: he had made a pact with Fremont that the pictures would first appear in Fremont's own account. That he considered Fremont a gentleman of the highest order is evident from Solomon's own words. It was a costly decision, however, not only for Solomon, but for American history.

We probably will never know what prompted Ritterband's sarcastic remark concerning Solomon's purported comments about Fremont upon his immediate return from the West. There may have been a quarrel or some misunderstanding over the use of Carvalho's art. Perhaps it was only a petulant response by Ritterband to his Uncle C., for whom obviously he had little affection.

As the Republican candidate Fremont ran on a strong anti-slavery platform, which alienated him from many of his Southern friends, including those in Charleston, a city where Carvalho had always maintained strong ties. It is possible that in the year of 1856, when every possible accusation was hurled against Fremont by the opposition, Fremont became a lame duck where Carvalho was concerned. Solomon did not approve of slavery and his admiration for Lincoln was unbounded, but there may have been family ties and

MEMOIRS OF MY LIFE,

BY

JOHN CHARLES FRÉMONT.

INCLUDING IN THE NARRATIVE FIVE JOURNEYS OF WESTERN EXPLORATION,

DURING THE YEARS

1842, 1843–4, 1845–6–7, 1848–9, 1853–4.

———

TOGETHER WITH A SKETCH OF THE LIFE OF

SENATOR BENTON,

IN CONNECTION WITH WESTERN EXPANSION.

BY

JESSIE BENTON FRÉMONT.

———

A RETROSPECT OF FIFTY YEARS,

COVERING THE MOST EVENTFUL PERIODS OF MODERN AMERICAN HISTORY.

SUPERBLY ILLUSTRATED BY ORIGINAL PORTRAITS, DESCRIPTIVE PLATES,
AND, FROM THE MISSOURI RIVER TO THE PACIFIC, BY A SERIES
OF SKETCHES AND DAGUERREOTYPES MADE
DURING THE JOURNEYS.

———

THE ILLUSTRATIONS ARE MASTERPIECES OF

DARLEY, HAMILTON, SCHUSSELE, DALLAS, KERN, WALLIN AND OTHERS.

ENGRAVED UNDER THE SUPERVISION OF

J. M. BUTLER,

WITH MAPS AND COLORED PLATES.

———

VOL. I.

———

CHICAGO AND NEW YORK:
BELFORD, CLARKE & COMPANY.
1887.

Title Page from Fremont *Memoirs*.

FRÉMONT IN 1856

(Photograph by Brady, engraved by Buttré.)

John Charles Fremont, from an engraving by Buttré.

pressures which ruptured the friendship they had once held. In any case, when Fremont decided to have Jessie's portrait painted some years later, he chose the Italian society portraitist, Giuseppe Paganini.

When Fremont's *Memoirs* finally were published in 1887, a couple of years before his death, the title page, which lists the names of the various contributing artists, makes no mention of Carvalho, whose name appears only on one text page.

In the Huntington Library, California, there is a salesman's prospectus for a second volume of Fremont's memoirs, which was never published. With it was a complete set of plates for Volume 2, which was to include the fifth expedition. In examining the plates, Walt Wheelock, author of an article about Fremont and the fate of the daguerreotypes, found that perhaps two-thirds of the plates concerned the fifth expedition. Upon examining the first volume of Fremont's *Memoirs*, he discovered that half of them were also about the fifth expedition; the titles had been changed for use wherever they were inserted in the text.[10] If Wheelock's research is correct (and the author's own research indicates that it is), it means that about two-thirds of the plates in the published Fremont *Memoirs* were copies from photographs of the missing Carvalho daguerreotypes—which makes the omission of his name even more curious.

As to the fate of the daguerreotypes, it is believed that they perished in a fire which swept the Fremont home, destroying most of their valued possessions.

In an excerpt from the *Memoirs* of 1887, Jessie said:

> When we were leaving for Arizona in '78, the boxes containing the steel plates and wood blocks were placed in Morrell's 'Fire Proof' warehouse, which was destroyed by fire in October of '81. We lost much that was stored in that warehouse, choice books, pictures, and other treasured things, but these materials for the book we had placed for greater security in the safes below the pavement where the great fire passed over them, and left them completely unharmed.[11]

In referring to steel and wood blocks, Jessie undoubtedly meant those engravings and block prints which were made in the drawing

room studio of the Fremont home. The daguerreotypes have long
been lost. It is hoped that as private collections of American photo-
graphica become more available to museums and an aware public,
some of the negatives and/or photographs made by Brady from the
Carvalho daguerreotypes will come to light. The loss of this valu-
able material must have been a devastating blow to Carvalho, and
may well enter into the apparent cooling of the Fremont-Carvalho
relationship.

It is known that Carvalho painted a portrait of his intrepid
leader, which he donated to a Sanitary Fair auction in New York in
1865.[12]

In 1856, Brady took a photograph of John Fremont, which was
then engraved by Buttré, and has been used by Allan Nevins in his
work on Fremont.[13]

The Pennsylvania Academy of Fine Arts has a portrait of Fre-
mont, previously attributed to Sully, but no longer considered valid.
In comparing the oil portrait to the Brady photograph, the
similarities were found to be too striking to be mere coincidence.
Furthermore, the painting bears all the stylistic qualities of a Car-
valho portrait c. 1856-59, painted from a photograph, rather than
from life. In the hard contrasts of light and dark, there is resem-
blance to the Carvalho portraits of Paul Morphy and Judah Touro.
The strong lighting of the face, heavy emphasis upon the nose and
probing into the character of the man are consistent Carvalho
characteristics. The western landscape in the background, with its
horizontal banks of clouds, is almost a copy of a distant view in
Carvalho's portrait of his wife, Sarah, done in 1856.

A letter from the Pennsylvania Academy gave the following in-
formation:

> The color of Fremont's jacket is warmer, and the background
> less vivid. . . . The painting had been restored some time in
> the past, though poorly. There is some damage, a slight am-
> biguity and overpainting around the mouth area. Some restora-
> tion would be necessary before making the slide (color) . . .[14]

The condition of the canvas, together with the poor restoration
and overpainting of the mouth area would account for the almost

John Charles Fremont, c. 1856. o/c, 30 x 25. Pennsylvania Academy of the Fine Art.

disappearing chin area, and the inability to check, by naked eye, for the usual Carvalho handling of the corners of the mouth.

The painting of hair, white collar, and lapels of the dark coat are done in the same manner that Carvalho treated his own in his self portraits. I believe it is safe to attribute this painting to Carvalho, pending further study of the work in color.

II

The year 1856 was an eventful one. The first railroad locomotive crossed the first bridge constructed across the Mississippi River; the 2700-ton steamship *Pacific* sailed from Liverpool to New York with 240 persons on board, and was never heard from again; Longfellow's "Hiawatha" was enjoying great popularity; temperance societies and the hooped skirt were in vogue, and the idea of women's rights was beginning to stir; presidential fever was running high, and there was a mounting fear of war around the country; the *Merrimac* steamed out of the Boston Navy Yard; McKay's great clipper ships were plying a busy trade upon the high seas; theater, opera, concerts and literary circles were popular diversions.

Fremont lost the election, and Carvalho's dreams of political inheritance were vanquished.

In 1856 Carvalho was an active member of the Maryland Artists' Association. He returned to the life of a painter of portraits and a daguerreotypist, and involved himself in the affairs of the Baltimore Jewish community, becoming a founder and Secretary-Treasurer of the small Sephardic congregation of Beth Israel in 1857, with Samuel Etting as president. Although Carvalho's old friend, Isaac Leeser, kept an eye on the small congregation and did what he could to help, financial troubles plagued them until they disbanded in 1859.

For a concise account of Solomon's activities within the community at large, and specifically within the growing maturity of American Jewry, we turn to Dr. Korn's account:

> . . . Jews were establishing strong roots in their communities and were feeling a growing assurance both as Jews and as Americans. Rather than mutter in silence over affronts to their

faith in America and abroad, they were organizing for joint action of protest and remonstrance. Carvalho was one of the leading figures in this movement, as in synagogue affairs. In late November, 1857, Jewish spokesmen from Illinois, Kentucky, Ohio and elsewhere converged upon Baltimore to formulate a petition to the President of the United States in connection with the Swiss treaty. Since certain of the Swiss cantons refused by law to permit any Jews to dwell within their borders, the United States in effect was consenting to discrimination against American Jews should a treaty be signed with Switzerland which did not insist upon the right of American Jews to travel and do business in these cantons. Solomon Carvalho was a member of the Baltimore committee on arrangements and was chosen to preside at the banquet which the Baltimore community tendered to the visiting delegates. As toastmaster, it was his responsibility to deliver the address of welcome to the assemblage and to call for the conventional toasts to which distinguished guests responded. The Baltimore Jewish community obviously had great respect for this man to appoint him their spokesman in this national movement.[15]

Preserved in the archives of the Rosenbach Collection is the following letter and toast, signed by Carvalho:

Dear Sir: I have the pleasure to enclose the Third Regular Toast—which the Committee of Arrangements have selected for you to respond to this evening.
I am respectfully,
S. N. Carvalho
Balt. 1 Nov/57
Col. M. I. Cohen
Delegate. . . .
Balt.
The Israelists Citizens of the U.S. May they ever be true and loyal to that Government—based upon, and the exponent of the religion of our Fathers—We shall always be true to it, while we are true to ourselves.
to be responded to by
Col. M. I. Cohen[16]

In the following year, Solomon became Chairman of the Program Committee, and acted as secretary at certain meetings of the Baltimore Jewish community.

. . . Carvalho was by way of becoming a permanent fixture in Baltimore Jewish communal affairs. When the Mortara case aroused the resentment and indignation of Jews all over the globe against the legalized kidnapping of a Jewish boy from his parental home, Carvalho was appointed to the Baltimore committee, in December 1859, which was charged with the task of attempting to persuade the State Department and the President to make an official American protest to Rome. He was also elected to office of Curator of the Hebrew Young Men's Literary Association of Baltimore, one of the earliest such groups to be founded in the United States.

Carvalho participated eagerly in the cultural programs of this group. . . . The minutes of several debates, which he assigned to prepare as 'critic,' reveal a characteristically far-ranging interest in the life and problems of mankind. With other men of his age and of a like curiosity, Carvalho was quenching his thirst for knowledge and satisfying his need for literary expression.[17]

CHAPTER X

BALTIMORE

Although Solomon was engaged in communal and literary affairs, he had not given up painting portraits and taking daguerreotypes, as the following advertisement indicates:

Portrait Painting
S. N. Carvalho, Artist, offers his professional services to the public. Portraits painted from life, and from the smallest daguerreotypes. Likenesses in all cases warranted. Apply at his studio in person or by letter, at No. 92 Saratoga Street, Baltimore, Md.[1]

In the exhibition catalogs of the Artists' Association of Maryland from 1848 to 1907, Carvalho was represented by landscapes, (mentioned previously) and by portraits of George Murray Gill, president of the Baltimore Chess Club in 1859 (an organization with which Carvalho evidently was closely affiliated), the world famous chess champion, Paul Morphy, and, under the headings of "Genre" and "Literary Titles," paintings called "The Itinerant Book Vendor," and "Voltaire and M'll D'Noyer."[2] The portraits of Gill and Morphy are in the collection of the Maryland Historical Society. The whereabouts of the genre and literary works are unknown.

Solomon was in good company, exhibiting his works along side those of such artists as Gilbert Stuart, David, Sully, Rembrandt Peale, Reynolds, Richard Caton, Lawrence, Jarvis, Cole, Doughty, Kensett, Blythe, Mount, and many more.

139

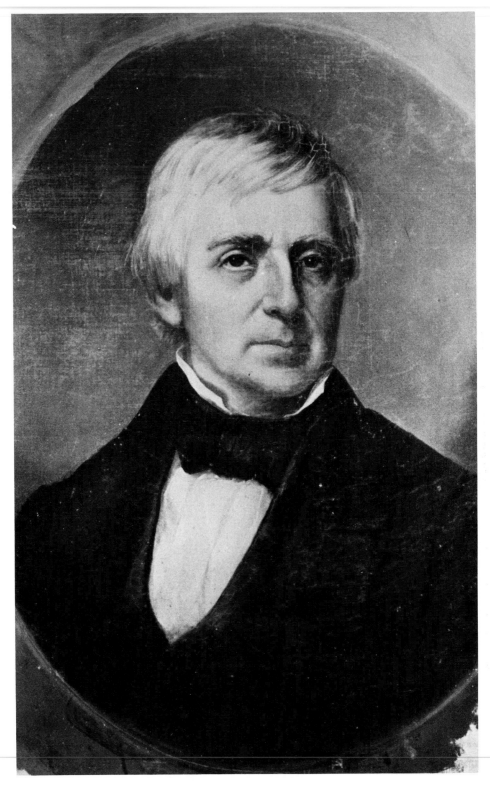

George Murray Gill, 1859. o/c, 30 x 25. Maryland Historical Society.

The oval portrait of George M. Gill, shown in dark coat with white stock against a plain ground, is a typical Carvalho study in his persistent desire to give life to the character of the sitter. In this work prominence is given to expression of the eyes, the distinctive nose, and definitive handling of the corners of the mouth. In these characteristics and in its intimate atmosphere, it is reminiscent of the Brigham Young portrait.

Gill's blue eyes, beneath his bushy brows, are steady—an intelligent, rather determined face, with ruddy complexion crowned by fine, white hair. The painting is signed by Carvalho and dated 1859.

According to a letter of 1953 from the Maryland Historical Society about Carvalho's work:

> . . . under date of July 8, 1856, he presented to the President and members of the Baltimore Chess Club a portrait of its President because of his respect for the President and for the courtesies which he had received from the club. There is no evidence that Morphy ever played at the Baltimore Chess Club, nor has the writer been able to find out the name of the President of that club in 1856.[3]

We know that Carvalho painted the portrait of Gill in 1859, and that Gill was president of the Chess Club that year. Were there, then, two Carvalho portraits, one of a man unknown from 1856, which portrait now remains "whereabouts, unknown?"

The portrait of Paul Charles Morphy, who had recently returned to the United States as world chess champion is a work with some interesting speculation attached.

Morphy was born in New Orleans in 1837 and died there in a bathtub, presumably of apoplexy, at the age of 47 years. He was a strange man, an eccentric genius, a recluse after the age of twenty-one, and probably the most brilliant chess player in history until the arrival of Bobby Fischer.

James Foster's letter to Dr. Korn gives the date of the Morphy portrait as c. 1865. However, further communique from Mr. Foster in March, 1953, quotes references from the account book of the Baltimore Chess Club, showing that Solomon was paid the sum of twenty-five dollars for a Morphy portrait in February 1860, and the

same sum for said portrait in March, with another entry in
November of six dollars:

> paid S. N. Carvalho on acct. Morphy portrait for D. H.
> Miller.[4]

Thus the portrait of Paul Morphy must have been done some-
time in 1860, when Morphy was about twenty-three years of age
and already retired from chess playing.

Carvalho's portrait of him is a strange work, having the
smooth, creaseless skin of the child in "Child with Rabbits," and
the harsh contrasts of light and dark which are also true of the por-
traits of Fremont and Isaac Mendes Seixas Nathan.

The Morphy portrait undoubtedly was done from a photograph.
The features, flesh, and details of collar and coat are entirely photo-
graphic in quality, and there is not the feeling of psychological or
emotional involvement typical of Carvalho's known portraits from
actual sittings. This is an indication that Carvalho never met the
man.

The colors are low key: brown hair and eyes, black coat and
stock, white collar and shirt, with a dull maroon waistcoat. The
background is dark shadings of grey.

Carvalho himself played a good game of chess, and his great
admiration for Morphy is evident in his participation in a party for
Morphy held in 1859.

In possession of the author is a program cover, made of some
sort of celluloid. Carvalho's name is shown clearly on the list of
committee members, and it is noted that the name, "Earnest Mor-
phy," is listed on the right side. Was he a brother of Paul? It is an
interesting document; while it does not say that Paul Morphy was in
attendance at this entertainment in his honor, it indicates that the
Baltimore Chess Club was actively engaged in contests between
players of many nations.

The psychological depth lacking in the Morphy portrait may be
additional proof of Mr. Foster's statement that there was no evi-
dence that Paul Morphy ever played at the Baltimore Chess Club.
Surely, Carvalho did not know the man, and the portrait probably

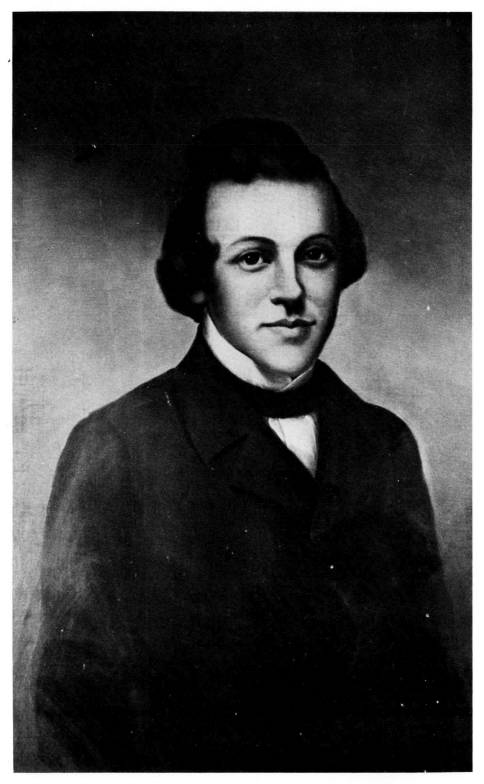

Paul Charles Morphy, c. 1859. o/c, 36 x 28 7/8. Maryland Historical Society.

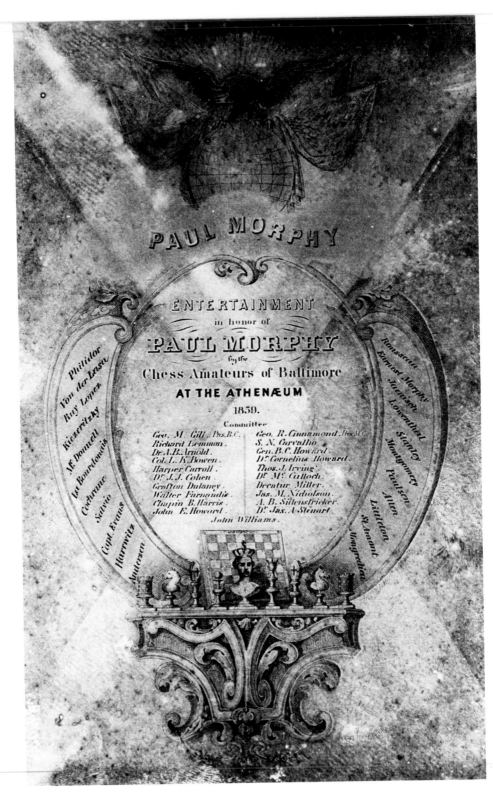

Program, 1859. Author.

was painted from a photograph taken upon Morphy's triumphant return from the chess battle grounds of Europe at age twenty-one.

Little is known about Carvalho's photographic pursuits while living in Baltimore. There is one known surviving daguerreotype from those Baltimore years, which Solomon made of two of his children, c. 1856. The two probably are David and Charity, respectively eight and three years of age. Although the surface of the daguerreotype is somewhat scratched and needs cleaning, the images are sharp and clear. David seems to be saying: "Hurry, Father," and Charity appears to be sliding impatiently out of her high chair.

I

Sometime in 1856, Solomon painted a portrtrait of his wife, Sarah, which is now in the collection of the writer. It is different from his usual handling of portraits and deserves detailed study. Like Samuel F. B. Morse, Carvalho painted male subjects with a rugged air. Evident in his portrait of Sarah is the romantic idealism of the mid-nineteenth century woman.

Although Solomon used the warmer colors of Sully in this work, the techniques are those of followers of Gilbert Stuart and also of William Page: he plays a multitude of thick against thin layers, transparent against opaque, warm against cool. He builds his shapes with color, impasto, glazes, to produce the luminous flesh.

The drapery behind Sarah was a device often used in the eighteenth century, and also was used sometimes by Stuart, and frequently by Sully. The warm red drapery is applied in swirls of thinly applied pigment, and becomes unrepresentational if studied closely, as does the arm of the chair.

The catalog of possessions in the painting is a feature true of paintings of both the eighteenth and nineteenth centuries; perhaps it is an indication of harmonious family life. In this case, it also helps to date the portrait.

When the painting was uncrated (at the same time as the Self Portrait mentioned in Chapter III), the heavy coats of varnish had turned Sarah's skin yellow. Her dress and eyes were green. The window, behind to her right, had been completely covered by heavy overpainting. The pages of the book that she is dreaming over were

solid brown as was the bowl of the vase holding the flowers due to the aged, heavy coats of varnish. Her sweetly curving mouth had almost disappeared.

In a back room of the Lowe Art Museum, under direction of the Registrar, Carol Hotchkiss, the author began the delicate task of cleaning the entire surface of the painting, and, following that, removal of the darkened varnish.

The change was drastic. Working on one small area, marked off in squares with chalk, Sarah's skin was found to be a pearly pink in color. Her green eyes turned to the brightest blue, matching the original color of her gown. Her lips became visible, ripe and red as the rose in the vase. Upon removal of the varnish from the pages of her book and from the bowl of the vase, two miniature western landscapes appeared.

In removing the varnish from the left side of the painting, above the arm of the chair, it was discovered that one whole strip of original work had been blotted out by heavy, dull red overpainting. When this was further removed, there appeared a window, with a view of distant mountains, and the pinks and purples of a western sunset bending towards the viewer and greying out into dusk.

Although the portrait bears no date, we are able to "read" what we need to know. Sarah, a beautiful woman, is perusing, dreaming, over the pages of her husband's adventure in the far West, and he has reproduced sketches in miniature of the scenery. The landscape in the book may be a view of Pike's Peak. These facts, together with an approximation of her age, yield the date, c. 1856.

If one examines the placement and treatment of the scenery through the window, one thinks of Sully. If we re-examine the portrait of John Charles Fremont, we see that the painter has handled the background space in much the same style—one reason, perhaps, for the former attribution of the Fremont portrait to Sully. It also recalls Sully's portrait of Susan Chisholm, with the graceful head and blooming complexion, dark eyes and hair.

After cleaning and removal of varnish and overpainting, the portrait was turned over to experts for relining and final restoration.

Pictorially, the portrait of Sarah is a rich, satisfying work. Technically, it shows a high degree of knowledge and skills, and it

Rio Grande River, c. 1854-55. o/c, 36 x 42. Kahn Collection, Oakland Museum, Oakland.

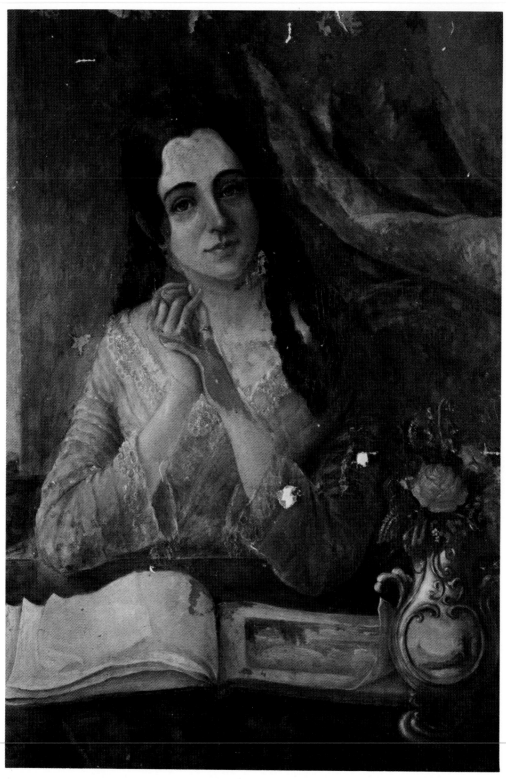

Sarah Solis Carvalho, c. 1856. o/c, 38½ x 30. Author.

may be that the "Self Portrait" also should be dated to this period of Carvalho's career. The two are about the same size, and were framed as a pair, though Solomon's portrait seems to portray him at a younger age than he would have been in 1856.

Outside of four, possibly five, known works, this painting is the only other Carvalho painting which utilizes the romantic, decorative elements of drapery, possessions, and scenery or allegorical connotations.

William Page used drapery in his backgrounds, a practice favored by Venetian painters. Page had access to essays by Hazlitt and Benjamin Robert Haydon in the *Encyclopedia Britannica* on Titian, and words against the academic methods, as well as Merimee's treatise which was translated into English in 1839. He also had learned the methods of Stuart through his teacher, Samuel F. B. Morse. Although there is nothing to indicate that Page and Carvalho, who were contemporaries, knew one another, certainly they had access to the same information and possibly had lessons with the same teacher. Both were typically mid-nineteenth century Americans.

> To be American was to be antitraditional, to depend not on a knowledge of traditional standards but on personal perception. A concept of the free individual was at the center of all thought. Experimental science was the ideal model for this American modernity, since it tested by function without preconceptions and its results drew none of their validity from antiquity of lineage.[5]

In addition to Solomon's participation in the Baltimore Chess Club, his avid interest in history caused him to accept an invitation to join the Maryland Historical Society on November 7, 1859:

> Baltimore, Sir: I beg to acknowledge receipt of your communication informing me that I am elected an active member of the Maryland Historical Society on the 4th inst.
> Your obt. Svt.
> S. N. Carvalho
> Pres. E. A. Dalrymple
> Cor. Sec.
> Maryland His. Society[6]

There is no further reference as to his activities as a member of the Society.

II

While Carvalho was pursuing his art and busying himself in community affairs, the restless, versatile man also was delving into the realm of science.

> One of our friends, Mr. S. N. Carvalho of Baltimore, has succeeded in making an improvement in the steam engine, which promises to effect first, a saving of 25 per cent in the consumption of fuel, and then to economize the time needed for a given amount of work. . . . Mr. Carvalho, by what he terms the oxy-hydrogen retort, [*sic*] has overcome one at least of the causes of waste of heat, and supplies dry steam at a higher heat than ordinary to the cylinder, whereby a saving of fuel and increase of power are produced . . . it is our duty, as chronicler of passing events relating to Israelites, to record an invention by one of us, which has, in the brief space of time elapsed since it was patented (January 3d, 1860), obtained the approbation of practical men of science, who have pronounced it the very thing wanted at the present time . . . it will no doubt be improved on by himself, cannot fail to rendering steam navigation more free from danger, and increase the capacity for carrying freight for sea craft impelled by steam, in the room saved by the less quantity of coal to be stowed away . . . We believe that the apparatus can be shut off from the cylinder, to supply it with ordinary steam if desired or needed, so that in no event can it prove injurious to the engine. We append the certificates of the proper officers of the Navy Yard at Washington, D.C., from which it will be seen that the invention has been approved of by those whose testimony is of the highest value.[7]

There follows the official report to Commander F. Buchanan, Commandant of the Navy Yard, from his Engineer and Master of Machinery, M. E. Bright, who says that Carvalho's invention:

> . . . shows the savings of twelve per cent of fuel over the ordinary mode of steaming, and the engine averaging four revolutions more per minute . . . and if the apparatus were applied to the Rolling Mill boilers, I am inclined to think the savings would be at least from twenty to twenty-five per cent in fuel,

and give an increased amount of steam . . . very practical for stationary boilers, and is not liable to become deranged.[8]

There is a second endorsement, addressed to Solomon Carvalho, from Samuel Cross, Engineer Ordinance Department, praising the invention and its arrangement.

At the time of patent, Carvalho's address was No. 61 South Gay Street, Baltimore. He published a pamphlet about his invention; the printer was Jos. Robinson. A copy of the document is in the collection of the Maryland Historical Society.

Inventions in steam would take more and more of Solomon's time in future years, and, as we shall discover, it would be to his benefit.

In November of 1857, there was an interesting addition to the family history of the Carvalho-Solis clan: Solomon's friend, Rabbi Isaac Leeser, married Isabella Polock to Morris Rosenbach. These two were the parents of the bibliophile, A. S. W. Rosenbach. One of Isabella's nieces married Dr. Solomon Solis-Cohen, a Carvalho relative, and as a child, "Abie" Rosenbach spent summers with the doctor and his wife. Rosenbach may have known his distant relative by marriage, Solomon Nunes Carvalho. It is a fact that he knew Solomon's son, David. They shared something in common: rare books.

CHAPTER XI

THE 1860's

On February 9, 1860, Solomon's father, David Nunes Carvalho, died in Baltimore after ten successful years in that city as a daguerreotypist and a businessman. He had the distinction of introducing the manufacture of marbled paper to America—a venture which evidently gave him financial security.

Solomon paid the five dollar fee for his father's burial in the Hebrew cemetery, and after settling family affairs moved his family to New York City.

According to the files of the National Academy of Design, Carvalho lived at "Dodsworth's 204 Fifth Avenue" in 1862, and in 1864 was located at "59 East 13th Street."[1] Presumably these are studio addresses, as a granddaughter reports that their place of residence was 177th Street in Tremont, then a suburb of New York.

During the 1860's, Solomon painted a number of family portraits, portraits of businessmen and other notables, and continued his scientific experiments in steam and photography.

In 1860, Carvalho painted a portrait of Thomas Hunter, President of Hunter College. Although the work was famous in its day and was mentioned in books which were published during Solomon's lifetime, repeated efforts to locate the portrait have been fruitless.

A portrait of little Annie Abrams at the age of two dates from 1861, and is in the collection of the Carvalho family. Solomon por-

David Nunes Carvalho, c. 1858. o/c. S.N.C. Marshuetz.

trays a charmingly rounded little girl, with curly hair, dark eyes and full lips, wearing a ruffled dress and looking quite seriously out at the viewer. (Annie Abrams later became the wife of Solomon's son, David.)

The energetic Carvalho could not stay still for long, and by March of 1861 was in New Orleans, where he must have been for some time according to the following letter dated March 28th:

> My Dear Mr. Leeser: Your favor dated from 257 Lexington Str. Balto. came safely to hand. . . . My stay here has been prolonged by circumstances beyond my control. I hope to be at home by the middle of April, by which time my invention will be in successful operation here. I have been *quietly practicing my profession* during the whole course of this great revolution, which has shaken the very foundations of the Union. (Italics mine.)—All the time to a casual observer there has been no visible appearance of excitement. Some few parades of Volunteer troops—*but without one obtained information from the public prints,* he never would imagine so great a revolution, and pregnant as it is with so much either of good or evil, could have been conceived, matured and perfectly carried out, without the shedding of one single drop of blood. (Italics mine.) I believe in the great principle of men being governed by their own consent. I believe the people of the South can and will maintain a separate government.—Time will develop all things . . . I have not seen Mrs. Rosalie Jonas for three weeks. She has been confined to her chamber from indisposition. I am painting a large portrait of the late Judah Touro, full length with a view of the Touro Almshouse in the background. I am painting it on speculation. It is nearly finished. . . . Yours truly,
> S. N. Carvalho[2]

This remarkable letter is full of information of value to the historian who specializes in the Civil War period. How peaceful it all sounded "without the shedding of one single drop of blood." His mention of "public prints" is a graphic reminder of the power of the printed word for propaganda purposes.

According to the letter, Carvalho had been in New Orleans for sometime while setting up his invention, which was undoubtedly a steam heating apparatus. Besides painting portraits he also had occupied a good part of his time trying to sell subscriptions to the

Occident for his friend, Leeser, and helping the Jewish community of New Orleans. Solomon's sentiments with reference to secession are probably typical of most of the southern Jewish community, and give further substance to suggestions behind the apparent cooling of the Fremont-Carvalho friendship.

Carvalho mentions Mrs. Rosalie Jonas, wife of George Jonas, whose brother was a close friend of Abraham Lincoln. This does not necessarily indicate that he knew of her brother-in-law's friendship with Lincoln; however, it is a distinct possibility. In the turbulent campaign to elect Fremont as president, both Carvalho and Lincoln were well known figures, and it is likely that Lincoln's friend, Jonas, was also a member of that campaign. One of Carvalho's important portraits of his New Orleans period was that of the philanthropist, Judah Touro.

For a discussion about Solomon's portrait of Judah Touro, we are indebted to Bertram Korn's research and essay on that work:

> The model which Carvalho utilized for his portrait can probably be established with some assurance. There are in existence only two portraits of Touro, and at least one copy of a contemporary daguerreotype. . . . The portraits are owned by Monte M. Lemann and Rabbi Julian B. Feibelman, both of New Orleans. The Feibelman portrait . . . is unsigned. The Lemann portrait is inscribed on the back of the canvas, 'To my friend Touro/Rinck.' A. D. Rinck was a local artist who worked in New Orleans beginning about 1840. . . . If the stories about Touro's excessive reticence are accurate, Rinck may have painted this portrait without Touro's knowledge or consent, possibly from a copy of the daguerreotype which is said to have been taken through the contrivance of friends without Touro's prior approval. The painter of the Feibelman portrait probably also used the daguerreotype; indeed, the expression on Touro's face in this painting is closer to that in the daguerreotype than to that in Rinck's portrait. . . . It is, of course, possible that Carvalho was given the opportunity to utilize either the Rinck-Lemann portrait or the . . . Feibelman portrait; but it seems far more likely that he used the same daguerreotype likeness which may already have been utilized by Rinck and the painter of the Feibelman portrait. At any rate, all three portraits are quite similar to each other and to the photographic likeness: the subject is wearing the same type of clothing, the same hat and the same dour appearance. The Rinck

Judah Touro, 1861. o/c. Touro Infirmary, New Orleans.

portrait gives Touro a softer expression; the Feibelman portrait makes him look considerably older; the Carvalho portrait gives him the sternest appearance of all three portraits.[3]

As with all Carvalho portraits known to have been copies from a daguerreotype, the light and shadow effects are harsh. Since the author has seen only photographic reproductions of the painting, the cause of extreme darkness is uncertain, but may be due to heavy varnish.

The almshouse in the distance is an iconographical element which refers to Judah Touro's charitable contributions to the community. We will see that Solomon uses this device again in an important portrait from the 60's, but instead of an almshouse, it will be the Capitol of the United States.

I

In 1862, Carvalho returned to New York to be with his family, and it was an active year. He exhibited two paintings in the National Academy of Design exhibition: No. 163, "Moonlight on the Rio Virgin. (For Sale)," and No. 425, "Vas. Houghton."[4] The location of these two works is unknown.

From this same period comes the lively portrait of Solomon's young son, Jacob Solis Carvalho. Whether or not the portrait was done from life is difficult to ascertain. It is hard to keep small children still for very long, and the strong lighting in this painting may indicate that it was done from a photograph. In this respect, it bears resemblance to the brightness of the Morphy portrait. While painting portraits of various family members, Solomon was busy in his studio painting likenesses of important members of the New York community.

Aaron Lopez Gomez was a wealthy New York merchant. Sometime around 1862, Solomon painted a regal portrait of the gentleman, seated in a chair of the Victorian style. He appears to be a solid, substantial citizen with a sense of humor. Carvalho emphasizes the eyes, with their unevenly bushy brows and crinkle lines at the corners, and the nose. Unlike other Carvalho portraits, there are not the deeply indented lines at the corners of the mouth. It is a

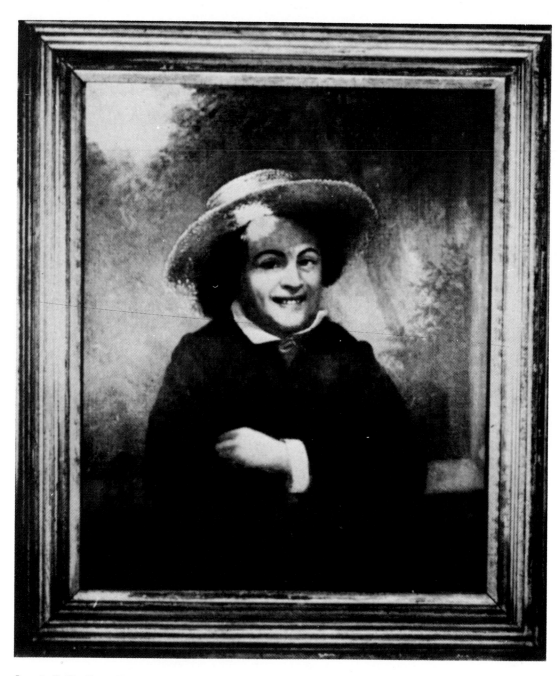

Jacob Solis Carvalho, c. 1862. o/c. Mrs. Helen Spigel Sax. Philadelphia.

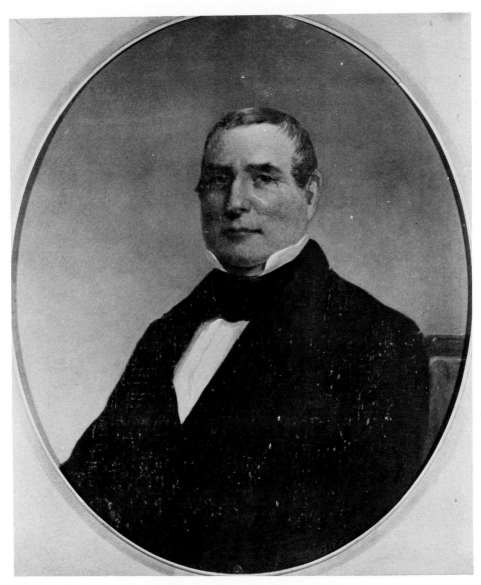

Aaron Lopez Gomez, c. 1862. o/c. Mrs. Henry S. Hendricks, New York City.

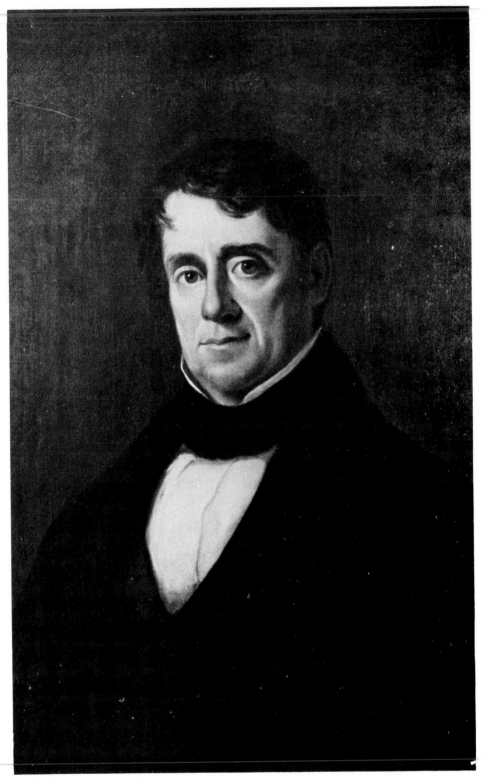

Isaac Seixas Mendes Nathan, c. 1862. o/c. Emily S. Nathan.

softer, almost smiling mouth, matching the humor depicted in the eyes.

In the photograph, one notices flaking of the paint, and perhaps some touching up on the ear. In the flesh of Gomez' cheeks, one can almost feel the aging skin and the veins. It has the intimacy of a portrait drawn from life. In contrast to the Gomez portrait is the portrait of Isaac Mendes Seixas Nathan, (who was born in 1785 and died in 1852) done from a photograph sometime around 1862. The smooth flesh is strikingly reminiscent of the portrait of Paul Morphy, though the lighting is more subdued. There is an artificial quality about the face, which, as in the Morphy portrait, indicates that Carvalho may not have known the man personally. The Carvalho characteristics remain: the prominent nose, the enormous, staring eyes, and the crispness of the white collar around the chin.

There is an interesting commentary concerning Carvalho from the "Family Memoirs of Edward L. Wells," in which he writes about his life in 1862:

> I made the first money in my life ($40) by searching a title, & had a few other pieces of business during my practice. One of these was a case in court for a portrait-painter, Carvalho. He was unable, it appeared, to pay me any fee, but offered to paint my portrait, a proposition which I 'declined with thanks.' After the War, in 1866, I think, when walking down Broadway one day, I saw in a picture-store window displayed a large portrait of my former client, who, it appeared, had attained some celebrity, but I am still without my fee.[5]

The year 1864 saw Carvalho exhibiting, again, at the National Academy of Design, with entry No. 256, entitled "Portrait. The Artist."[6] It is presumed that this was a self portrait, and may well be the work which Mr. Wells saw in the shop window while walking down Broadway. Its location is unknown.

Carvalho's miniature of his sister, Miriam, c. 1864, is one of his few known female portraits. It is a dainty work, depicting a fragile young lady, with delicate ruching across her breasts. A bow is tied into the carefully drawn hair which is done in corkscrew curls, and her young, luminous flesh glows above her dark bodice. As always, the emphasis is upon the eyes and nose, and, as in the Gomez portrait, the mouth is softened.

David Hays Solis
The Artist's Brother-In-Law

Miriam Nunes Carvalho Osorio
The Artist's Sister

Solomon Da Silva Solis
The Artist's Brother-In-Law

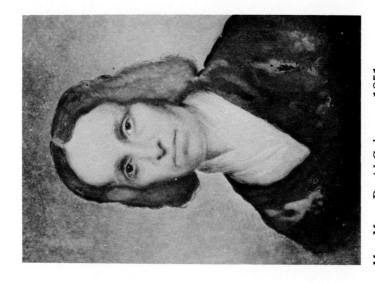

Mrs. Myer David Cohen, c. 1851

Myer David Cohen. c. 1847

The Misses Solis—Cohen, Philadelphia.

In noting the expression in the face and the pose of young Miriam, one wonders whether or not the Leonardo painting of the "Mona Lisa" was in Solomon's mind. One also is reminded of miniatures by South Carolinian Charles Fraser, who, as mentioned previously, may have been an early teacher of Solomon Carvalho.

There is little knowledge of Solomon's photographic pursuits during this period. It is interesting to speculate upon whether or not Solomon engaged in photographing the battles of the Civil War. Probably he did not, for despite Solomon's empathy for the South, he also had an admiration for Abraham Lincoln that bordered on hero worship.

II

In 1865, Carvalho painted a portrait of the President, one of only four allegorical portraits of Lincoln. One is a work by David Gilmour Blythe showing Lincoln fighting a dragon, which now hangs in the Karolik Collection of the Boston Museum of Fine Arts. Another is by Edward Dalton Marchant, Art Collection of the Union League of Philadelphia, the other by William F. Cogswell, White House Historical Association.

The Carvalho portrait of Lincoln was supposed to have hung in a public building in Washington, but it dropped out of sight, not to be discovered until sometime in 1952. At that time a photograph of the portrait and the following critique appeared in *Portfolio*, the publication of The Old Print Shop in New York. (A picture of it also appeared in *Antiques Magazine*, Feb., 1957). The portrait was purchased by Mr. Justin Turner of Los Angeles in 1960, and presented to the Rose Art Museum, Brandeis University, in Waltham, Massachusetts.

A New Lincoln Portrait by Solomon N. Carvalho.
To find a new portrait of Lincoln, which belongs to his period, is something so important that such a picture usually makes the front page of the Sunday magazine sections of our great papers. The portrait by Solomon Nunes Carvalho, opposite, stands out among Lincoln items, because it is unusually well done, has unique and interesting iconographical elements, and is from the hand of a painter and early daguerreotypist whose importance

Annie Abrams, 1861. o/c, 19½ x 16. Private Collection.

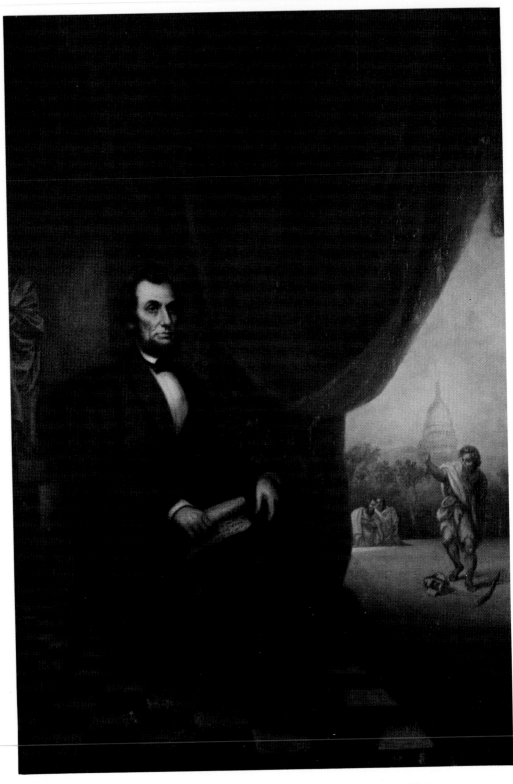

Abraham Lincoln, 1865. o/c, 44 x 34. Rose Art Museum, Brandeis University.

has recently begun to reappear. The portrait, signed and dated, is large, handsome, with a brooding calm, the atmosphere not worldy but ideal, is one of the only two recorded of Lincoln which have allegorical attributes. . . . In the Carvalho Lincoln, the Capitol building appears, as a symbol of union, presumably; Diogenes, having at last found an honest man, stands in a posture of amazement, his lantern fallen to the ground; Lincoln is holding a scroll on which can be read the words, 'With malice toward none, with charity for all,' from the last paragraph of the second inaugural address; and on the left is a statue of an 18th century personage wearing a toga, probably George Washington, the artist thus recalling the beginnings of our unity as well as its promised preservation. The statue may be based on that by Chantrey, in Boston. The portrait either marks Lincoln's second inauguration, on March 4, 1865, or was painted as ·a tribute after his martyrdom the following month. . . . It has been said that Carvalho and Lincoln were personally acquainted, but this cannot be demonstrated at present. However, family tradition is explicit as to Carvalho's admiration and affection for the Union leader, and these emotions come through strongly in the picture.[7]

The account from the *Portfolio* mentions the possibility that Carvalho and Lincoln knew one another, which could not be proven, but family tradition testifies to Carvalho's admiration for Lincoln.

Two of the daughters of David Nunes Carvalho, son of Solomon, have been explicit about the personal relationship between their grandfather and President Lincoln. One of the two ladies wrote to the author that her father, David, repeatedly told the story that he went with his father to the White House when Solomon painted Lincoln's portrait, and that he was taken up by Lincoln upon his lap and allowed to play with the President's watch.

According to the date of David's birth, he would have been seventeen years of age in 1865, which makes him large, indeed, to sit on Lincoln's lap. It may be that in the confusion of passing years, the child involved also became confused in the minds of the descendants. It could have been either Jacob, who would have been thirteen, or Solomon, who would have been nine. Unfortunately, the answer to the question of whether or not the portrait was painted from actual sittings cannot depend on family hearsay. It bears no

similarities, however, to portraits known to have been done by Carvalho from photographs.

In Beaumont Newhall's book on the history of the daguerreotype there are a number of photographs of Lincoln, and one is unidentified. The unidentified plate has certain similarities with Carvalho's own daugerreotype of himself, and the daguerreotype of James Hamilton. It may be that Carvalho was the man behind the machine in both unknown works—pose, emphasis on hands, and mood is much the same, as is the lighting.

The Lincoln portrait is a handsome work with carefully balanced diagonals and massing of forms, with Lincoln standing out near the center axis.

The eye is led into the picture by the black and white floor tiles, and we are directly confronted by the care-worn Lincoln, scroll in hand, in front of the draped figure of Washington. The red drapery carries the eye once again around Lincoln, the circular massing complementing his seated figure in his chair. The red tassel directs the eye to Diogenes and the vista, which, by the action involved in the scene, once again invites contemplation of the President.

If the portrait had been painted after Lincoln's death, iconographical indications would indicate this fact. There are none.

The article quoted from the *Portfolio* is a reminder that paintings of this subject and importance usually make front page news. In a search through the files of the late Claire Carvalho Weiller, a granddaughter of Solomon, the following letter was discovered, bearing the date March 10, 1952:

> I have been given a tip today which may be of use to you. A lady came to the shop today to look at the portrait of Lincoln. It soon came out that she had been a fugitive across Europe since the age of 14, when she left Poland. Hitler drove her from Germany to Holland, where he caught up with her and she had to hide. Five years ago she arrived here. Two weeks ago she read in the DAY an article about the Carvalho Lincoln, apparently a long one, with the portrait illustrated. I called Mr. Rubin at the DAY, and he is going to send me a copy for our files. BUT more interesting he said he remembers seeing a book, called he remembers "The Men Of Ages" in which the frontpiece was this portrait of Lincoln. . . . He also recalled

something about a group of plates being discovered which were
by Carvalho. I should think the thing to do would be to inter-
view Mr. Rubin at leisure, and see how much he can pull out
of the bottom of his memory.[8]

Unfortunately there was no further correspondence from the
source, and any efforts on the part of this writer to locate either the
article mentioned or the book have met with no results.

III

The year 1865 is the year in which Carvalho finished his large
version of the Grand Canyon, previously discussed.

From 1867 comes the painting mentioned in Chapter VIII,
"Two Fishermen At the Edge of a Stream." It is a pity that we
cannot see this work in color as there is a lushness about it even in
black and white. There is also a loosening of technique in the han-
dling of trees in the middle and far grounds which seems almost im-
pressionistic. The touch of the bright hat which appears white in the
reproduction, lower right corner, makes one think of the red hats of
Corot. Carvalho also may have been looking at the works of Claude
Lorraine and John Constable.

The location of the stream could be some place on Long Is-
land. Although this is only a black and white photograph, it demon-
strates Carvalho's preoccupation with changes of atmosphere, the
varied intensities of light, shimmering sunlight on water, and the
changing reflections in the stream—preoccupations which were evi-
dent in his earlier Western landscapes. There is a freshness, a spon-
taneity in this later work which makes one wonder if it were not
done in the open air. It also marks a turning point in Carvalho's
style—a point which will be treated in the next chapter.

In 1868, Carvalho painted a portrait of fellow Charlestonian
Charles Henry Moise. Moise had gone to New York, and perhaps to
other cities in the North as well, to ask for contributions to the
shrunken treasury of the Hebrew Benevolent Society of Charleston.
The conditions of that city in general were greatly depressed follow-
ing the Civil War.

Moise collected $1100; Carvalho painted his portrait and sent it

to the Society to be sold as an additional source of revenue, but
the Society, in gratitude, presented it to Moise himself. Harold
Moise, the family genealogist, has sought without success to
locate its present whereabouts.[9]

In 1869, Carvalho still was painting and serving his friends, as
the following letters show:

New York Feb 8/69
My Dear Mr. Carvalho
I avail myself of your kind offer to write to a friend in
Philadelphia. I wish to procure an engraving of Mrs. Oldmixon
formerly an actress and who once kept a large Boarding school
in Philadelphia. I want the best that can be had. A small one
that could be inserted in a book of octavo size.
Very truly yours, Wm. B. Macklay
Whatever expense it is I will very cheerfully pay.[10]

There follows a letter from Carvalho to a doctor:

Dear Doctor: I am repainting the sky of my larger picture. As
soon as it is finished will send it. I today ordered a box for
"Fanny Noctin"—will send that forward, soon. If you can find
time oblige me by filling the enclosed order—it is for a particu-
lar friend whom I would wish to serve.
Yours truly, S. N. Carvalho.[11]

The latter is quite possibly the letter to "a friend in Philadel-
phia," mentioned in Wm. B. Macklay's letter to Carvalho.
Carvalho's signature in this letter is written with his usual flourish.
However, the body of his message is in a jerky, almost childlike
hand, and foretells the affliction which will so greatly affect Sol-
omon and his artistic future.

Two Fishermen At The Edge of a Stream, 1867. o/c. photo: American Jewish Archives. (location of painting unknown.)

CHAPTER XII

FAILING EYESIGHT

In July 1971, an answer to a letter to John Dewar, Associate Curator of Western-American Art at the Los Angeles County Natural History Museum, put the author in touch with the firm of Zeitlin and Ver Brugge in Los Angeles, a firm that deals in rare books and manuscripts, and Old Master drawings and prints. They were in possession of a large family group portrait, with previously suggested attributions to either Henry Sargent or Solomon Carvalho.

Mr. Zeitlin sent a black and white reproduction for study, and due to some startling similarities within the painting to other Carvalho works, a large color transparency was requested. Study of that transparency revealed even greater similarities except for the faces of the Serrano family members, nearly all of which looked exactly alike, and were reminiscent of faces from Italian paintings of the 1400's. Furthermore, the face of one child is so distorted as to appear grotesque, a feature that is incomprehensible from so accomplished a portraitist as Carvalho.

After seeing examples of Henry Sargent's work, studying historical details of his life, and considering the date of his death, 1845, it seemed unlikely that the "Problem Portrait," (as the writer calls it), could have come from Sargent's hand. Sargent had had European training, and his works have the flavor of a much earlier period in the history of art.

In the list of "possibilities," Samuel Osgood's name appeared,

as Osgood had painted off and on in Charleston during 1830, 1839 and 1840, and had moved to San Francisco later in his life. Thus, a search was begun for examples of the work of Samuel Osgood.

The Brooklyn Museum supposedly owned two portraits by Osgood; however, query letters produced a blank, since the portraits could not be located; and letters to the Frick Reference Library asking if they might have photographs available, brought forth no images for inspection.

One portrait finally was located, that of a lady, and is reproduced in Anna Wells Rutledge's work on the artists of Charleston. One glance confirmed the opinion of the author that Osgood, an American who was trained in Europe, could not have painted the Serrano family portrait. The Osgood work was strongly pre-Raphaelite in style, somewhat saccharine, but with a good structural knowledge of the body. Titles of other works by Osgood, and of which no reproductions could be found, indicated that this judgment could be valid for his portraits and fancy pieces, for example: "Ellen Cutting Her First Tooth," and "Girl In Swiss Costume," (see Index, "Osgood," Rutledge, *Artists In the Life of Charleston*).

To add to the cloud surrounding the "Problem Portrait," Mr. Zeitlin wrote that they had not been able to verify even the identification of the subjects, and that because the painting was removed from the Serrano house in Monterey when the house was dismantled, the painting had been entitled "Portrait of Florencio Serrano and His Family," but with a question mark. The family portrait is oil on canvas and measures 37 inches by 42 inches, framed.

The first obvious similarities to Carvalho's works appear in the still life on the table, which is strikingly like that in Solomon's portrait of his wife, Sarah, and in the larger still life upon the floor. It consists of a large urn, carved stool with drapery and the mandolin, the latter being a favorite nineteenth century device used both in daguerreotyping and painting as a prop. This larger still life recalls Carvalho's use of carved garden bench, cane and other foreground articles in his early canvas, "The Lovers."

The handling of foliage and the far view echo the treatment and coloration of foliage and view in both "The Lovers" and in the portrait of "Sarah." The treatment of the sweeping red drape and the detail of the rich carpeting recalls the tile floor and red drapery in the "Lincoln" portrait.

Portrait of Florencio Serrano and His Family (?), c. 1865-69. o/c 37 x 42.
Zeitlin and Ver Brugge, Los Angeles.

The decorated wall, left side, takes the place of a draped George Washington. The patterned rug replaces a black and white inlaid floor, and the trees and foliage take the place of an almshouse or Capitol building.

The oldest son is almost a copy of Solomon's portrait of his young cousin, Moses Finzi Lobo; the thin, elegant woman, with her swan-like neck and sloping shoulders reminds one of the young lady in "The Lovers." However, the posing is stiff and the faces strange, especially that of the little girl who, in the color reproduction, becomes actually grotesque.

That Carvalho's hand is in this work is certain. He may have begun cartoons for the portrait while he was working in California, and carried it back to the east coast with him. In California, we know that he also had access to daguerreotype equipment, and other operators who followed him were equipped for photography. The painting appears to have been done in stages, begun most probably in 1855-56, and not completed until almost as late as 1869.

If one examines the carpet through a magnifying glass, it becomes that sea of colors that Carvalho spoke about in his journal, while mentioning his fondness for the flowers and colors of the western plains. It is also kin to the lush handling of foliage in "Two Fishermen by the Edge of a Stream."

The awareness of details, the catalog of possessions, the document lying on the table (similar to the papers upon the ground in "The Lovers," Sarah's treasured book, and Lincoln's rolled Address), all have the Carvalho touch.

It is the opinion of the author that Carvalho completed the portraits using photographs, and that the distortion, especially in the face of the little girl, is the result of the encroaching cataracts which, in his own words, cost him his painting career. The condition was creeping up on him towards the late 1860's—a condition for which he eventually was to undergo surgery.

I

In February 1971, an inquiry about a listing in the Schomberg Collection of the New York Public Library turned up a faded, leather-bound portfolio entitled *Album of Martinique*, consisting of

twenty-four photographs of sites on that island, identified, signed and dated by S. N. Carvalho, along with an inscription of great interest:

> No. 77 West 124th St.
> My dear Sir,
> The long delay in the publication of my article, 'A Ramble In Martinique' which now appears in the January Number of 'Harper's Monthly,' prevented me from having the pleasure at an earlier day. The accompanying Album, containing photographic finds from negatives I made during my late visit to Martinique, about four or five months after you performed the operation for cataract. I have no doubt that an imprudent use of my eye while absent, has caused a relapse of my 'prolapsed iris' which has prevented me from practicing my profession since my return.
> Will you do me the honor to accept this volume as a mark of the deep obligation under which I subscribe myself.
>
> Yours,
> to Dr. Cornelius R. Agnew S. N. Carvalho[1]
> New York

Thus, the reason why Carvalho stopped painting almost completely. There is a small miniature of his wife, Sarah, which may have been done sometime around 1873-74, after his eyes had had time to heal. The photograph of the miniature depicts Sarah in her middle to late fifties. Although the eyes and nose are as firmly drawn as usual, her shawl, hair and shoulders seem blurred. Whether or not this is due to damage of the paint through the years or to Carvalho's eyesight, is difficult to say.

Solomon's inscription to Dr. Agnew refers to his article in *Harper's Monthly*, which appeared in January of 1874, but was entered in the Office of Library of Congress late in 1873. He speaks of the lengthy delay in publication, but we know from the photographs in the Schomberg Collection that he traveled to Martinique in 1872, as all are signed and dated.

It is difficult to tell the time of year, but since Carvalho says that he made the visit ''four or five months after'' surgery, it is likely that the voyage took place during the fall. Solomon had grown up among the islands, and undoubtedly had the presence of mind to wait until the tropical storm season was over—probably to-

Sarah Solis Carvalho, c. 1871-73. miniature. Private Collection.

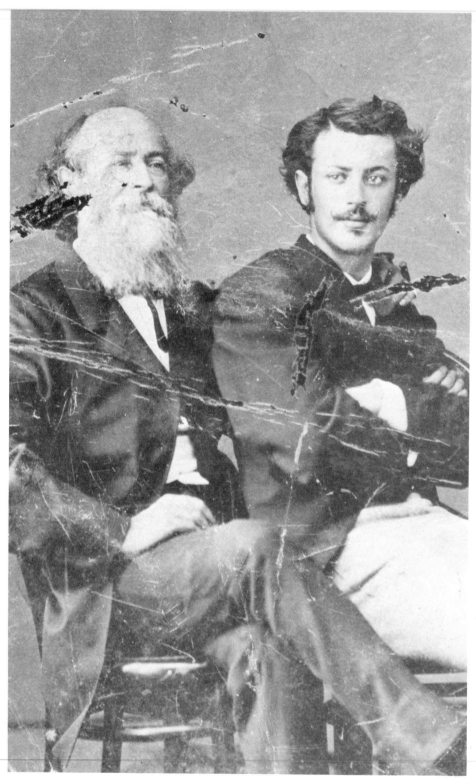

Solomon Nunes Carvalho and son, David Nunes, on voyage to Martinque.
c. 1871-72. Taken from tintype. Author.

wards the end of November. David, Solomon's oldest son, accompanied his father on this voyage, and a photograph of the two of them taken while on board ship shows David to be a very handsome young man, indeed. Carvalho was fond of Martinique, and may have visited relatives on the island. Benjamin D'Azevedo and his family lived in Martinique during that time, and there was a connection with the Lobo family of Barbados.

Solomon's article on Martinique bears his name in the table of contents, but not on the front page of the article itself. Walt Whitman's "Prayer of Columbus" appeared in the same publication as did the works of other authors of note.

Despite Solomon's operation and his age, which was approaching sixty, his vigor, perception, powers of observation, and his interest in folk tales and customs appear to be as virile as they were during the fifth expedition of 1854.

In Carvalho's published account of the journey, he describes in detail the approach to the island by steamer, beginning with the first sight of Mount Pelee, 4500 feet above sea level, shrouded by a blue haze. He offers a panoramic account of the sweeping terrain which became more and more rugged, and more detailed, as the ship approached land.

As always, his romantic nature and gift with words paints a graphic picture of climate, the fragrance of lemon and lime blossoms and rushing waterfalls. At the same time, his scientific background never eluding him, he can be as dry as a surveyor in describing a town.

One of the artistic wonders of St. Pierre was a fountain, and Carvalho gives a delightful description of it:

> It is of bronze, of the most elegant design and workmanship. Its height is about fourteen feet. The principal figure is a graceful water-nymph bearing on her head a kind of basket, from the rim of which flow jets of water. Around the central figure are four kneeling mermaids, each holding a dolphin, each of which throws into the air a delicate column of water. At certain seasons, generally in August, this fountain has exhibited the singular phenomenon of spouting forth myriads of living fish, each from half an inch to an inch in length, their bodies as transparent as crystal, with the exception of the head, which is of a dark color. When the sunlight strikes the jets of water at such

times, it looks as if millions of precious stones were flashing
through the air, splashing down on the slippery marble pave-
ment, and being swept off into the sewers. . . . The inaugura-
tion of the fountain was marked by a singular freak of ex-
travagance. Before the water was turned on a large quantity of
claret was emptied into the mains above the fountain, so that
when the pressure of water came the dolphins for several min-
utes spouted nothing but ruby wine. The poorer citizens, hav-
ing received a hint of what was to happen, were on hand with
their pitchers, and were amazed and delighted at what appeared
to them a miraculous display.[2]

A miraculous display, indeed, compliments of the donor of the
fountain, and duly noted by the equally impressive Solomon Car-
valho who could not help looking at life and writing about it in this
way, even poisonous snakes.

The bane of this delightful paradise is a serpent—what paradise
is without its bane?—called by the fearfully suggestive name of
the 'iron lance.' This reptile, with venomous taste, chooses the
coolest and most delightful places in the garden for his retreat,
and it is literally at the risk of one's life that one lies down on
the grass, or even takes a rest in an arbor.[3]

Carvalho goes on to describe the effects of the venom from this
reptile, and says that nearly 800 persons were bitten each year, on
an average. Then he writes:

The advent of a modern St. Patrick would be heartily wel-
comed in Martinique, and if he would purge the island of
poisonous reptiles as thoroughly as the ancient saint swept the
Emerald Isle, he would have his picture in every house and a
shrine in every church.[4]

Neither operation nor age dampened the carefree Carvalho's ac-
tions, however, for he rambled in those infested gardens, taking his
chances with the 'iron lance' and its deadly bite, and sat on a bench
to eat a mango d'or:

. . . the pulp is deep yellow in color, of the consistency of
ice-cream, and a delicious aroma exhales from it. To partake of
the mango in full perfection is one of the indescribable luxuries

Album of Martinique, 1872. Schomburg Center for Research in Black Culture. The New York Public Library. Astor, Lenox and Tilden Foundations.

Album of Martinique, 1872. Schomburg Center for Research in Black Culture. The New York Public Library. Astor, Lenox and Tilden Foundations.

Traveller's Palm. The Stem of each leaf contains
one gallon pure water. Governor's garden. Mart'que

Album of Martinique, 1872. Schomburg Center for Research in Black
Culture. The New York Public Library. Astor, Lenox and Tilden
Foundations.

of tropical life. Look at the large tree opposite spreading branches bending under the weight of its delicious burden. What a lovely contrast of the golden globes with the dark green foliage! . . . Ah, here is the fruit! If you have never eaten a mango, you must be instructed in the art. Roll up your sleeves, pin a napkin under your chin, and have a basin of water close at hand; strip the peel from the mango, revealing the delicious, golden-hued, creamy pump; seize the fruit by the ends with both hands, and bite tenderly into it. Be as careful as you will, the abundant juice will overflow from your lips and run over your hands and wrists. But you rinse face and hands in the water beside you, and repeat the operation until the appetite is sated.[5]

In the pages that follow, Carvalho gives an amusing account of government intervention and hocus pocus regarding the estate of a wealthy deceased citizen. In order to seize the property from the heirs, metal wires were attached to the hands and head of the corpse, and the room was darkened so that the wires did not show. The high officials, in front of the heirs and witnesses, asked the corpse if he wished any of his property to go to his heirs. To the horror of the spectators, the corpse raised his head and answered with a negative movement. To the question, did he want his estate to go to the city of St. Pierre, the corpse raised his right hand in the affirmative; whereupon the high officials immediately confiscated the property, with no argument from the superstitious natives.

A few paragraphs of Carvalho's "Rambles" are devoted to the structure of society, the religion and educational facilities of Martinique, pointing out that while the wealthy were educated in France, the local schools, which were run by the clergy, were of excellent quality. There was a college at St. Pierre which attracted students from other islands in the West Indies, as well as from South American countries.

One day Carvalho took a trip to Fort de France, the capital of Martinique, and about twenty-two miles from St. Pierre by steamer. Here he found a festival going on, and one can sense his pleasure in the scene by the following description of one of the native women:

. . . a tall, handsome negress, whose costume attracts general attention. She wears a long, flowing robe of fashionable dimen-

sions, of figured solferino or crimson damask satin of very superior quality, extending downward from her waist. The body and sleeves are of white muslin, the sleeves puffed. A small heavy green silk shawl pinned in front over her arms falls gracefully over her neck, while her head is surmounted with a magnificent Madras handkerchief with brilliant yellow and purples squares, secured in front by several large pins of solid gold. Her ear-rings are of the same material, representing huge cylinders . . . around her neck are four rows of gold beads three-quarters of an inch in diameter, with bracelets of four rows of the same size on her arms, presenting a most gorgeous appearance, while pendent from the centre may be seen half a dozen different articles of jewelry. This gorgeously dressed female, we are assured, may be seen every day in the market-place of Fort de France earning her livelihood by selling salt pork and cod-fish by the penny's worth.[6]

Fort de France lay opposite Trois Iles, the birthplace of the Empress Josephine, whose statue stood in the public square of Fort de France, and is described by Carvalho in some detail, along with a lengthy account of Josephine's early life in Martinique.

The life of Josephine is followed by several romantic tales concerning legendary young ladies of the island whose ends were different from those of the ordinary mortal. These tales are written with the same flair and romantic viewpoint as the rest of Carvalho's article.

He gives an interesting account of sorcery, or "obeah," and winds up his rambles in Martinique with a short summary of the changing character and disposition of the population, and a prediction:

The old barbaric instincts are fast dying out, and in another generation they will probably have become altogether matters of tradition.[7]

In comparing the illustrations which accompany Carvalho's text with the photographs in the Schomburg Collection portfolio, it was found that nine of the engravings were taken directly from Carvalho's work. Of the other scenic views and portraits which expand the pictorial aspects of the article, we have no knowledge of origin. Some may well be from Carvalho photographs which were

not included in the portfolio for some reason, or they may have
been taken from earlier photographs or engravings by an earlier
traveler.

We have seen Carvalho as artist, explorer, historian, inventor,
daguerreotypist, activist and politician. *The Occident* carried a note
with reference to Solomon Carvalho as a writer:

> Would some intelligent correspondent favor us with a list of
> our writers and the books composed by them? We can name
> Dr. Isaac Hays, a magnitude in medicine, Isaac Harby, Jonas
> B. Phillips, Major Noah, the brothers Cardozo, of Charleston,
> Dr. J. S. Cohen, S. N. Carvalho, Mrs. Rebecca Hyneman,
> Miss Moise, and a few of minor note.[8]

Thus Carvalho was appreciated by the Jewish community, and given
due recognition even before his "Rambles" appeared in print.

CHAPTER XIII

LATER YEARS

Although Solomon's painting career was hindered by his operation, his energy was not to be suppressed and he continued to lead an active life in other directions.

In 1870, Solomon and Sarah directed a religious school which was part of the facilities of the Hand-In-Hand Congregation in New York City, and in that year they had some forty-five children enrolled. Sarah had been a dedicated teacher for many years, having interned with the beautiful Rebecca Gratz in the days when the Carvalhos lived in Philadelphia. By 1876, the Congregation had grown so large that the members leased Grace Episcopal Church at 116th St. between 1st and 2nd Avenues, where they remained for five years, changing their name to Temple Israel sometime in the late 1880's.

Solomon had been working at his steam inventions since 1860, and in 1877 and 1878 patented two developments, the first being "Professor S. N. Carvalho's Entirely New Steam Super-Heating System by Hot Water Circulation, under Pressure," for which he was awarded The Medal of Excellence by the American Institute in New York. His office address was 119 Liberty Street, and the patent for his new system bears the date July 3, 1877. He wrote of his new invention:

> The object of the Carvalho apparatus is to economize heat by abstracting and conveying into useful channels some of the

183

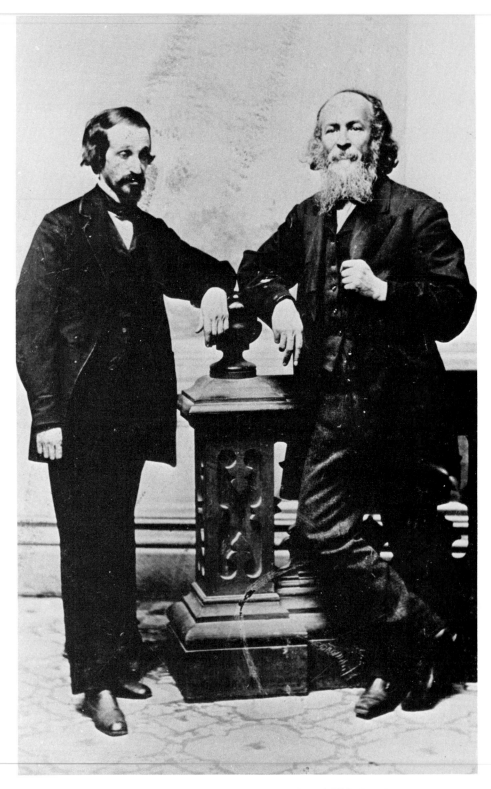

Solomon Nunes Carvalho and Unknown Friend, c. 1876. Dr. Bertram W. Korn.

waste heat of the chimney gases, particularly under high rates of combustion with forced draughts, to direct their usefulness to the vaporization of any entrained water, and superheating the steam by means of it, and at the same time controlling the amount of this superheating at will, by transferring all the heat abstracted from the waste in the chimney, or other points at which the absorbing parts may be placed, over and above that required to dry or superheat the steam, to the feed water entering the boiler.[1]

Carvalho envisioned this latest development as being useful for heating buildings, baking bread, boiling soap, sugar manufacture and other industrial purposes, for in April of 1878, he produced another circular calling attention to the value of his invention:

> Highly Important
> To Engineers, Piano Manufacturers, Cabinet Makers, Sugar Refiners, Bread and Cracker Bakers, Chemists, Hotel Keepers, Woolen and Cotton Mills, Dyers, Brewers, Oil Refiners, Soap Boilers, Dessicating Vegetables and Milk, and all other Industrial and Manufacturing Pursuits where Heat at Elevated Temperatures, High Pressure Steam and Boiling Water are employed, either for Power, Drying & Curing Lumber, Refining, Cooking or Heating purposes.[2]

Thus, as a scientist Carvalho remained active, and apparently his inventions, unlike his art, brought him the additional benefit of financial success.

At the time of his latest publication, Carvalho's office had been moved to 107 Liberty Street, and between his inventions and his family, Solomon led a busy life.

> According to a granddaughter, Maie:
> They lived in Tremont, then a suburb of New York City, about 177th Street, as I remember. There were two large houses next to each other, surrounded by flower gardens, and a vegetable garden and a barn. Grandmother and Grandfather and a general houseworker lived in one—and I remember she was young, happy, smiling Irish girl, always singing. . . . It was a great treat to drive up for the weekend. Uncle Jack Carvalho, who was a batchelor, then, would stop at our house in town at 4:30 p.m. Friday in his runabout with a spanking horse driving it; and what a thrill when it was my turn to go to Grandmother for

the weekend . . . I can still feel the joy . . . and the drive over
McCombs Dam Bridge after leaving the cable cars and elevated
train tracks overhead and onto Jerome Ave., where one would
see men letting their racing trotting horses practice. . . . Uncle
Jack would let me drive for a *very* short distance until we
reached the base of the hill which led to Grandfather's house. I
remember my darling grandfather, when I was
small . . . wearing a black velvet smoking jacket; and as we
were greeted with a hug and kiss, and a whisper of 'put your
hand in my pocket,' and we did that AT ONCE, and pulled out
a soft, VERY CRUSHED chocolate cream candy—its original
form having been shaped like a thimble; but its taste was
marvelous . . . he entertained us royally. We all loved to visit
him, and Grandmother, too. She . . . always seemed to be able
to change the temper of her grandchildren into a pleasing one,
without any change of voice—as we all had (and still have) the
hot impatient tempers which we all claim we inherit from both
our Portuguese and Spanish forbears.[3]

Apparently Sarah Carvalho had a rather novel method of teach-
ing her grandchildren how to control their tempers:

I heard Grandmother say, 'Remember, . . . dear, what I told
you. When you feel this way, go fill your mouth with water
and rock away in a rocking chair until you have to swallow
it.'[4]

In the second house mentioned by Solomon's granddaughter
lived Charity Carvalho, who had married Adolf Marsheutz. They
had four children, Jules, Solomon, Sarah and Ethel, and the weekend
visits to the grandparents were always filled with their youthful
companions.

Solomon had had a friendship of many years with Julian Abr-
ams, who had married an Englishwoman, Elizabeth Lumly. They
had lived in New York before going abroad, where they stayed until
their children were almost grown and educated. One of these chil-
dren was Annie, the charming little girl whose portrait was painted
by Carvalho when she was two years old.

When the Abrams children were almost grown, Julian Abrams
brought his entire family back to the United States, and rented a
house in Whitestone, Long Island.

One day, Solomon and Julian met on the street in New York City, and resumed their old friendship.

Grandfather and Grandmother Carvalho had them come over to all meet again. Mother (who was Annie Abrams) and Aunt Charrie (Charity Carvalho) became friends at once AND FOR LIFE, and Mother was asked to spend a weekend with Charrie very often. And the story goes that Uncle Jack fell in love with Mother . . . and planned to pop the question. . . . She liked Uncle Jack very much, but had no idea he was seriously interested. She said she was playing the piano (one weekend), the young people were dancing. She looked across the room and *there stood an Adonis, so handsome*, a large opera cape flowing his shoulders, and she was frozen. He came across the room (he had been away on a long business trip) and said: 'this must be the girl the whole family are in love with. Come on, let's dance.' 'I cannot,' said Mother. 'it's my turn to play.' 'Nonsense,' said my Dad (who was David Carvalho), 'let someone else do it.' And without any music he waltzed her around the room.[5]

David Nunes Carvalho and Annie Abrams were married, and Sarah Carvalho had to help teach her new daughter-in-law how to cook, as the European-trained Annie could play the piano, converse in other languages, embroider beautifully, but could not cook even a potato.

Maie Carvalho recounts an amusing story about Solomon, told to her by her grandmother, Sarah.

It seems the heavy red velvet curtains in his studio were old and soiled, so one day when he was out, she took them down and GAVE them away to an old-clothes man. That same day, Grandfather, walking along a street, saw some red velvet curtains hanging out of a shop. You can imagine Grandmother's dismay when he arrived home, with a package, and exclaimed that he was sure they were the same color of his old curtains, and felt Grandmother would be pleased as she had said he needed NEW ones—only to discover they were the ones SHE had given away! He thought he had been so clever. Dear Grandfather![6]

Solomon's eldest son, David, inherited his father's gift for photography and his bent for scientific inquiry, and went on to be-

come a well-known criminologist, working as a handwriting expert and an authority on the age and composition of various inks. In this area of his work, he collected a rare library of manuscripts produced before the fourteenth century, part of that collection is now in the Free Library of Philadelphia, the city of his birth.

He published a book called *Forty Centuries Of Ink*, and is the subject of a book written by his daughter, Claire Carvalho, in collaboration with Boyden Sparkes entitled *Crime In Ink*, which deals with cases won by Carvalho, the most famous of which was the notorious Dreyfus case. David, convinced that Dreyfus was innocent of all charges, investigated the letters and documents connected with the Dreyfus case, and was able to prove his innocence. As a result of David Carvalho's work in his behalf, and the tirades of Emile Zola who stirred popular sentiment to force an official investigation, Dreyfus eventually received a pardon. David never accepted a fee for his labors, believing that a terrible injustice had been righted, which was payment enough. He was known to refuse fees often throughout his long and distinguished career.

Jacob Carvalho was president of a large lumber company in New York. He was married late in life, to a Susan Walker, and they built a lovely home in Lawrence, Long Island, where they lived until death. Jacob cherished his father's paintings, and the two portraits now in the collection of the author, hung in "Jack" Carvalho's bedroom until he died, whereupon they passed into the hands of relatives.

Another Carvalho son, Solomon Solis, went into the newspaper business, first with Pulitzer, and then with the Hearst chain, remaining with Hearst until his death. He also married late in life, to a fellow newspaper worker, Helen Cuisak, and there were two children from this marriage. "Sol," as he was called, was a connoisseur of Chinese porcelains, and had an extensive collection, famous in its day, which went on the New York market in 1914, handled by the American Art Galleries and with an illustrated catalog of 244 pages.

To the only surviving Carvalho daughter, Charity, family tradition assigned the roles of a painter of miniatures, in addition to being a loving daughter, wife and mother.

A letter from this late period of Solomon Carvalho's life, at

age seventy, gives us a good index with which to measure his love and concern for his family.

> 24 E. 131 st.
> N.Y. March 10, 1885

My dear Niece

The portrait of your beloved Father (David Hays Solis, who had died three years previously), which I send you—was rolled up for some years and upon opening I found it to be slightly imperfect—but in the proper light in which the portrait ought to be hung—it will hardly be noticed. I have always considered the expression good and the lineaments. Pray accept it as *my* work, also as a souvenir of the great event in *your life* which you are about to Celebrate,—I know that you have chosen *excellently well*. And I pray that yourself and dear Solomon may enjoy a long and happy life—all the felicitations and joyful expressions suitable on this occasion. Aunt Sarah requests me to tender, and regrets dear Charrie's illness will prevent her from being present on the happy occasion. Dear Charrie also sends to you & dear Solomon, your dear Mothers, Sisters, etc. all the kind wishes which are usual among dear and valued friends. I do not think I will be able to be present, but should I not come, accept my hopes for the future prosperity of you both.

Your afftc. Uncle

S. N. Carvalho[7]

Sarah died on May 2, 1894, and Solomon went to live with his daughter, Charity, until his own death on May 21, 1897. Both are buried in a plot belonging to The Congregation Shearith Israel in New York City, the Sephardic synagogue founded in 1654.

Two references to Solomon Carvalho are of special interest because they are contemporary with his last years.

> Mr. Carvalho's productions—whether in art or in literature——are of national importance, and their author unites acquirements rarely met with in one individual. Mr. Carvalho now resides in New York City.[8]

And the second:

> In recent years, Mr. Carvalho has been engaged in scientific researches and has been awarded several patents for super-heating apparatus and steam engineering appliances. He has also devoted much of his time to the preparation of a volume entitled

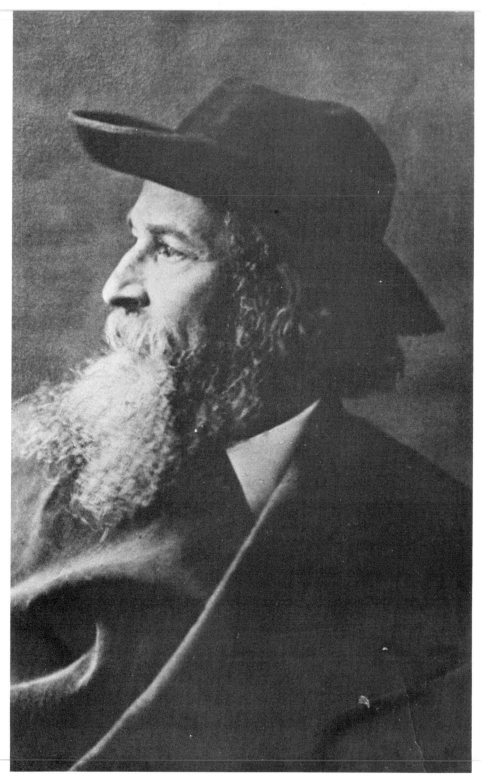

Solomon as an Old Man, photograph courtesy of the late Claire Carvalho.

'The Two Creations: A Scientific Hermeneutic and Etymologic Threatise on the Mosaic Cosmogony from the Original Hebrew,' a work betraying profound scholarship and one calculated to awakened much interest in the literary and scientific world.[9]

After mentioning Carvalho's activities as a member of Fremont's fifth expedition, Mr. Markens mentions that

at the request of John Bigelow, who was in later years United States Minister to France, Mr. Carvalho contributed from his note-book, incidents of the journey which was embodied in Mr. Bigelow's 'Life of Fremont.'[10]

It is interesting to note that in his *Preface*, among those whom Mr. Markens 'desires to tender his acknowledgments . . . who have kindly complied with requests for material and otherwise aided in the preparation of this volume . . . is S. N. Carvalho, of New York.

CONCLUSION

The many lives of Solomon Nunes Carvalho, a man of the nineteenth century, are not only an expression of the tenor of America during the early and middle years of that period, but also make Carvalho kin to men of the Renaissance.

Carvalho embraced life and experimented with it as an artist, photographer, scientist, adventurer, literary and cultural activist, and inventor. In addition to all of these activities, he enjoyed the blessings of a happy family. Whatever he did, he did well.

It appears that Solomon was busy with "today," and had no thoughts about becoming a celebrity or "tomorrow." He did not keep a daily ledger of his artistic works (unlike his supposed teacher, Thomas Sully). As a rule, he did not sign his paintings; and when he wrote for publication, in some instances he used "S.N.C." as a psuedonym. Perhaps because he *was* a busy man who did not keep meticulous personal records, and was unconcerned with fame, there has been a lapse in historical memory about Solomon Carvalho. He has been known only as the artist who went west with Fremont, and who wrote a journal about that fifth expedition.

Extensive research has unearthed "lost" materials: documents, letters, works of art, all of which combine to give a cohesive picture of Solomon, the man. Some definite statements now can be made as to his place in American art and history.

Carvalho's journal is the only account of the Fremont fifth ex-

pedition and has served historians of western Americana since 1856. His lucid style provides more than good reading; his detailed observations and psychological insight give an invaluable picture of the central route to the West, its settlers and Indian inhabitants of that time. His words are quoted by historians and writers of children's books. His judgments seem to be tempered with a desire for justice; his reasoning retains both scientific objectivity and sincere human interest. A welcome bonus is the fact that Carvalho wrote with a keen sense of humor. As mentioned earlier, Carvalho, like Charles Willson Peale, had a sense of history in the making, and helped to make it. As we approach the Bicentennial in American history, we should pause to consider a man who is only recently beginning to be noted by his country.

In studying the portrait of Lincoln, the western landscapes, and other works by Carvalho, the question of why so competent a painter should have been so little known is intensified. Apparently, he had good patronage, as he made a living as an artist from around 1834-35 until his eyesight began to fail in the late 1860's, or a period of about twenty-seven years.

It has been said that there are no such things as lost paintings, only misplaced ones. In Carvalho's case, there had been a dearth of his works to examine until Dr. Bertram W. Korn's brilliant research on Carvalho came to fruition in 1954. Since that time, more paintings have come to light. Solomon Carvalho's missing works can be categorized as those painted during parts of his life which have no record, those which are described in his journal or mentioned in letters, and those known by titles in exhibition catalogs. In the period of the twenty-seven or so years that he worked as an artist, daguerreotypist and photographer, Carvalho must have produced a fairly respectable body of paintings and other works, the bulk of which, like his daguerreotypes, is hidden from our sight. Even so, there is enough of his art available to demonstrate a steady stylistic current running through his portraiture, and a developing technique which is cut off suddenly as he is reaching his peak, or perhaps another plateau as an artist. Unfortunately for art history, he became involved in his inventions, never again turning to his brushes. We will never know what might have been, except that a turn towards what is now called Impressionism is suggested in two late works.

It has been suggested that Carvalho taught art. There has been no evidence to confirm or deny this supposition. Apprenticeship had long been an established tradition. Indeed, for those would-be painters who were far away from the larger cities where the academies were located, study with some more facile, developed painter in the more immediate area was the only method of learning, outside of studying books on the subject, and printed reproductions. By mid-century, the idea of individualism was becoming more and more popular, and it was the thing to boast that one was a self-taught artist, a concept touted even in the halls of the National Academy. We do not know that Carvalho taught students. We know that he taught his son, David, the art of photography and passed on to him his scientific awareness. He taught his daughter, Charity, the art of painting miniatures. He taught his other sons, Jacob and Solomon, the art of connoisseurship.

In terms of Solomon Carvalho's involvement with his fellow artists, he appears mysteriously isolated. To date, his name does not appear in the writings of artists who were his contemporaries, nor did he leave records indicating those artists with whom he might have associated.

Carvalho might be called eccentric by the critics of his day. He was much his own man, involved in all kinds of intellectual and community affairs, sincere and faithful with regard to his family and friends, a thoroughly active individual and an example of the spirit of the scientific and restless adventure of his times. He probably was little affected by the dual between realism and idealism which had afflicted many of his fellow artists such as Morse, Fulton and Shaw, who put down their brushes and turned to inventing . . . as did Carvalho himself, later. There were few art critics in nineteenth century America, and those artists who did not conform were either rejected or ignored altogether. Carvalho probably was considered a non-conformist. He was one of the few Jewish artists of his day, predating his successful artistic brethren of the twentieth century. It is not known whether Carvalho's religious affiliation was a cause of this apparent isolation. It would not seem to be consistent with the times. More possibly, Carvalho simply did not pursue his art from the frame of reference that art was all there was to living. In any case, his isolation, if real, might well be the factor that limited his triumph as a recognized artist.

Idealism had emotional, often sentimental and literary connotations. The sentimental Ideal was the product of a broad romantic movement of the nineteenth century, as demonstrated in the works of Sully and his followers. Carvalho did make one attempt in this area, witness "The Lovers." Unlike the genteel, idealizing portraits of Sully, however, the majority of Carvalho's portraits do not suffer from that affliction, but seem more direct, honest statements in the tradition of Stuart, but in Carvalho's own style. In this respect, his work is more representative of the spirit of his age.

The practical qualities that were in motion at the same time, those qualities which relate Carvalho to the earlier C. W. Peale, find him equally at home with art, mechanical and scientific investigations.

The loss of his daguerreotypes must have been a terrible blow to Solomon, both financially and personally. Though it was small comfort to him then, from today's vantage point all was not lost. Expansion towards the West in the nineteenth century and the craze for travel created a demand for pictures of far places and exotic subjects. The moving panorama was an early attempt to fill this need, and Carvalho surely had seen an early moving diorama when it was shown in Charleston in 1837. His own daguerreotypes of the West were the basis for steel engravings and woodblock prints. Thus his work was to influence many more people than he was to realize, for the sale of engravings was widespread. Illustration became a specialty with such artists as Felix Darby, and with the introduction of lithography, a cheaper method of printing, Currier & Ives became the rage. The appearance of Carvalho's "Child With Rabbits" on bank notes of the United States, Canada, and South America, gave him international exposure and adds luster to his image today.

By 1864, while the Hudson River School was favoring smaller, more intimate paintings, the Rocky Mountain "school" was blowing itself up to huge, showy proportions. Carvalho's benign "Grand Canyon" had preceded Bierstadt's harsh, exaggerated works by four, perhaps five years. His daguerreotypes of the West had been reproduced not only for book plates, but also in oil paintings by James Hamilton. Meanwhile, Carvalho quietly went his own way, painting portraits and landscapes based on the flexible formulas devised by Gilbert Stuart but producing works which seem singularly his own, and not connected with any one school, or literary affecta-

tion, carrying on scientific experiments, and continuing to utilize his knowledge of photography.

In his reaction to the American landscape, he was first of all himself, true to the nineteenth century spirit of freedom and inquiry, and American without European taint. He subordinated color to gain mood, participating in nature with a pantheistic and a sensuous joy. His landscapes are as harmonious as Carvalho himself.

His portraits, for the most part, are devoid of any sentimentality. They are penetrating studies of character, the portraits of George Murray Gill and Abraham Lincoln, mentioned for examples. It is hoped that those missing likenesses of important personages will be discovered, like the finding of the Lincoln portrait, in order to enlarge our storehouse of art historical knowledge.

There is still work to be done. The daguerreotype plates, or negatives made from them in Brady's studio, may be lying around, uncatalogued, in a private place. The identification of unknown paintings in the collection of the Church of Jesus Christ of Latter-Day Saints is continuing, and Carvalho works may turn up. Throughout Utah, a search is underway for the purpose of cataloguing and recognition of works of art, including those works in private collections.

Hopefully, the addition of this research will make people more aware of Carvalho, his art and life, which will in turn help in our search for other Carvalho works.

Solomon Carvalho's strong individuality probably served to win him admirers, as well as encourage some animosity among his contemporaries. And though his painting career was suddenly halted at a point where he showed a changing style, still, what works we have indicate an innate talent, more than a competent limner, and a valuable addition to the annals of American portraiture and landscape painting.

He was much alive and aware, a symbol of his era and a figure recognized by many luminaries of his own day. Solomon Nunes Carvalho deserves our recognition today.

ADDENDUM:

The following works by Solomon Nunes Carvalho were found too late to be included into the body of the text, and are added as an addendum to the art collected, here.

1. *David Nunes Carvalho,* c. 1868. o/c 6 × 8″
A note affixed to the back of the painting, in the handwriting of Maie Nunes Carvalho, daughter of David, says that the portrait is of her father. However, there are some inconsistencies in her use of "great-greats;" and the author believes this work to be a self-portrait of Solomon Nunes Carvalho, c. 1840. The young man is shown with a receding hairline and full beard which, as we know from his self-portrait of 1844, were characteristic. David Nunes Carvalho, while fond of sporting a mustache, did not grow a full beard until middle age or later, nor did he have the receding hairline of his father, Solomon.

2. *Hudson River Scene?* c. 1858-59. o/c 33 × 50″
A fine painting, indeed, this large landscape has the strangely benign, brooding quality that all known Carvalho landscape paintings possess. In composition, it is reminiscent of the "Rio Grande" (Kahn Collection, Oakland Museum, but does not suggest the far West. The atmospheric haze, handling of foreground detail, massing of rocks, and the lone, bright little plant sprouting bravely from one lower corner are familiar Carvalho touches. The birch trees appear a little too bright and the author believes this to be due to the taste of the restorer of this painting.

3. *Unknown Man on a Grey Horse* date and size unknown (not pictured) (Old Print Shop, N.Y.)
The scene is Charleston, S.C.
A hatted man with black hair and large black eyes sits upon a muscular horse, foreground of the painting. Around the horse's hoofs grow plants, flowers, etc. There is a wall, directly behind, with shrubbery and vines; and beyond the middle ground is a view of brick buildings and a street of Charleston. The scenery seems rather well done and convincing, and painted "on the spot." The man, however, and his steed, are rigid, out of proportion, and one feels that they are fillers. The eye of the horse is belabored, reminding one of the eye of the mother rabbit in "Child With Rabbits." The landscape and architectural renderings bear the hand of Carvalho. The foreground foliage seems familiar. Only the man and horse are foreign. It is possible that this is an early student work by Carvalho; or perhaps a collaboration between Carvalho and another student as an exercise.

197

David Nunes Carvalho, c. 1868. o/c 6 x 8. Son of the artist. Mr. and Mrs. David N.C. Tucker, Chatham, N.J.

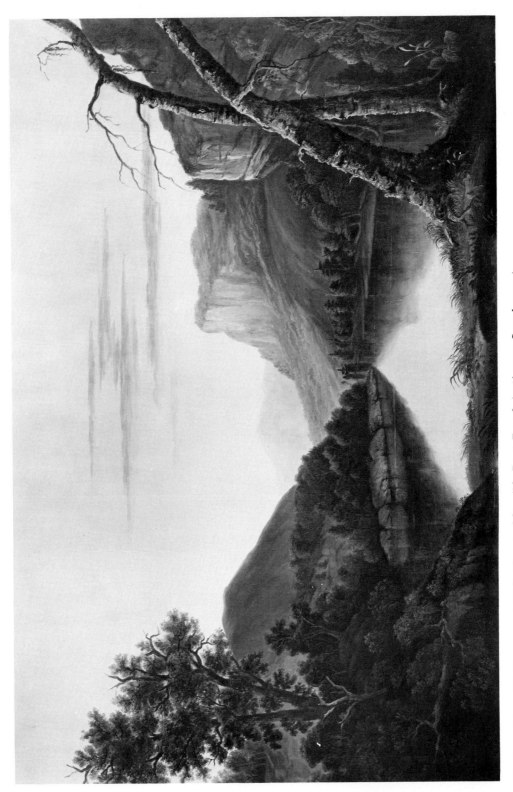

Hudson River (?) Scene, c. 1858-59. o/c 33 x 50. Post Road Antiques, Larchmont.

APPENDIX A

INVENTORY OF EXISTING WORKS BY CARVALHO

Paintings

Title	*Location*	*Date*
Dr. David Camden De-Leon	Collection, The Jewish Museum, New York	c. 1836
Beth Elohim Synagogue (interior)	Beth Elohim Synagogue Charleston, S.C.	1838
Beth Elohim Synagogue (exterior)	American Jewish Historical Society, Waltham, Mass.	c. 1838
Child With Rabbits	Private Collection	c. 1840
Johavath Isaacs	Alice deFord Philadelphia, Pa.	c. 1840
Unknown Young Man	Dr. Bertram W. Korn Philadelphia, Pa.	1841
Landscape	The Misses Solis-Cohen Philadelphia, Pa.	c. 1842
Moses Finzi Lobo	Dr. Bertram W. Korn Philadelphia, Pa.	1843

Myer David Cohen	Mrs. Marvin Jacoby Fort Washington, Pa.	c. 1843-44
Self Portrait (miniature)	Private Collection	1844
Isaac Leeser	Mr. Maxwell Whiteman Philadelphia, Pa.	c. 1845
Myer David Cohen	The Misses Solis-Cohen Philadelphia, Pa.	c. 1847
Self Portrait	The author	c. 1849
Solomon Da Silva Solis	Mrs. Helen Spigel Sax Philadelphia, Pa.	?
David Hays Solis	Mrs. Helen Spigel Sax Philadelphia, Pa.	?
Solomon Da Silva Solis	Mr. & Mrs. Charles Ro- senthal Binghamton, N.Y.	?
Little Miss Carvalho	Maryland Historical Soc. Baltimore, Md.	c. 1850
Beatrice Cenci	Private collection	?
David Nunes Carvalho (Son of the artist)	Mr. & Mrs. David N.C. Tucker, Chatham, New Jersey	c. 1868
Fruit Dish	Mrs. George Keller Philadelphia, Pa.	c. 1850
The Lovers	Private Collection	c. 1848-50
Mrs. Myer David Cohen	Misses Solis-Cohen Philadelphia, Pa.	c. 1851
Moses Before the Amale- kites	Private Collection	c. 1852
Sketch of a Dead Child	Mr. William R. Palmer	1854

Brigham Young	The Church of Jesus Christ of Latter Day Saints, Salt Lake City, Utah	1854
Wakar, Utah Indian Chief	Thomas Gilcrease Institute of American History and Art, Tulsa, Okla.	1854
Entrance to the Chochotope Pass	Mrs. Marvin Jacoby Fort Washington, Pa.	1854
Rio Grande River	The Kahn Collection Oakland Museum, Oakland, Calif.	c. 1854-55
John Charles Fremont	Pennsylvania Academy of the Fine Art, Philadelphia, Pa.	1856
Portrait of Sarah Solis Carvalho	The author	c. 1856
David Nunes Carvalho	S.N.C. Marshuetz	c. 1858
George Murray Gill	Maryland Historical Soc. Baltimore, Md.	1859
Paul Charles Morphy	Maryland Historical Soc. Baltimore, Md.	c. 1859
Annie Abrams	Private Collection	1861
Judah Touro	Touro Infirmary New Orleans, La.	1861
Jacob Solis Carvalho	Mrs. Helen Spigel Sax Philadelphia, Pa.	c. 1862
Isaac Mendes Seixas Nathan	Emily S. Nathan	c. 1862

Aaron Lopez Gomez	Mrs. Henry S. Hendricks New York, N.Y.	c. 1862
Miriam Nunes Carvalho Osorio (miniature)	Private Collection	c. 1864
Abraham Lincoln	The Rose Art Museum Brandeis University Waltham, Mass.	1865
Florencio Serrano and Family	Zeitlin & Ver Brugge Los Angeles, Calif.	c. 1856-68
Two Fishermen at the Edge of a Stream	American Jewish Ar- chives Cincinnati, Ohio	1867
Sarah Solis Carvalho (miniature)	Private Collection	c. 1871-73
Miriam Woolf Hirsch	Marion H. Hirsch Clearwater, Fla.	c. 1841
John M. Hirsch (minia- ture)	Willard Hirsch Charleston, S.C.	c. 1841
Unknown Young Man (miniature)	Willard Hirsch Charleston, S.C.	c. 1841
Hudson River Scene	Post Road Antiques Lar- chmont, N.Y.	c. 1858-59

Daguerreotypes, Photographs

Title	*Location*	*Date*
Miriam Hirsch/two sons, Isaac & Melvin	Willard Hirsch Charleston, S.C.	c. 1849-50
Self Portrait	Library of Congress	c. 1848

Two of Solomon Carvalho's Children	Library of Congress	c. 1856
Indian Village	Library of Congress	c. 1853
Album of Martinique	Schomberg Collection New York Public Library New York, N.Y.	1878
Carvalho's Art on Paper Money	Dr. John A. Muscalus Bridgeport, Pa.	c. 1855-67

APPENDIX B

WORKS KNOWN TO HAVE BEEN DONE, WHEREABOUTS UNKNOWN

Daguerreotypes

Daguerreotypes, Fifth Fremont expedition, 1853-54 (exception: one plate, Library of Congress, Indian Village).

Paintings

"Fanny Noctin," 1869

The Itinerant Book Vendor

Entrance to the Valley of St. Clare, between Utah and California

Sunset on the Los Angeles River

These three were exhibited at the Maryland Historical Society, and are mentioned in their magazine, June, 1947, pp. 133-34.

The Grand Canyon, c. 1854-55. (canvas destroyed).

The Grand Canyon, c. 1865.

Vas. Houghton, portrait. Item #425, National Academy of Design, 1862.

Moonlight on the Rio Virgin, Item #163, National Academy of Design, 1862.

The Artist, portrait. Item #256, National Academy of Design, 1864.

Thomas Hunter, c. 1860.

Senator William C. Preston, 1841.

Charles Henry Moise, 1868.

Intercession of Moses for Israel, c. 1852.

Western Landscape, c. 1856 (photograph of oil painting exists in the *Memoirs* of John Charles Fremont).

Western Portraits, landscapes, and drawings mentioned by Solomon Nunes Carvalho in his journal (exceptions: Portrait of Warka and Sketch of a Dead Child), and in personal correspondence.

NOTES
CHAPTER I

[1]Charles Reznikoff and Uriah Z. Engleman, *The Jews of Charleston* (Philadelphia, 1952), p. 66.

[2]Edward Biddle and Mantle Fielding, *The Life and Works of Thomas Sully, 1783-1872* (Charleston: Garnier & Co., 1969), p. 3.

[3]Anna Wells Rutledge, *Artists In the Life of Charleston* (Philadelphia: American Philosophical Society, Transactions, vol. 39, part 2, November, 1949), p. 137.

[4]*Ibid.*, "Henry Benbridge (1743-1822?), American Portrait Painter," *American Collector*

[5]*Ibid.*, *Artists In the Life of Charleston*, p. 133.

[6]*Ibid.*, p. 209.

[7]Reznikoff and Engleman, *The Jews of Charleston*, p. 80.

[8]Rutledge, *Artists In the Life of Charleston*, p. 138.

[9]*Ibid.*, p. 139.

[10]*Ibid.*, p. 141.

[11]*Ibid.*, p. 103.

[12]Bertram W. Korn, *Incidents of Travel and Adventure In The Far West, by Solomon Nunes Carvalho*, (Philadelphia: Jewish Publication Society, 1954), p. 19. Edited and with an *Introduction* by Bertram Wallace Korn.

[13]Sarah D'Azevedo, native of Holland, married in Charleston, May 24, 1814.

[14]Korn, *Incidents of Travel and Adventure*, p. 20.

[15]Solomon Nunes Carvalho, *Incidents of Travel and Adventure In the Far West* (New York: Derby & Jackson, 1857), p. 171.

[16]Korn, *Incidents of Travel and Adventure*, p. 21.

[17]Reznikoff and Engleman, *The Jews of Charleston*, pp. 56, 57.

[18]Korn, *Incidents of Travel and Adventure*, p. 23.

[19]*Ibid.*

[20]Reznikoff and Engleman, *The Jews of Charleston*, p. 138.

²¹Lyons Collection, American Jewish Historical Society.

²²Unpublished letter to Bertram W. Korn, 1954.

²³Carvalho, *Incidents of Travel and Adventure*, p. 105.

²⁴South Carolina Department of Archives and History, Miscellaneous Records, vol. 5x, p. 443.

NOTES
CHAPTER II

¹*American Hebrew*, American Jewish Archives, Elzas Collection, Obituary, June 4, 1897, p. 160.

²Hannah R. London, *Shades Of My Forefathers*, (Springfield, Mass.: The Pond-Ekberg Co., 1941), pp. 60-61. (Forward by John Haynes Holmes.)

³Sartain's *Union Magazine of Literature and Art*, Vols. 2-7, 1848-1850, p. 48.

⁴James Thomas Flexner, *The Light of Distant Skies*, (New York: Dover Publications, Inc., 1969), p. 245.

⁵Unpublished letter to Bertram W. Korn, March 20, 1953, from Hannah J. Howell, Frick Art Reference Library.

⁶Dr. John A. Muscalus, *Solomon Carvalho's Art On Paper Money Issued in the United States and Canada* (Bridgeport, Pa.: Historical Paper Money Research Institute, 1969), p. 2.

⁷Unpublished letter from Dr. Muscalus to the writer, June 30, 1972.

NOTES
CHAPTER III

¹Unpublished letter, courtesy of Maie Nunes Carvalho, granddaughter of Solomon Nunes Carvalho.

²Charity Hays and Jacob da Silva Solis were married in ceremony conducted by Dr. Emanuel Carvalho, uncle of Solomon Carvalho.

³*The Occident*, III, (1845), p. 420. American Jewish Archives.

⁴From an unpublished letter to the author from Robert F. Looney, Print & Picture Dept., The Free Library of Philadelphia, May 24, 1972.

⁵Robert Taft, *Photography and the American Scene* (New York: The Macmillan Co., 1942), pp. 6, 7.

⁶Beaumont Newhall, *The Daguerreotype In America* (New York: New York Graphic Society, Rev. Ed., 1968), p. 78.

⁷This may not be, as has been thought, a note to S. N. Carvalho, but instead, a note to Manuel Carvallo, then Representative from Chile to the United States, who was living in Washington until January, 1854. The spelling is the Spanish; it may simply be an error on Morse's part.

NOTES
CHAPTER IV

[1]New York Historical Society, *Dictionary of Artists in America, 1564 1860*, p. 113.

[2]*The Occident*, IX, 1851, American Jewish Archives.

[3]Korn, *Incidents of Travel and Adventure*, pp. 29, 30.

[4]Dropsie College Library, Leeser Manuscript Collection.

[5]*Ibid.*

[6]*The Occident*, X, 1853, pp. 21-31, American Jewish Archives.

[7]*Ibid.*, X, 1852, p. 26, American Jewish Archives.

[8]Rutledge, Artists In the Life of Charleston, p. 164.

[9]*The Occident*, X, 1853, p. 502.

[10]*Ibid.*, X, 1853, pp. 502-4.

[11]*Revised Standard Edition*, (New York: Thomas Nelson & Sons, 1952.)

[12]Unpublished letter from James Foster, Director, Maryland Historical Society, to Bertram W. Korn, March 20, 1953.

[13]*Photographic and Fine Art Journal*, V. III, 1852, p. 256.

NOTES
CHAPTER V

[1]*Humphrey's Journal of Photography*, Vol. IV, 1853, p. 383.

[2]Robert Taft, *Photography and the American Scene* (New York: The Macmillan Company, 1942), p. 256.

[3]James Horan, *Mathew Brady, Historian With a Camera* (New York: Crown Publishers, 1955), pp. 20-21. (See Horan's footnote.)

[4]*The National Magazine*, V. 11, 1853, p. 572.

[5]*Humphrey's Journal*, Vol. IV, 1853, p. 383.

[6]*Ibid.*

[7]Beaumont Newhall, *The Daguerreotype in America* (New York: New York Graphic Society, 1968), p. 88.

[8]*Ibid.*

[9]*Ibid.*

[10]Carvalho, *Incidents of Travel and Adventure, p. 17.*

NOTES
CHAPTER VI

[1]Carvalho, *Incidents of Travel and Adventure*, p. 20.

[2]*Ibid.*, p. 22.

[3]*Ibid.*, pp. 23, 24.

[4]Charles Macnamara, "The First Official Photographer," *The Scientific Monthly*, Vol. 42, Jan-June, 1936, pp. 70-71.

[5]Richard Rudisill, *The Mirror Image. The Influence of the Daguerreotype on American Society* (Albuquerque: University of New Mexico Press, 1971), p. 103.

[6]Carvalho, *Incidents of Travel and Adventure*, p. 31.

[7]*Ibid.*, pp. 30-31.

[8]*Ibid.*, pp. 32-33.

[9]*Ibid.*, pp. 37-38.

[10]*Ibid.*, pp. 38-39.

[11]*Ibid.*, p. 41.

[12]*Ibid.*, pp. 42-44.

[13]*Ibid.*

[14]*Ibid.*, p. 55.

[15]*Ibid.*

[16]*Ibid.*, p. 58.

[17]John Charles Fremont, *Memoirs of My Life, (Including the Narrative Five Journeys of Western Exploration during the Years 1842, 1843-4, 1845-6-7, 1853-4), Together With a Sketch of the Life of Senator Benton by Jessie Benton Fremont* (Chicago and New York: Belford, Clarke & Co., 1887), p. xvi.

[18]*The Philadelphia Evening Bulletin*, March 18, 1854, p. 2.

[19]Carvalho, *Incidents of Travel and Adventure*, p. 65.

[20]*Ibid.*, p. 67.

[21]James D. Horan, *Mathew Brady, Historian With a Camera* (New York: Crown Publishers, 1955), p. 79.

[22]Carvalho, *Incidents of Travel and Adventure*, p. 67.

[23]*Ibid.*, p. 68.

[24]*Ibid.*, p. 75.

[25]*Ibid.*, p. 76.

[26]*Ibid.*, pp. 78-79.

[27]*Ibid.*, pp. 82-83.

[28]*Ibid.*, p. 83.

[29]Rudisill, *The Mirror Image*, p. 103.

[30]Carvalho, *Incidents of Travel and Adventure*, p. 83.

[31]Rudisill, *The Mirror Image*, p. 104.

[32]Carvalho, *Incidents of Travel and Adventure, p. 87.*

[33]*Ibid.*, p. 101.

[34]*Cummings' Evening Bulletin*, Philadelphia, Monday, April 10, 1854.

[35]*Ibid.*, April 11, 1854.

[36]*Daily National Intelligencer*, Washington, Weds., April 12, 1854.

[37]*Ibid.*, Weds., June 14, 1854.

[38]*Ibid.*, Monday, June 12, 1854.

NOTES
CHAPTER VII

[1]Carvalho, *Incidents of Travel and Adventure*, pp. 140-41.

[2]*Ibid.*, p. 146.

[3]*Ibid.*, p. 142.

[4]*Ibid.*, p. 157.

[5]*Ibid.*, p. 169.

[6]*Ibid.*, p. 246. (Does ''view'' indicate daguerreotypes?)

[7]*Ibid.*, p. 247. (Col. Ferrimore Little and lady, doubtless ''Fanny and Terry Littlemore,'' which Carvalho used to hide his sitters' identities at the time.)

[8]Enoch Wood Perry was in Dusseldorf in 1852. There may have been a single source of artist's supplies in Salt Lake City, in which case, canvas and methods of stretching it likely would be uniform for artists buying and working in that area. Unpublished letter to the author from Miss Cathy Gilmore, The Church of Jesus Christ of Latter-Day Saints, Salt Lake City, June 26, 1972.

[9]Unpublished letter to the publisher from Donald T. Schmidt, The Church of Jesus Christ of Latter Day Saints, Salt Lake City, May 6, 1975.

[10]Carvalho, *Incidents of Travel and Adventure*, p. 189.

[11]*Ibid.*

[12]*Ibid.*, pp. 192-93.

[13]*Ibid.*, pp. 196-7.

[14]*Ibid.*, pp. 206-7.

[15]*Ibid.*, p. 211.

[16]*Ibid.*, p. 212.

[17]*Ibid.*, pp. 220-21.

[18]*Ibid.*, p. 244.

[19]*Ibid.*, p. 249.

[20]*Ibid.*, p. 250.

[21]Justin G. Turner, ''The First Decade of Los Angeles Jewry: A Pioneer History (1850-1860),'' *American Jewish Historical Quarterly*, Vol. 54, no. 2, Dec., 1965, p. 132.

[22]*Los Angeles Star*, July 8, 1854, col. 2, Los Angeles Public Library.

[23]*Ibid.*, August 24, 1854, col. 2, Los Angeles Public Library.

[24]*The Southern Californian*, August 31, 1854, Turner, ''The First Decade,'' *American Jewish Quarterly*, Dec., 1964, p. 113.

25Newhall, *The Daguerreotype in America*, p. 88.

NOTES
CHAPTER VIII

[1]Barbara Novak, ''American Landscape: The Nationalist Garden and the Holy Book,'' *Art In America*, Jan-Feb., vol. 1, 1972, p. 52.

[2]Oliver Larkin, *Art and Life In America* (New York: Holt, Rinehart & Winston, 1966), p. 200.

[3]Unpublished letter to the author, November, 1969, anonymous.

[4]Letter, courtesy American Jewish Archives.

[5]Carvalho, *Incidents of Travel and Adventure*, p. 216.

[6]Unpublished letter from Elvira N. Solis to her niece, Sat., March 28, n.d., courtesy, Dr. Bertram W. Korn.

[7]See the *Maryland Historical Magazine*, June, 1947, p. 133.

[8]*Ibid.*

NOTES
CHAPTER IX

[1]Unpublished letter from the Maryland Historical Society, March 20, 1953, courtesy Dr. Bertram W. Korn.

[2]Maryland Historical Magazine, June, 1947.

[3]*Photographic and Fine Art Journal*, v. 8, 1855, pp. 124-25.

[4]Fremont, *Memoirs*, p. xvi.

[5]Letter from Abraham Lincoln to Henry O'Conner, Sept. 14, 1856, auction catalog, Parke-Bernet Galleries, Inc., New York, 1952.

[6]John Bigelow, *Memoir of the Life and Public Services of John Charles Fremont* (New York: Derby & Jackson, 1856), p. 430.

[7]Fremont, *Memoirs*, p. xvi.

[8]Morris Schappes, *The Jews In the United States* (New York: Citidel Press, 1958), p. 90.

[9]Ritterband letter, Sept. 11, 1856, courtesy of Dr. Bertram W. Korn.

[10]San Diego Corral of the Westerners, Westerners Brand Book, No. II San Diego, 1971 pp. 48-53, article by Walt Wheelock entitled "Fremont's lost plates."

[11]Fremont, *Memoirs*, p. xvi.

[12]See *Spirit of the Fair*, April 5-23, 1865, N.Y.

[13]Allan Nevins, *Fremont, The West's Greatest Adventurer* (2 vols.; New York: Harper & Brothers, 1928).

[14]Unpublished letter to the author from Valerie D'Ippolito, Research Assistant, Pennsylvania Academy of Fine Arts, March 17, 1972.

[15]Korn, *Incidents of Travel and Adventure*, pp. 42-43.

[16]Rosenbach Collection, American Jewish Historical Society.

[17]Korn, *Incidents of Travel and Adventure*, pp. 44-45.

NOTES
CHAPTER X

[1]*The Occident Advertiser*, XVII, 1859-60, p. 2, American Jewish

Archives. (An interesting ad from this page was one placed by Rev. Leeser, asking for a governess of the Jewish faith to live with a family in Charleston.)

[2]*Maryland Historical Magazine*, June, 1947, pp. 129-136.

[3]Unpublished letter to Dr. Bertram W. Korn from James W. Foster, Director, Md. Hist. Soc., March 20, 1953.

[4]Unpublished letter to Dr. Bertram W. Korn from James W. Foster, March 31, 1953.

[5]Joshua Charles Taylor, *William Page, The American Titian* (Chicago: University of Chicago Press, 1957). p. 27.

[6]Maryland Historical Society, Nov. 7, 1859.

[7]*Occident*, p. 180.

[8]*Ibid.*

NOTES
CHAPTER XI

[1]Unpublished letter to the author, from Alice Melrose, Director, National Academy of Design, March 13, 1972.

[2]Bertram W. Korn, "Some Additional Notes On the Life and Works of Solomon Nunes Carvalho," *The Seventy-Fifth Anniversary Volume of the Jewish Quarterly Review*, Philadelphia, 1967, pp. 363-65.

[3]*Ibid.*, pp. 365-66.

[4]Unpublished letter to author, Melrose, March 13, 1972.

[5]Rutledge, *Artists In the Life of Charleston*, p. 165.

[6]Letter, Melrose, March 13, 1972.

[7]"The Old Print Shop *Portfolio*," Vol. XI, Feb., 1952, No. 6, pp. 123-24.

[8]Unpublished letter from Agnes Halsey, The Old Print Shop, N.Y., to the late Claire Carvalho Weiller, March 10, 1952.

[9]Korn, *Jewish Quarterly Review*, 1967, p. 362.

[10]Courtesy, American Jewish Archives.

[11]*Ibid.*

NOTES
CHAPTER XII

[1]Courtesy, New York Pub. Lib., Schomberg Collection. An interesting note: Carvalho's contemporary, Camille Pissarro, was born in 1831 in St. Thomas, W.I., of a Creole mother and Portuguese Jewish father. Pissarro had eye trouble, and died, blind, in 1903.

[2]Solomon Carvalho, "Rambles in Martinique," *Harper's New*

Monthly Magazine, No. CCLXXXIV, January, 1874, Vol. XLVIII, p. 163.

[3]*Ibid.*, p. 164.

[4]*Ibid.*

[5]*Ibid.*, p. 166.

[6]*Ibid.*, p. 170.

[7]*Ibid.*, p. 177.

[8]*The Occident*, Vol. XXV, (1867-68), p. 422.

NOTES
CHAPTER XIII

[1]P. 5, Pre 1959 Imprints, vol. 97, p. 367, Franklin Institute Library, Philadelphia.

[2]"Prof. S. N. Carvalho's New System of Superheating Steam, and Producing the Rapid transfer of heat at High Temperatures by Hot Water Circulation Under Pressure," courtesy American Jewish Historical Society, p. 1.

[3]Unpublished letter to the author, from Maie Nunes Carvalho, June 13, 1970.

[4]*Ibid.*

[5]*Ibid.*

[6]*Ibid.*

[7]Korn, *Jewish Quarterly Review*, letter to Emily Grace Solis, 1967, pp. 367-68.

[8]Henry Samuel Morais, *The Jews Of Philadelphia*, (Philadelphia: The Levytype Company, 1894), p. 361.

[9]Isaac Markens, *The Hebrews In America* (New York: By the Author, 1888), pp. 203-4.

[10]*Ibid.*, p. 204.

BIBLIOGRAPHY
SOURCES CONSULTED

Books

Benezit. Vols. 3, 1950-56. France: Librarie Grund, 1950.

Berea, T. *Handbook of 17th, 18th and 19th Century American Painters*. Chattanooga: Dalewood Enterprises, 1968.

Biddle, Edward, and Fielding, Mantle. *The Life and Works of Thomas Sully, 1783, 1872*. Charleston: Garnier & Co., 1969.

Bigelow, John. *Memoris of the Life and Public Services of John Charles Fremont*. New York: Derby & Jackson; Cincinnati: H. W. Derby & Co., 1856.

Blackwell, Basil. *A Guide to Records in Barbados*. Oxford: University of West Indies, 1965.

Carvalho, Solomon Nunes. *Incidents of Travel and Adventure in the Far West*. New York: Derby & Jackson, 1857.

Cohen, Jacob Xenab. *Jewish Life In South America*. New York: Bloch Publishers, 1941.

Corman, Harry J., and Thompson, Arthur W. *Sources For American Civilization, 1800-1900*. New York: Columbia University Press, 1960.

Cundall, Frank. *Bibliography of the West Indies*. Kingston: Institute of Jamaica, 1909.

Dictionary of American Biography. Vol. 6, 1931; vol. 16, 1935; vol. 5, 1930. New York: Charles Scribner's Sons.

Dunlap, William. *History of the Rise and Progress of the Arts of Design in the United States*. Vol. 2. New York: Benjamin Blom, 1965.

Elzas, Barnett A. *The Jews of South Carolina*, Philadelphia: 1905.

Flagg, Jared B. *The Life and Letters of Washington Allston*. New York and London: Benjamin Blom, 1892.

217

Flexner, James Thomas. *The Light of Distant Skies*. New York: Dover Publications, Inc., 1969.

———. *That Wilder Image*. New York: Dover Publications Inc., 1970.

Fremont, John Charles. *Memoirs Of My Life, 1813-1890*. Chicago: Belford, Clarke, 1887.

Golden, Harry Lewis. *Jewish Roots In the Carolinas*. Greensboro: Deal Print Co., 1955.

Goveia, Elsa V. *Slave Society In the British Leeward Islands at the End of the 18th Century*. New Haven: Yale University Press, 1965.

Groce, George C. *The New York Historical Society's Dictionary of Artists in America, 1564-1860*. New Haven: Yale University Press, 1957.

Harlow, Vincent Todd. *History of Barbados*. Oxford: Clarendon Press, 1926.

Henige, David P. *Colonial Governors—A Comprehensive List*. Milwaukee and London: University of Wisconsin Press, 1970.

Horan, James D. *Mathew Brady, Historian With A Camera*. New York: Crown Publishers, 1955.

Hotten, John Camden. *Barbados Biographies*. New York: G. A. Baker & Co., Inc., 1931.

———. *The Original Lists of Persons of Quality, 1600-1700*. New York: G. A. Baker & Co., Inc., 1931.

Jacobowitz, Arlene. *James Hamilton. (Special Exhibition, March 28-May 22, 1966)*. Brooklyn: The Brooklyn Museum, 1966.

Jewish Encyclopedia. Vol. XII. New York and London: Funk & Wagnalls Co., 1905.

Karolik, M., and M. *Collection of American Paintings, 1815-1865. Published for the Museum of Fine Arts, Boston, Mass*. Cambridge: Harvard University Press, 1949.

Korn, Bertram Wallace, ed. *Incidents of Travel and Adventure in the Far West, by Solomon Nunes Carvalho*. Philadelphia: Jewish Publication Society, 1954. (Edited and with an Introduction by Bertram Wallace Korn.)

Lancour, A. Harold. *Passenger Lists of Ships Coming to North America, 1607-1825*. New York Public Library Bulletin, May, 1937, vol. 41, p. 389.

Larkin, Oliver W. *Art and Life In America*. Revised ed. New York: Holt, Rinehart and Winston, 1966.

———. *Samuel F. B. Morse and American Democratic Art*. Boston: Little, Brown & Co., 1954.

Levinger Elma E. *Jewish Adventurers In America*. New York: Bloch Publishing Co., n.d.

Ligon, Richard. *A History of Barbados*. University College of the West Indies, 194?.

London, Hannah. *Portraits of Jews*. New York: William Edwin Rudge, 1927.

Lynch, Louis. *The Barbados Book*. New York: Taplinger Publishing Co., 1964.

Marcus, Jacob R. *American Jewry, Including West Indies*. Detroit: Wayne State University Press, 1970.

Markens, Isaac. *The Hebrews In America*. New York: By the Author, 1888.

Miller, Dorothy. *The Life and Work of David Gilmour Blythe*. Pittsburgh: University of Pittsburgh Press, 1950.

Morais, Henry Samuel. *The Jews of Philadelphia, (Their History from the Earliest Settlements, to the Present Time)*. Philadelphia: The Levytype Co., 1894.

Morse, Edward Lind. *Samuel F. B. Morse, His Letters and Journals*. 2 vols. Boston and New York: Houghton Mifflin Co., 1914.

Muscalus, John A. *Solomon Carvalho's Art On Paper Money Issued in the United States and Canada*. Bridgeport, Pa.: Historical Paper Money Research Institute, 1969.

Nevins, Allan. *Fremont: The West's Greatest Adventurer*. 2 vols. New York: Harper & Brothers, 1928.

Newhall, Beaumont. *The Daguerreotype In America*. Revised ed. New York: New York Graphic Society, 1968.

———. *Latent Image—Discovery of Photography*. New York: Doubleday, 1967.

———. *History of Photography*. New York: Museum of Modern Art, 1964.

Reznikoff, Charles, and Engleman, Uriah Z. *The Jews of Charleston*. Philadelphia, 1952.

Rinehart, Floyd and Marion. *American Daguerrean Art*. New York: Clarkson & Potter, Inc., 1968.

Rosenbloom, Joseph R. *A Biographical Dictionary of Early American Jews*. University of Kentucky Press, 1960.

Rudisill, Richard. *Mirror Image—The Influence of the Daguerreotype on American Society*. Albuquerque: University of New Mexico Press, 1971.

Rutledge, Anna Wells. *Artists In the Life of Charleston*. Philadelphia: American Philosophical Society, Nov., 1949. (Transactions of the American Philosophical Society, New Series, vol. 39, part 2, 1949.)

Sartain, John. *Reminiscences of a Very Old Man*. New York: D. Appleton & Co., 1899.

Schappes, Morris U. *The Jews In the United States: A Pictorial History 1654 to the Present*. New York: The Citadel Press, 1958.

Schwarz, Karl. *Jewish Artists of the 19th and 20th Centuries*. New York: Philosophical Library, 1949.

Shilstone, Eustace M. *Monumental Inscriptions in Barbados*. New York: American Jewish Historical Society, 1956.

Simonhoff, Harry. *Saga of American Jewry*. New York: Arco Publishing Co., Inc., 1959.

———. *Jewish Notables in America, 1776-1865*. New York: Greenberg Publishers, 1956.

Stevenson, Noel C. *Search and Research*. Revised ed. Salt Lake City: Deseret Book Co., 1959.

Szarkowski, John. *The Photographer and the American Landscape*. New York: Museum of Modern Art (Doubleday, distributor), 1963.

Taft, Robert. *Photography and the American Scene*. New York: Macmillan Co., 1942.

Taylor, Joshua Charles. *William Page the American Titian*. Chicago: University of Chicago Press, 1957.

Thone, James A. *Emancipation in the West Indies*. New York: American Anti-Slavery Society, 1839.

Three Hundred Years—A Volume to Commemorate the Tercentenary of the Re-Settlement of the Jews in Great Britain, 1656-1956. Published for the Tercentenary Council and the *Jewish Chronicle* by Vallentine Mitchell, London, 1957.

Tolman, Ruel P. *The Life and Works of Edward Greene Malbone*. New York: New York Historical Society, 1958.

Tuckerman, Henry. *Book of the Artists*. New York: Putnam, 1867.

Upham, Charles Wentworth. *Life, Expectations, and Public Services of John Charles Fremont*. Boston: Ticknor & Fields, 1856.

Waller, John Augustine. *A Voyage in the West Indies*. London: for Sir R. Phillips & Co., 1820.

Wagner, Harr, and Bashford, Herbert. *A Man Unafraid—The Story of John Charles Fremont*. San Francisco: Harr Wagner Publishing Co., 1927.

Wehle, Harry B. *Samuel F. B. Morse, American Painter: A Study Occasioned By An Exhibition of His Paintings*. New York: Metropolitan Museum of Art, 1932.

Wolf, Edwin, II. *Rosenbach*. New York: World Publishing Co., 1960.

Wolf, Simon. *The American Jew As Soldier and Patriot*. Publ. of the American Jewish Historical Society, No. 3, New York, 1895.

Periodicals

American Art Review. Feb. 24, 1880.

American Collector. Vol. XVII, Oct., 1948.

American Historical Society. *Writings On American History*. Reference Dept., Otto Richter Library.

American Jewish Historical Quarterly. Vol. 54, no. 2, Dec., 1965.

Antiques Magazine. Vol. 71, 1957.

Art In America. Vol. VI, 1918; vol. XVII, 1929; vol. 1, 1972.

The Cosmopolitan Art Journal. Sept., 1858.

Cummings' Evening Bulletin. Philadelphia, Monday, April 10, 1854 and Tuesday, April 11, 1854.

Daguerrean Journal. I, 1850; II, 1851; III, 1852.

Humphrey's Journal of Photography. Vol. IV, 1852, vol. V, 1852.

Korn, Bertram Wallace. "Some Additional Notes On the Life and Work of Solomon Nunes Carvalho." *The Jewish Quarterly Review*. Seventy-Five Anniversary Volumn, (1967).

Los Angeles Star. July 8, 1854 and Aug. 24, 1854.

Maryland Historical Society Magazine. Baltimore, June, 1847.

National Intelligencer. June 10, 1854, June 13, 1854.

National Magazine. Vol. II, 1853.

The Old Print Shop Portfolio. Vol. XI, no. 6, Feb., 1952.

Parke-Bernet Auction Catalog. New York, 1952.

Philadelphia Evening Bulletin. March 18, 1854.

Photographic and Fine Art Journal. Vol. III, 1852.

Sartain's Union Magazine of Literature and Art. Vols. 2-7, 1848-50.

The Scientific Monthly. Vol. 42, Jan-June, 1936.

The Southern Californian. Aug. 31, 1854.

Splitter, M., "Art in Los Angeles, 1850-1900," n.d.

Turner, Justin G. "The First Decade of Los Angeles Jewry: A Pioneer History (1850)1860)." *American Jewish Historical Quarterly*. Vol. 54, no. 2, Dec., 1965, p. 132.

Other

American Jewish Archives. Cincinnati, Ohio. (Files)

American Jewish Historical Society, Waltham, Mass. (Files)

British Museum, Print Room. Heal Collection of Trade Cards.

Personal correspondence, museums, galleries, libraries, historical societies, collectors, etc.

Unpublished Minutes. Pennsylvania Academy.

ACKNOWLEDGMENTS

So many people assisted in the building of this book that it is difficult to give adequate account and appreciation. However, I will try by first thanking all those unnamed persons who answered my letters of inquiry, but who had no information: I thank them for their time and efforts.

To: Nathan M. Kaganoff, American Jewish Historical Society; the Enoch Pratt Free Library; Margaret Aspinwall, *Antique's Magazine;* G. H. Dorr III, Director, Phoenix Art Museum; Rudy H. Turk, Director, Arizona State University Art Collection; the California Historical Society; W. N. Davis, Jr, California State Archives, Sacramento; Wilson Library, University of North Carolina; Karen Wright, Boston Museum of Fine Arts; Nancy Wynne, Amon Carter Museum of Western Art; the Eastman Kodak Library; Amherst College; Hannah J. Howell and Mildred Steinbach, Frick Reference Library; Carey S. Bliss, Curator, Rare Books, Huntington Library; Kathryn Carey, John Howell Books; Daniel E. Brennan, Hunter College; James E. Vale and Katherine Grant, Los Angeles Public Library; E.L. Inabinett, University of South Carolina; Franklin Institute Library; Wilburn C. West, Utah Institute of Fine Arts; Phyllis K. Owen, Brigham City Corp.; Marle V. Budd, State of Utah Archives; Margaret D. Lester, State of Utah, Dept. of Development Services; Janet F. White, University of Michigan; Ann B. Abid, City Art Museum, St. Louis; Alice G. Melrose, National Academy

of Design; Josephine Cobb, National Archives, Washington; Rebecca O'Neal, Smithsonian Institution; Emory University Library; Elayne Gardstein, National Gallery of Art; Ellen F. Bellingham, University of New Mexico Fine Arts Library; Linda S. Ferber, Brooklyn Museum; Howell J. Heaney and Robert F. Looney, Free Library of Philadelphia; Harvard University, Widner Library; Detroit Public Library; Ruth Ann Stewart, New York Public Library; Hebrew Union College, Jewish Institute of Religion Library; Allan Ottley, California State Library; Marjorie Groggins, Registrar, Rose Art Museum, Brandeis University, and Robert B. Gates, Santa Barbara Historical Society—to all the above, my sincere thanks for all efforts to expedite the writing of this book.

Others who deserve special acknowledgment and thanks: Mrs. Terry I. Helsley, South Carolina Department of Archives and History; Thomas J. Tobias, Charleston, S.C.; E. Milby Burton, Charleston Museum; Congregation Beth Elohim, Charleston. Carol Hotchkiss, Registrar, Lowe Art Museum, Miami, Florida; Wilson G. Duprey, New York Historical Society; John Dewar, Los Angeles County Museum of Natural History; Dr. Eliad-Evans, Curator, Society of California Pioneers; Marie F. Keene, Thomas Gilcrease Institute; Lesser Zussman, Jewish Publication Society; Mrs. Estaban M. Fernandez, Kennedy Galleries; New York City; Hannah London; Nancy Moure, Los Angeles County Museum of Art; Helen Spigel Sax, Philadelphia. Edwin S. Holgren, New York Public Library; Kenneth Newmann, Old Print Shop; Therese Heyman, Oakland Museum; Anna Wells Rutledge; Paul Mills, Santa Barbara Museum of Art; Rabbi Malcolm Stern; Richard H. Dillon, Sutro Library; Justin G. Turner, Los Angeles; Lesley Goates, Salt Lake City; Maxwell Whiteman, Philadelphia; Elizabeth Bailey, Registrar, Pennsylvania Academy, and members of her staff; Robert H. Land Reference Dept., Library of Congress, and all his staff; Mrs. Barbara Adt, History Dept., University of Miami; and Dr. Isaac S. Emanuel, Cincinnati—thank you all for patience and great help.

To Eugenia Holland and P. William Filby, Maryland Historical Society, Baltimore, I owe a special debt of thanks which will not be forgotten.

To: Dr. Jacob Marcus and his staff, American Jewish Archives; Mr. Bernard Wax, Director, American Jewish Historical Society,

and his staff; Mrs. Jean Blackwell Hutson, Curator, Schomberg Collection, New York Public Library; Robert L. Middleton, The Free Library of Philadelphia; Helen G. McCormack, Gibbs Art Gallery, Charleston; Sandra Taylor and the Photo staff, University of California at Los Angeles; Wilma Kaemlein, and Margaret McCurdy, University of Arizona; Dropsie College Library; Clint Barber, Salt Lake City; Virginia Rugheimer, Charleston, S.C., Library Society; Seymore Leibman; and Mimi Smolev—I am deeply grateful to you all.

To: Mr. and Mrs. Leonard Verdier, Jr., my gratitude and love for a gift of love.

To: Mrs. Henry S. Hendricks; Emily S. Nathan; Michael Wentworth, Director, Rose Art Museum; Mrs. Joan Tolhurst, Touro Infirmary; Mrs. Joseph Larus; Mr. and Mrs. Charles Rosenthal; The Misses Solis-Cohen; Mrs. George Keller; the Pennsylvania Academy of Fine Arts; Mrs. Helen Spigel Sax; Mr. Maxwell Whiteman; the American Jewish Archives; the Maryland Historical Society; Zeitlin & Ver Brugge; the Oakland Museum; the Kennedy Galleries; the Thomas Gilcrease Institute; Beth Elohim Congregation; the New York Public Library; The Church of Jesus Christ of Latter Day Saints; Mr. Willard Hirsch; Mrs. Marvin Jacoby, and the Jewish Museum, New York—my affection and thanks for permissions and pictorial help.

To: Richard Forgham, Port-au-Prince, Haiti and Philip Brodatz, without whose labor and understanding the photography would not have been possible—to say thank you is an understatement!

To: the late John Heistand, for his patient restoration of "The Lovers," my loving appreciation; and also to Herbert Ebeling, who undid a bad job of relining (caused by the author), with a minimum of scolding and admonition (which were richly deserved), and to Mr. and Mrs. Antonio St. Andrew for restoration of "Solomon" and "Sarah," and the recleaning of "The Lovers," a special debt of gratitude.

To: Cathy Gilmore, Salt Lake City, for her patience and help—sincere thanks to a good friend.

To: Dr. John A. Muscalus, Professor Richard Rudisill, and sculptor Willard Hirsch, my affection and appreciation for their scholarship and unselfish assistance.

To: Professor Thomas Correll who started me on this quest nearly eight years ago; Dr. Bertram W. Korn for unceasing support, understanding and loan of valuable material; Mrs. Mildred Merrick for research assistance, editing and enthusiasm; the Reference Department, Otto Richter Library, University of Miami, including Dr. Ana Rosa Nunez, Mrs. Miriam Chamberlain, and Susie, whose last name I never knew; Dr. Charlton Tebeau, author, historian, scholar, who gave me a gift of Time, personal interest and encouragement; the late Claire Carvalho Weiller, for a legacy; Maie Nunes Carvalho, for her strong backbone and constant encouragement; Professors Robert Willson and Donald M. Early, for editing and advice; Mr. and Mrs. Jacob Zeitlin, Los Angeles, for photographic help seldom encountered in research; my friend and typist, Esther Nedelman; my parents, and my son. If I have been guilty of any omisions, please dear Friends, forgive me!